Bruce Graham of SOM

Bruce Graham of SOM

Electa

Designer
Marcello Francone

Printed in Italy
© 1989 by Electa, Milano
Elemond Arte
Elemond Editori Associati
All rights reserved

First published in 1989 in the United States of America by
RIZZOLI INTERNATIONAL PUBLICATIONS, INC.
300 Park Avenue South, New York, New York 10010

It would be difficult to say with words or music what I feel I can say best with building. I have always seen my work as an architect as a continuum from the moment of my initiation until today (nor is it unique that I should, as others have done, return to directions which had been explored or even built earlier). There are two concurrent notions, if not principles, that have driven my search. Before any formal educational process, I had been fascinated by the possible manipulation of structure and materials to convey new interpretations and focuses of the life experience. Equally compelling is the force that drives me to think this manipulation could only take place if the stage itself was equally directed and managed. To date, the abortive attempts at stage management are very numerous. The number of players is enormous and, almost always, neither visionary nor supportive of the script. It appears rather that the animal instincts of our society fear the dreams that make up civilization. Nevertheless, the attempt, beginning with my arrival in Chicago and continuing to this day, has encompassed work for partial or total planning of this city and others in such projects as the Chicago World's Fair, King's Cross Station in London and Canary Wharf outside London. These projects have convinced me of the viability and the necessity for architects to recapture the lost field of city building. We must wrench this task from the grasp of the uninspired bureaucracy which now lays claim to it under the cloak of democracy, but who are in fact stalwarts of mediocrity.

Joining SOM and leading the firm into the area of urban design was essential to my work, and has become one of the most rewarding aspects of that involvement. In the process I have had the pleasure of working with leading architects from across this nation as well as some from Europe. The rapidity with which that work unfolded in clear directions and solutions is proof, at least to me, that while we all protect the individual vocabulary of a given architectural adventure (properly so), we can agree upon and delight in unexplainable spatial solutions which make up beautiful cities. Working intensely or fleetingly with Stanley Tigerman, Tom Beeby, Frank Gehry, Charlie Moore, David Chipperfield, Harry Cobb, Bob Stern and Steve Eisenour, as well as with my partners, has been most rewarding. Collaboration curbs the individual ego and generates electric communication through the manipulation of drawings, models and structures to produce the thing which we all love, architecture.

Structure on the other hand is a more privately held tool whether the structure be wood frames, bearing walls, steel frames or concrete tubes. I have been unusually fortunate to work intimately with engineers throughout my life at SOM. Fazlur Khan and Hal Iyengar, both great engineers, lent their talents freely to the wild meandering of my work. We dug deep into dreams and nightmares and searched for architectural adventures with forms and shapes that cursed us as well as, at times, blessed us. In particular, the concrete tube was the most frustrating because its relentless logic seems to prohibit spatial penetrations. The concrete and steel frames, however, I have perceived as a continuation of a four-dimensional grid that is indigenous to architecture and inherent in man-made spaces.

In the city of Chicago, we have created great landscapes of the middle west of America which are obvious yet complex. The boundaries are only what we choose and are rarely externally imposed. The nature of the palette; frames, curtain walls, infill, floor plates, and the crafting thereof, allows for infinite manipulation. It is there that I return again and again to regain strength and vigor. It is there that near certainty of concept appears.

The Hancock building is but a modulation of the grid. Its brutality is deliberate, but it is that dream of departure from the real world that engenders its gigantic quality and yet brings it back to earth and its master, the human spirit.

I have never seen architecture as entertainment any more than poetry, music, painting or sculpture, but rather as an adventure into the unknown which can extend the human experience beyond the ordinary needs of survival, sanitation and the other necessities. Architecture is at the outset functional, but that function must extend beyond the mundane to matters of the spirit. Functional buildings are a matter of law and we are good at it; but, if the only role is functionality, then architecture becomes a craft like that of medicine. We cannot explain every spatial move except that they must exist for the poetry to exist, and for that purpose does the artist in us live.

Bruce Graham

Contents

- 8 Who is Bruce Graham, Anyway? *Stanley Tigerman*
- 10 Kimberly-Clark Corporation, General and Executive Office Building and Cafeteria
- 14 Warren Petroleum Corporation Headquarters Office Building
- 16 Inland Steel Building, Corporate Headquarters
- 20 The Upjohn Company, Corporate Headquarters
- 28 United Airlines, Executive Office Building and Education and Training Center
- 32 Business Men's Assurance Company of America, Corporate Headquarters
- 36 Brunswick Office Building and Richard J. Daley Center
- 42 Boots Pure Drug Company, Ltd., Corporate Headquarters
- 46 John Hancock Center, Multi-Use Complex
- 52 One Shell Plaza
- 56 Sears Tower, Corporate Headquarters and Sears Tower Revitalization Project
- 62 Fourth Financial Center
- 68 First Wisconsin Plaza, Bank and Office Building
- 72 W.D. & H.O. Wills, Tobacco Processing Plant and Corporate Headquarters
- 76 Baxter Travenol Laboratories, Inc., Corporate Headquarters
- 84 Banco de Occidente, Banco de Occidente Zone 1 and Montufar
- 90 King Abdul Aziz University
- 94 Three First National Plaza, Office Building
- 98 Madison Plaza, Office Building
- 102 Grupo Industrial Alfa, Corporate Headquarters
- 106 National Gallery Extension, Design Competition
- 110 Huntington Center, Office Building
- 112 Josep Llorens Artigas Foundation Studio
- 116 The Terraces at Perimeter Center
- 124 One Financial Place
- 130 McCormick Place Exposition Center, Expansion Facility
- 138 Canary Wharf, Master Plan
- 142 Bishopsgate Project, Broadgate–Phases Five through Fourteen, Multi-Use Complex
- 154 King's Cross, Master Plan
- 156 Port Imperial, Master Plan and Multi-Use Development
- 158 Stockley Park, Business Park Campus
- 162 Holy Angels Parish Church

Appendix
- 164 *Biographical Note*
- 165 *Bibliographical Note*
- 166 *Photographic Credits*

Who is Bruce Graham, Anyway?

Monographs about architects, or, more precisely, monographs about their work, generally let the work stand on its own, without bringing nuances of personality into play. Frankly, under most circumstances it is not really important to establish the nature of an architect's personality, except as it relates to the peculiarities of an individual client or a specific project. Most architects, after all, practice their discipline in isolation, the parameters of which are determined by their unique interpretations of culture, user, geometry, philosophy, aesthetics—the elements that have conventionally had an impact on architectural practice. By this definition, then, the personality of the architect is intrinsic to the solutions at which he arrives in this individualistic pursuit. In the case of Bruce Graham, however, this assumption cannot be made.

When an architect spends the majority of his career interacting with and, to some degree exercising control over, a worldwide professional organization composed of over two thousand people, then an examination of his work must take this into account.

The magnitude of the architecture produced by Skidmore, Owings & Merrill (SOM), both in terms of sheer volume of building and the collective energy expended on the process of building, far exceeds that of any contemporary firm, and certainly is immeasurably greater than any previous synergetic architectural effort. At the moment of this writing, SOM and Bruce Graham are, for all practical purposes, indistinguishable. But who is Bruce Graham, and for that matter, who is SOM, anyway?

In the late 1950s, Sigfried Giedion wrote an adventuresome essay in the international architectural journal *Bauen und Wohnen* in which he described the challenge that SOM seemed to be facing, and the commensurate risk, in attempting to produce quality architecture for corporate American clients. In his essay, Giedion wondered if it was possible to introduce aesthetic values into such capitalistic enterprises, where the client's primary concern was profit. Like most authors, Giedion left the question of whether or not this was an appropriate venture, and whether or not it would ultimately succeed, unanswered. But the issue of the nature of SOM's practice, and the fact that the firm was a force to be reckoned with in the corporate, commercial architectural arena, had been raised.

It was at that point in time that I came to know Bruce Graham, who had just been elevated to general partner status in the Chicago office of SOM. I had been hired as a junior designer by his counterpart, Walter A. Netsch, Jr., to work on the Air Force Academy at Colorado Springs, at the closing moments of construction for that immense military complex. The completion of that project coincided with SOM's move to new headquarters in the Inland Steel building, whose authorship both Netsch and Graham share (not without continuing debate as to the extent of each of their roles, I might add). Graham had just become partner-in-charge, and thus, my boss. My experiences in that early period at SOM with Bruce left an indelible mark. It is safe to say that Bruce Graham never had an ambivalent bone in his body. In fact, he has often been criticized for shooting from the hip. That coincidence in our personalities represents as good a reason as any for the authorship of this introduction to his monograph, and goes a long way toward explaining the occasionally tempestuous quality of our connection at that time. While our relationship was distinctly hierar-

chical by virtue of our relative seniority, that is the nature of most of Graham's professional relationships. Few, if any, are perceived to be his equal. For decades his working methods were perhaps too deftly characterized as instructing or directing. His mode of communication at times appeared to be unidirectional; possibly he considered it a sign of weakness to engage in dialogue with other architects. This was the way in which he felt it necessary to conduct himself in the increasingly large and powerful SOM organization. As his own power grew within, and later beyond, SOM, he appeared to increase the distance he judged necessary to the establishment and maintenance of his authority. Along with the success he attained, I suspect a commensurate loneliness resulted from this self-imposed isolation. While the mythology perpetuated by the partners at SOM is that theirs is a team operation, there is little doubt that Bruce Graham is the definitive team leader.

Now leadership, like vanity, bears fruit that is sour as well as sweet. The conventional wisdom in corporate America (and as a firm SOM is nothing if not corporate in its inclination as well as its clientele) is that movement up the ladder is expedited by political posturing. Bruce Graham is anything but conventional in this sense. It is more than a little heroic to set moral boundaries and express belief systems as candidly as he has done, particularly when this stance often invites antagonism. He has not been entirely consistent in this propensity; on rare occasions he has backed away from a battle that needed fighting. His self-removal from the debates regarding the controversial 1992 Chicago World's Fair was uncharacteristic—and regrettable. Nonetheless, in this age of architects who market their services and in the process conform to the norms of free capitalistic profit motives, Bruce Graham's heroic conduct has been remarkable. The fact that he has taken this stand while a partner in an aggressively marketing-oriented architectural firm, makes his behavior even more notable.

By utilizing his power to fight against those forces in a large organization generally devoted to unconditionally satisfying clients, Bruce Graham has brought to SOM a morality uncommon in such situations. It can be said that failure is a constituent element of heroism. A client of his refers to Graham as a fallen hero. To the degree that this is so, in that he has had to fight continuously against the homogeneity implicit in the work of a gargantuan firm where everyone is accorded equal status, his efforts have made a considerable difference. His explosive personality is directed not only at colleagues, but (often to the dismay of his partners) at his clients as well. With regard to these highly charged characteristics, it is possible to see parallels with the personality of Frank Lloyd Wright. Graham's frustration at the inertia inherent in corporate life has led him into problems not normally associated with an administrative role in an immense architectural firm.

And so, when all is said and done, Bruce Graham is an architect—an individual fighting against the forces that conspire to make normative that which is not always acceptable from a moral viewpoint—not merely a corporate figure in mammoth practice. Through his continuous struggle he has ennobled, rather than diminished, that tradition in architectural practice that separates it from much of the endeavors of humankind.

Stanley Tigerman

1956 Kimberly-Clark Corporation, General and Executive Office Buildings and Cafeteria

Each entry starts with a quotation (in italics) from Bruce Graham.

City: Neenah, Wisconsin
Client: Kimberly-Clark Corporation
Two-story executive offices; one-story 500 × 150 foot general offices; cafeteria pavilion; on-grade parking
Black painted steel; clear glass; natural local stone

In 1956, architecture in America was awakening from twenty-six years of depression and war. Before then, architects and builders were unaware of any craft but that of temporary buildings. The architectural revolution in Chicago was not socially related, as in Europe, but was rather a search for an architecture that would express the technical man. We were learning both how to build buildings and what kind of society this democracy was becoming. We were learning to fit bricks together and to weld steel. Kimberly-Clark was just such a learning process, not only for myself, but for many of my contemporaries. Integration and collaboration with engineers was almost a religious ritual, anonymity a moral obligation. Buildings were thought to be the product of the cooperative rather than individual poetic statements.

An original headquarters for the well-known paper company is located on a fifty-acre site on Little Lake Buttes des Mortes. Three buildings make up the complex: the general office building, an executive office building, and a cafeteria. Planning a general office building sufficiently flexible to meet the varying space demands and departmental requirements of Kimberly-Clark resulted in the very large 500 × 150 foot, horizontal one-story structure. This glass-clad building is oriented around two landscaped courtyards that provide the office interiors with natural light. But for moveable partitions, there are no interior walls in the building and all support functions are housed below the main level. Retaining walls of local stone encompass the complex, and all three buildings are constructed of black exposed structural steel. The two-level executive office building is raised over a visitor parking area and the entrance lobby. The cafeteria, a sixty-foot clear span structure, faces the lake and, like the executive building, is connected by passageway to the main office building.

Bibliography: *Architectural Record*, February 1957; *Bauen & Wohnen*, April 1957; *Milwaukee Journal*, 18 November 1956.

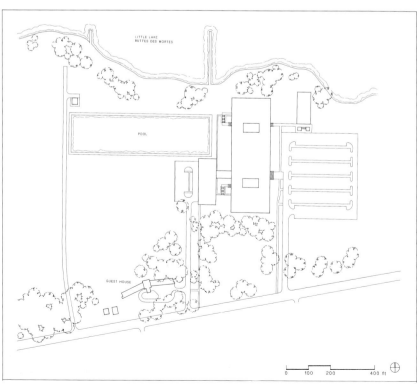

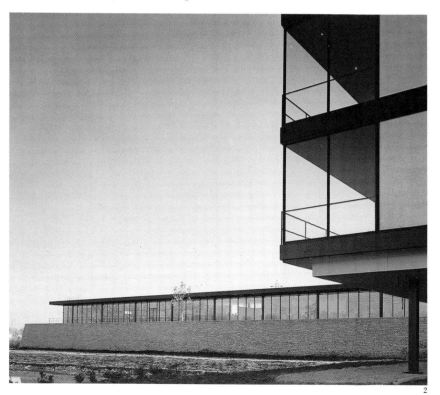

1. Site plan
2-4. Views of one-story general office building and two-story executive office building

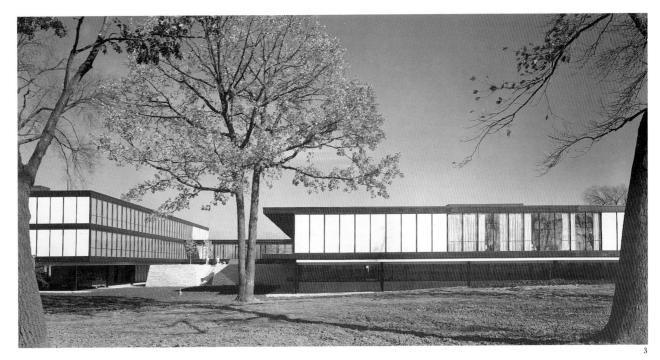

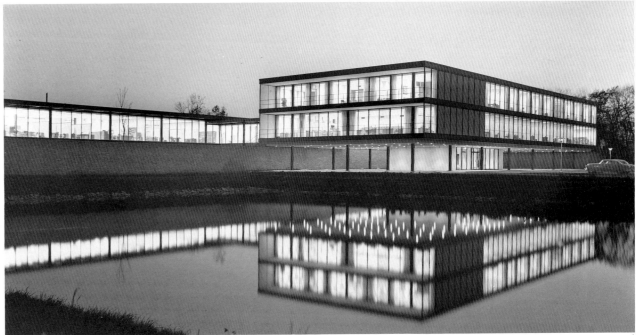

Kimberly-Clark Corporation

5-7. Views of general office building and enclosed passageway connecting the executive and general office buildings

8. Exterior of the cafeteria

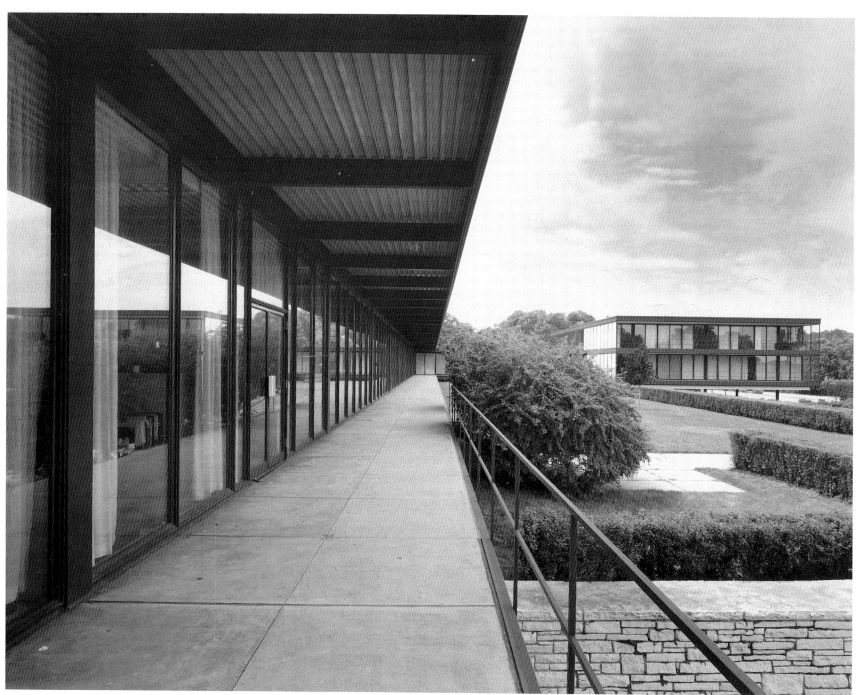

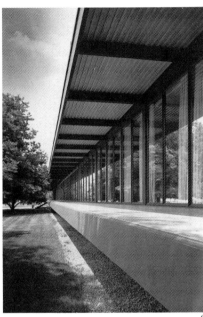

1957

Warren Petroleum Corporation Headquarters Office Building

9. Detail of exterior wall to show sunshades
10. Headquarters office building

City: Tulsa, Oklahoma
Client: Warren Petroleum Corporation
Twelve-story office building; two story cafeteria building
Aluminum and glass curtain wall; grey, heat-absorbing glass sunshades

Warren Petroleum was an early adventure into the integration of environmental system despite the fact that even with what we learned from Le Corbusier's experience, we knew very little about how to deal with inclement weather. The exterior sheet of glass, which absorbs heat and reradiates it to the exterior, was intuitive and successful.

The general and executive headquarter offices for the Warren Petroleum Corporation occupy a twelve-story tower and two-story cafeteria building near downtown Tulsa. A terrace of Italian travertine, marble, and granite with areas for plantings links the office tower and the two-hundred seat employee cafeteria. The corporation's need for a high proportion of flexible private and semi-private offices resulted in the tower's typical 108 × 108 foot office floor with a central service core of 36 × 46 feet. Four center bay columns are contained within the service core permitting a clear span of thirty-six feet from center core to outside wall. The furnishings and interior design of the executive floor, lobbies, and cafeteria were specially selected by the architects to be in keeping with the building's architectural quality. The exterior of the tower consists of aluminum and glass with projecting balconies that employ sunshades of gray heat absorbing glass. The walls of the ground floor lobby and the cafeteria are of polished aggregate precast concrete, aluminum, and glass.

Bibliography: *Architectural Forum,* June 1960; *Architectural Record,* August 1958; *Bauen & Wohnen,* February 1960.

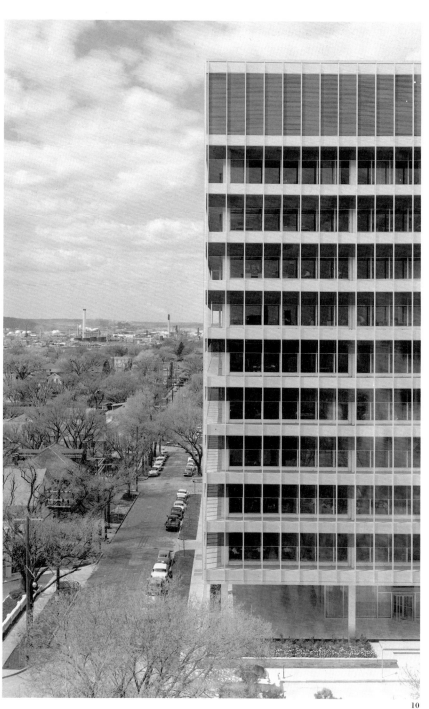

11. *View from executive office*
12. *Exterior at night*

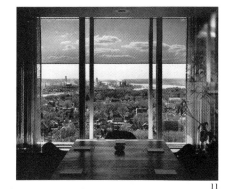
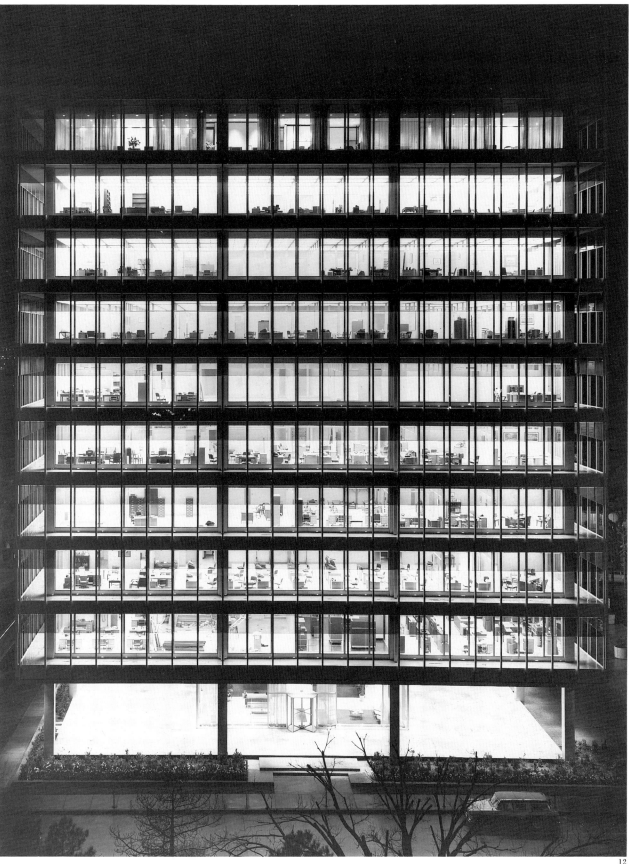

1958

Inland Steel Building, Corporate Headquarters

13. Shaft between office tower and service tower
14. Typical floor plan

City: Chicago, Illinois
Client: Inland Steel Company
Nineteen-story, sixty-foot clear space office tower; twenty-five story service tower
Stainless steel; tinted dual glazing glass

The Inland Steel Building was my first high-rise experience. Still driven by an innocent view of a society uncomplicated by traditions, we were in search of noble new materials. These materials had to fit into a city with a short history. The traditions of Mies were not as powerful as the honesty of structure exhibited by earlier Chicago architects such as Jenney, Sullivan, and others. However, the power of the grid and its hypnotic, endless quality permeated the building almost as an extension of smaller grids found within the huge American landscape. Awareness of fine materials began with this building not only in its exterior, but also in its furnishings and sculptures. Structure became even more religious, and as I look back now, more poetic.

This headquarters building was the first major structure in the Chicago Loop in more than twenty years. The building occupies sixty-six percent of its site, and houses the nineteen-story office tower separately from its twenty-five story service tower in order to provide interior spaces free from core facilities and columns. A 5 foot 2 inch × 5 foot 2 inch module governs office partitions and layout. The structural steel framing includes sixty-foot girders spanning the office floors and supporting the beams and steel decking. A stainless steel curtain wall with tinted, dual glazing glass encloses the office tower while stainless steel sheets provide cladding for columns and the service tower.

Bibliography: Architectural Forum, May 1955; April 1958; June 1960; Architectural League of New York, 1960; *Gold Medal Exhibition of the Building Arts*, 1960; *Architectural Record*, March 1957; May 1957; April 1958; *Art in America*, Winter 1957; *Bauen & Wohnen*, April 1957; *Chicago Sun-Times*, 12 September 1982; *Inland Architect*, March 1958; *Interiors*, October 1958; January 1959; December 1986; *Progressive Architecture*, June 1957; *Time*, 10 February 1958.
W. H. Jordy, *American Buildings and Their Architects*, Anchor Press/Doubleday, Garden City 1976; Museum of Science and Industry, *A Guide to 150 Years of Chicago Architecture*, Chicago Review Press, Chicago 1985; C. Woodward, *Skidmore, Owings & Merrill*, Simon and Schuster, New York 1970.

13

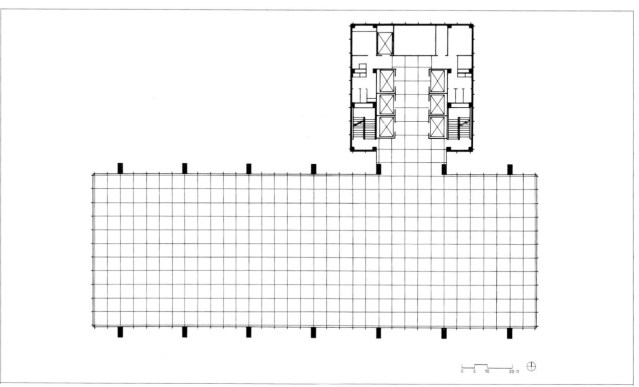

14

15. *View of facade looking west*
16. *View across First National Plaza*

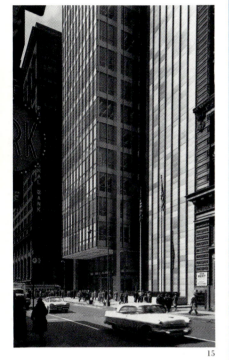

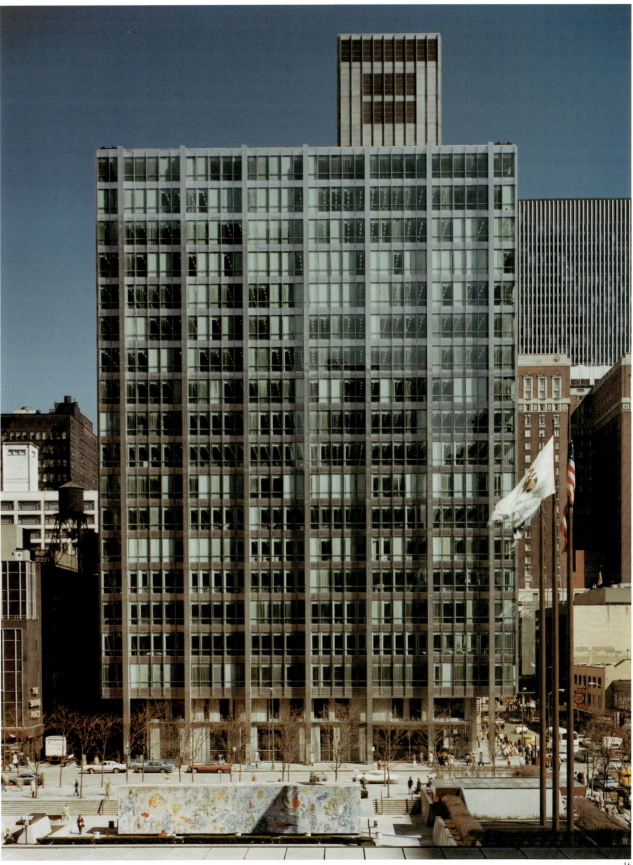

Inland Steel

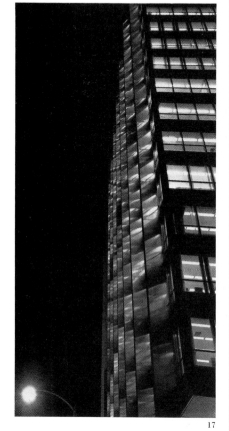

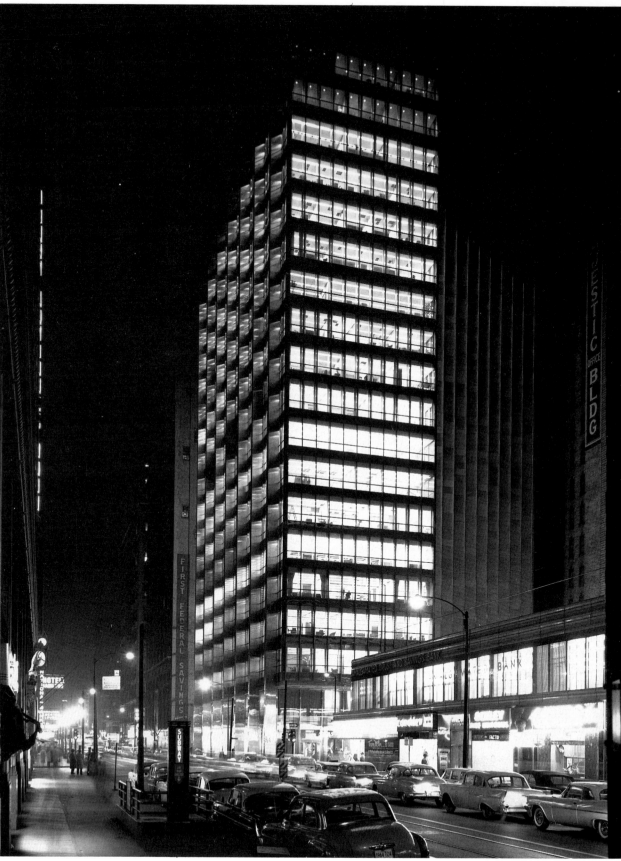

17, 18. Views of south and west facades 19. Interior, secretarial stations 20-22. Interior, executive office suites

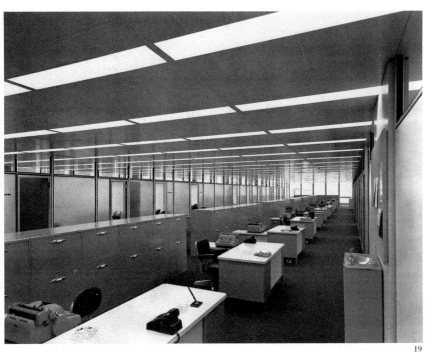
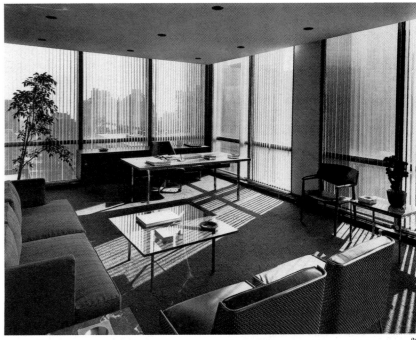
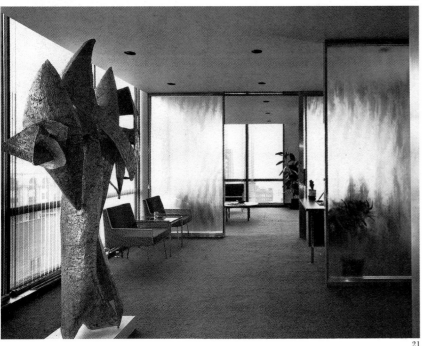

1961 The Upjohn Company, Corporate Headquarters

City: Kalamazoo, Michigan
Client: The Upjohn Company
One and one-half story office building; 432 × 932 foot space frame structure; eight landscaped courtyards
White aluminum; clear glass; natural stone retaining walls

The Upjohn building was an exploration, perhaps following in the footsteps of Gordon Bunshaft, in the design of a total environment, down to the most minute details such as chairs and ashtrays. The building's frame creates spaces that are defined yet endless; they are perfect yet violated so as to contain unexpected experiences such as one might find in a man-made forest. Structure, here, is still the primary articulator of space and the transmitter of ideas.

Set into a gradual incline on a one-hundred acre meadowland site, the one and one-half story headquarters building covers an area of 432 × 432 feet. The building is penetrated by a series of courtyards that feature pools, trees, terraces and sculptures and provide daylight throughout the large structure. The expansive front courtyard is one and one-half stories deep and opens to the building's entrance, while the other, smaller, courtyards are of a one-story depth. The building is covered by a steel space frame structure supported by cross-shaped columns. A continuous 6 × 6 foot modular ceiling of individually-cast plaster coffers set into and expressing the spaceframe, house the building's specially designed, recessed lighting system. The ceiling overhangs the supporting columns, providing a protected walkway around the exterior. An aluminum perimetric frieze of tetrahedrons articulates the roof's exterior edge. The interior open space office is divided by moveable steel and glass partitions that allow flexibility within the modular office system.

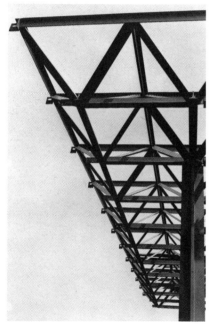
23

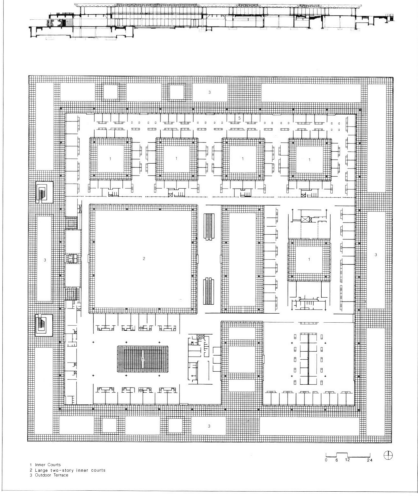

1 Inner Courts
2 Large two-story inner courts
3 Outdoor Terrace

24

Bibliography: Architectural Forum, November 1962; *Architectural Record,* December 1961; *L'Architecture d'Aujourdi'hui,* September 1962; *Arts & Architecture,* May 1962; *Building Progress,* August 1962; *Engineering News-Record,* 19 May 1960; *Inland Architect,* February 1966; *Kalamazoo Gazette,* 22 May 1958; 1 January 1961; 30 July 1961; *Landscape Architecture,* July 1971; *Progressive Architecture,* June 1962.

C. Woodward, *Skidmore, Owings & Merrill.* Simon and Schuster, New York 1970.

23. Construction photo of prefabricated space frame
24. Upper floor plan
25. Exterior, view from northeast

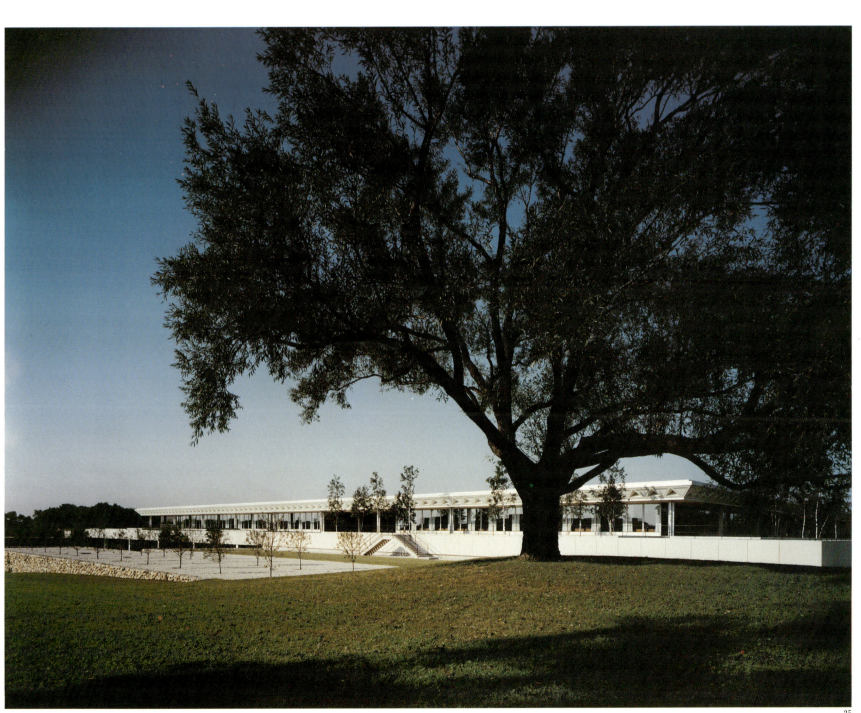

The Upjohn Company

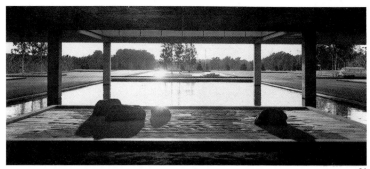

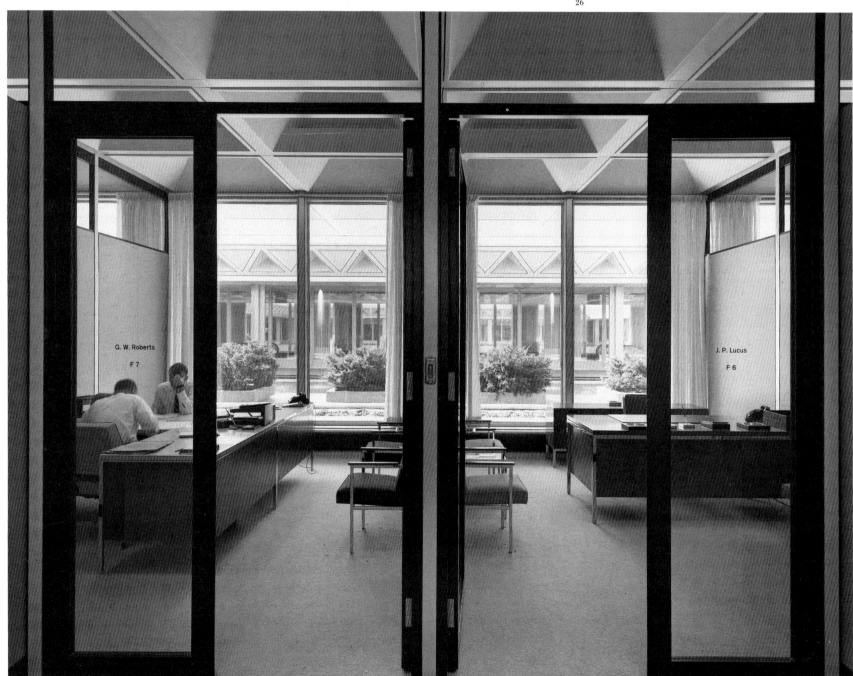

26, 27. Office interiors 28-31. Views of inner courtyards

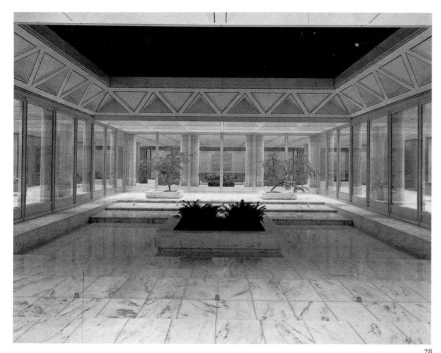

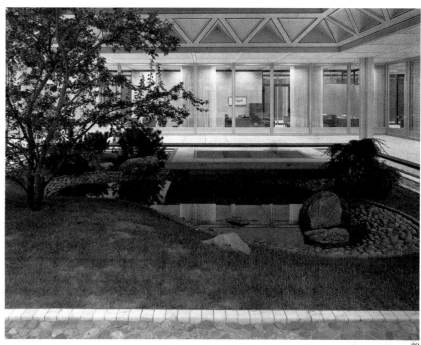

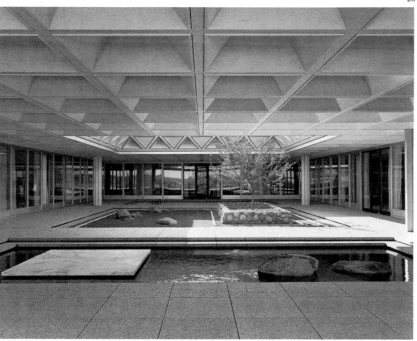

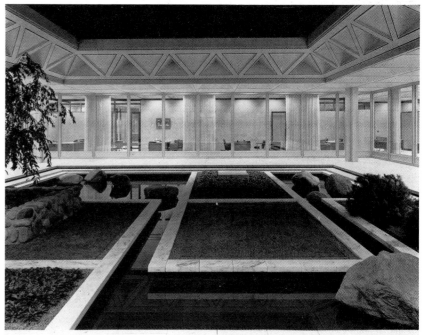

The Upjohn Company *32. Partial view of large inner courtyard* *33. Exterior of corporate headquarters* *34. Rectangular inner courtyard*

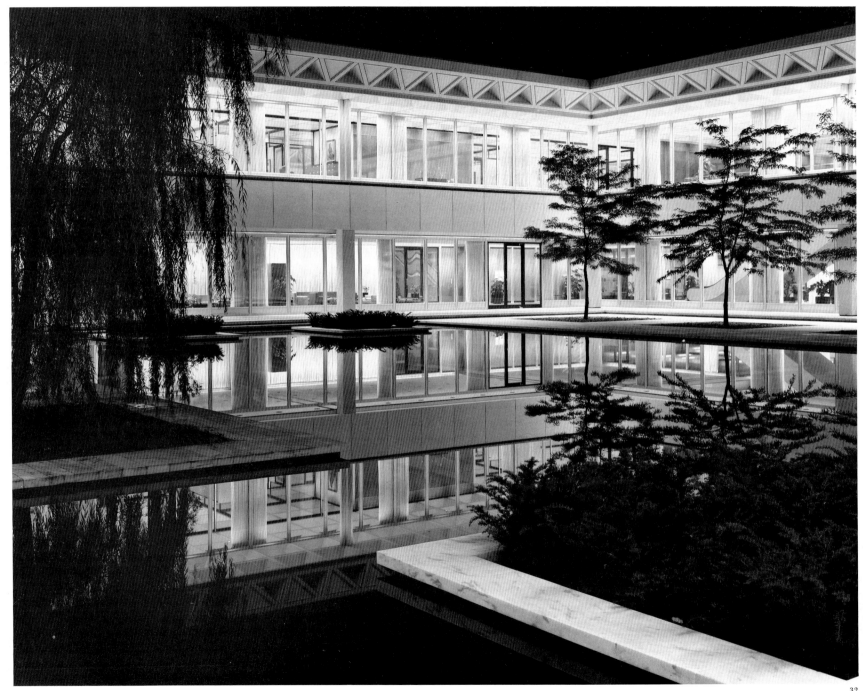

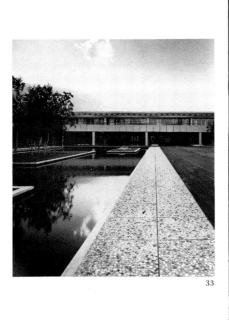

33

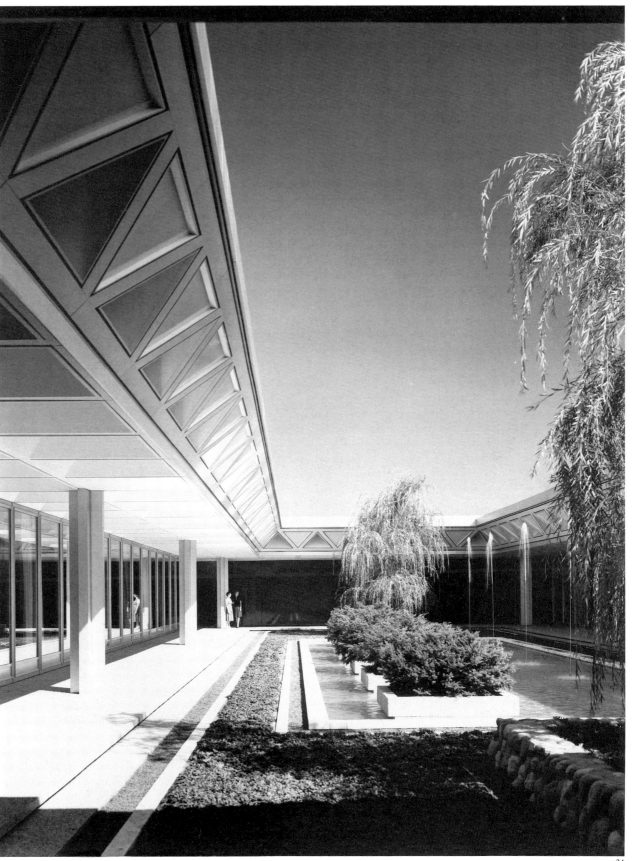

34

25

The Upjohn Company

35, 36. Inner courtyards

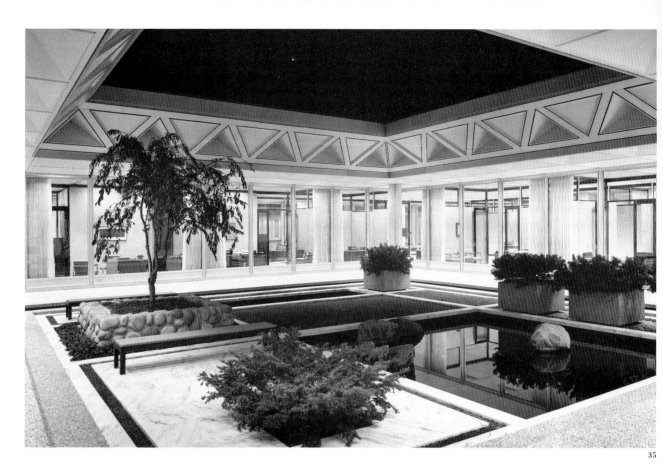

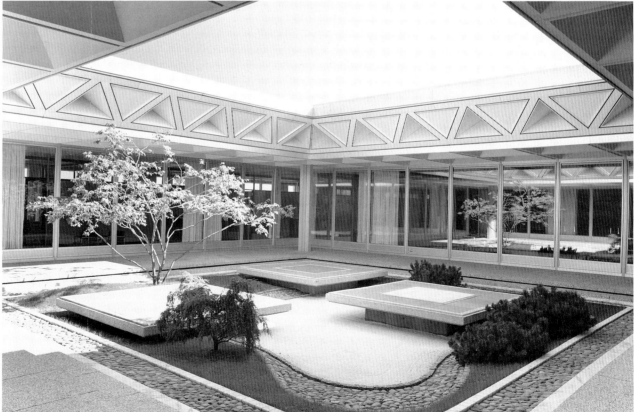

37. *View of entrance with reflecting pool*

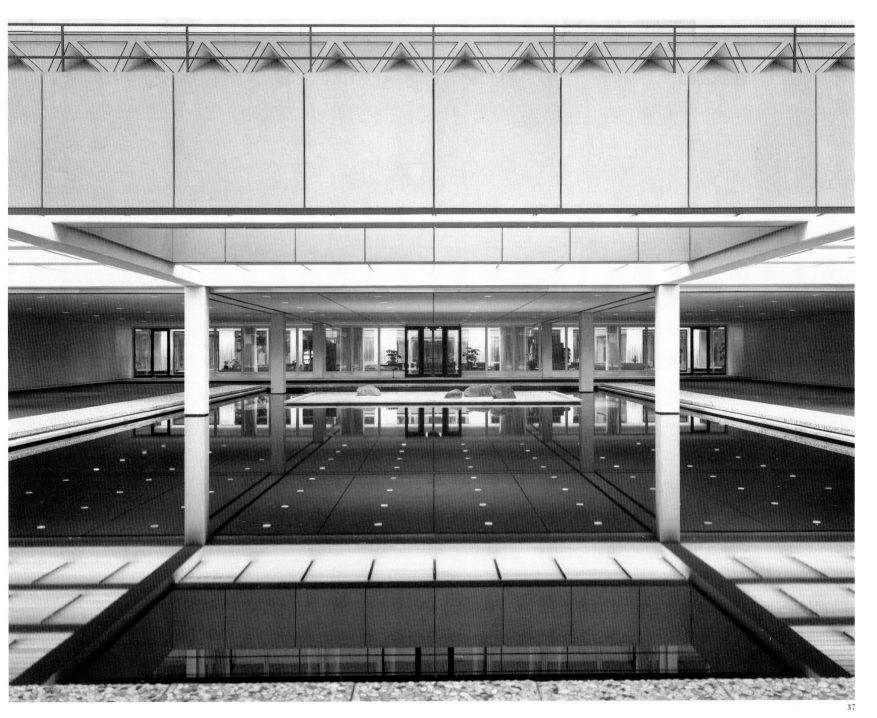

1962

United Airlines, Executive Office Building and Education and Training Center

38. Ground floor plan

City: Elk Grove Village, Illinois
Client: United Airlines
Two-story office building
Post-stressed 60 × 60 foot concrete bays framing three courtyards; setback clear glass window wall
Education center 44 × 44 foot concrete bays with flush glass

Since 1962, both the executive office building and the Education and Training Center have been expanded.

United Airlines was an extension of Upjohn, but executed in concrete rather than steel, utilizing large spans. It is a building where the structure is separated from the skin, and as an enclosure it attempts only to borrow a piece of space to define itself as a very small part of infinity. The two-story building stands as a counterpart to Bunshaft's Connecticut General building in its machine-like precision and its very clear sense of enclosure. Arbitrariness was not allowed to disrupt the frame.

The executive office building is a two-story structure with basement and has a 60 × 66 foot bay that provides flexible interior space. Offices are located on the upper floor with support facilities on the main floor. The auditorium, storage, and executive parking are located in the basement. The building is organized around three large courts and four core areas for elevators and service facilities. A large pond has been created for storm water retention at the low point of the site adjacent to the buildings. The very large span is achieved by a post-tensioned reinforced concrete system. The windows are clear glass, and are set back in aluminum frames. The concrete structure is painted white and remains exposed. The Education and Training Center, is built around a large landscaped court and is similar in appearance to the executive office building; it has a forty-four foot square bay. It contains sleeping and lounge facilities, staff offices, classrooms, and recreational and cafeteria facilities.

Bibliography: *Architectural Design*, April 1964; *Commerce*, 19 June-7 July 1963.

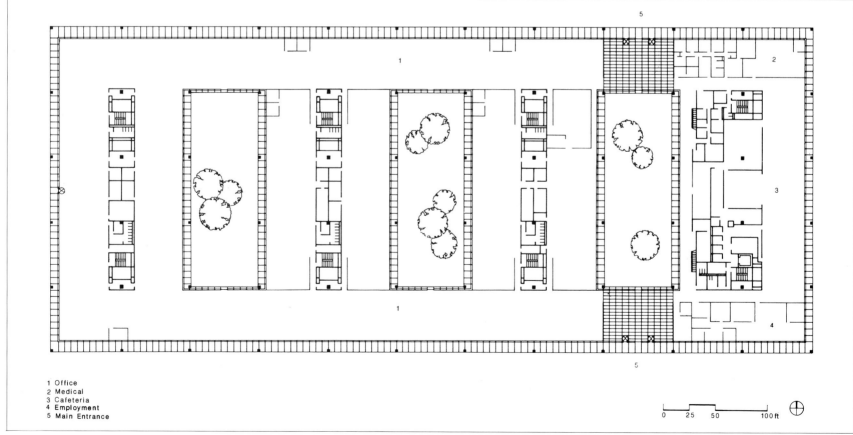

1 Office
2 Medical
3 Cafeteria
4 Employment
5 Main Entrance

39, 40. Exterior views of executive office building

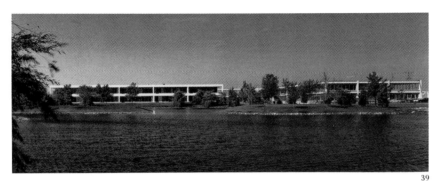

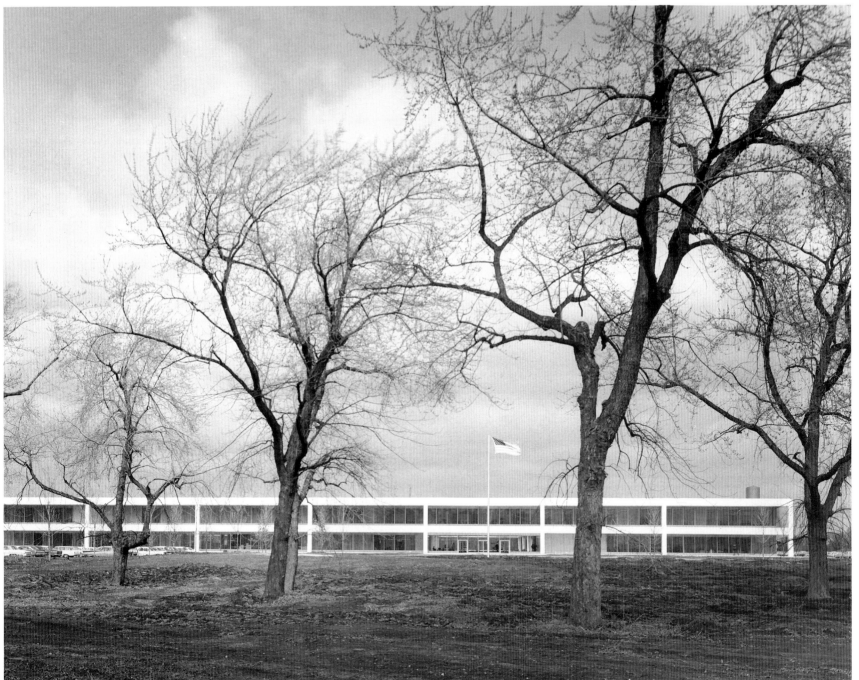

United Airlines

41. Exterior, Education and Training Center

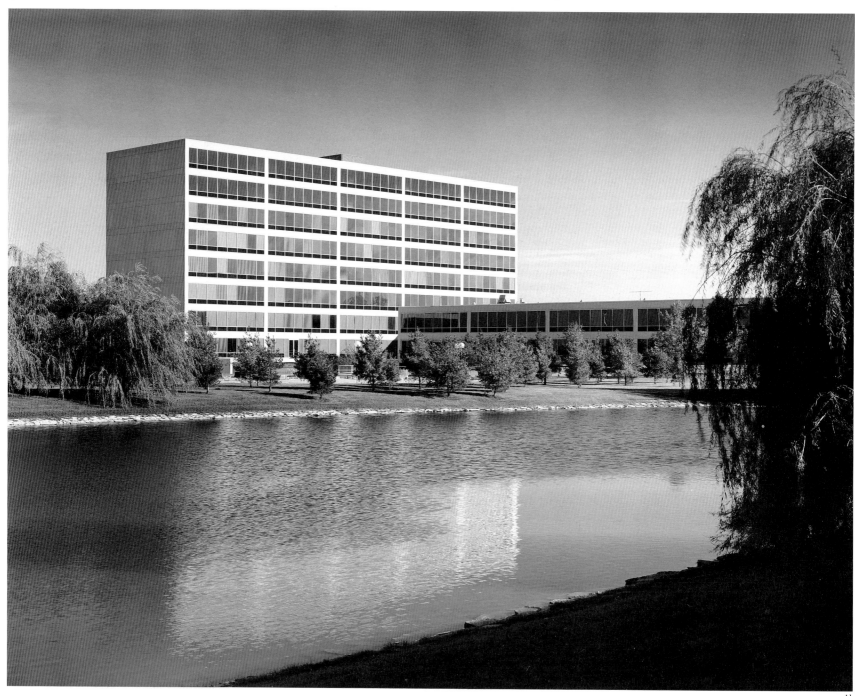

42, 43. Exterior and courtyard of executive office building

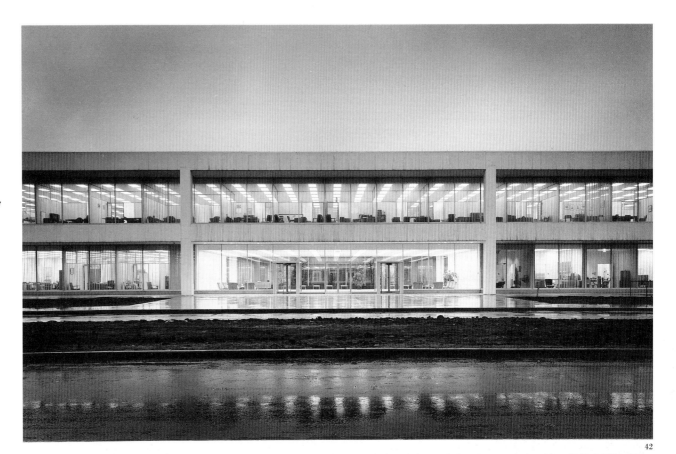

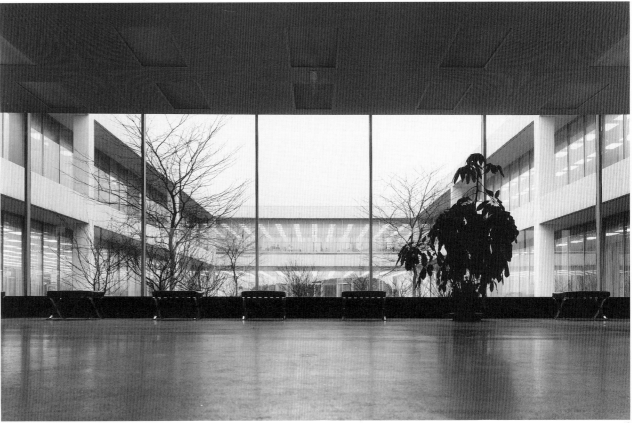

1964 Business Men's Assurance Company of America, Corporate Headquarters

City: Kansas City, Missouri
Client: Business Men's Assurance Company of America

Seventeen-story reinforced concrete tower

Exposed concrete frame; setback clear glass window wall

Business Men's Assurance is a high-rise continuation of the idea behind United Airlines, but now in a very delicate steel frame. Situated at the top of a hill, around which the wind and birds travel, the BMA sacrifices everything for the purity of its frame and the expression of its delicacy.

The BMA Tower is situated on seven acres and occupies the highest elevation in Kansas City. The nineteen-story office tower rests on a large raised plaza. Above the plaza level rise seventeen floors planned on a 6 × 6 foot module and devoted to general office use. The top floor houses executive office space. The steel framed structure is clad in white Georgia marble. The exterior wall of gray glass placed in black anodized aluminum frames is set back six feet from the exterior row of columns providing an open gallery and sun screen at each floor.

Bibliography: American Institute of Architects Journal (July 1964); *Architectural Forum*, July 1964; *Architectural Record*, October 1972; *Chicago Architectural Journal* 1, (1981); *Engineering News-Record*, 15 February 1962; *Kansas City Star*, 11 March 1961; 2 July 1961; 12 November 1961; 11 February 1962; 25 October 1962; 20 October 1963; *Kansas City Times*, 15 April 1960; 7 March 1961; 23 November 1961; 10 May 1962; *New York Times*, 14 June 1964.

44. Detail of exterior
45. Typical floor plan
46. Exterior view of tower

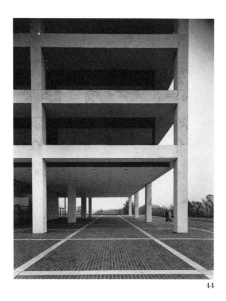

44

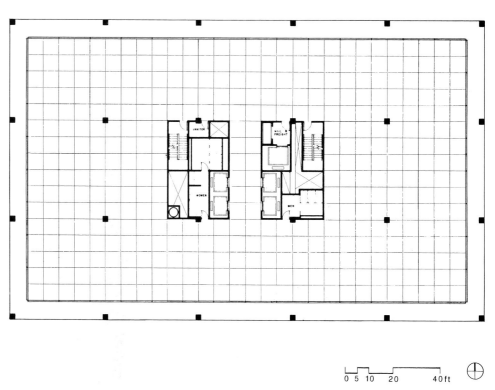

45

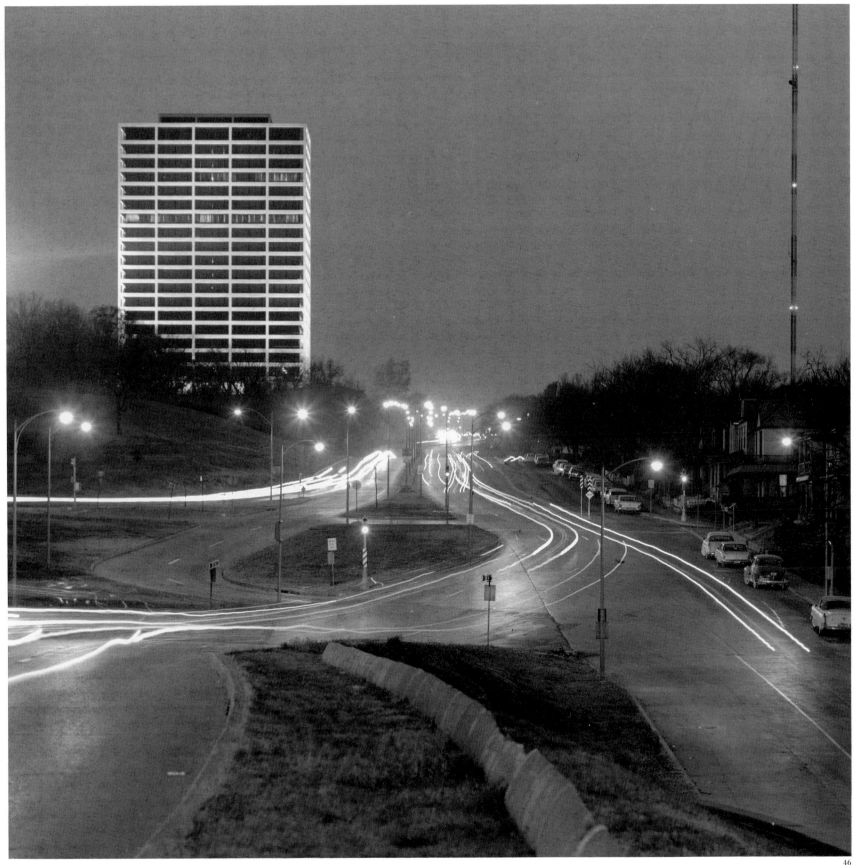

47. Entrance to tower
48. Exterior of tower from east

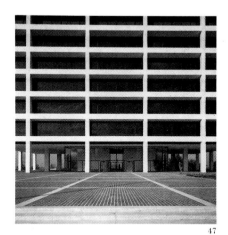

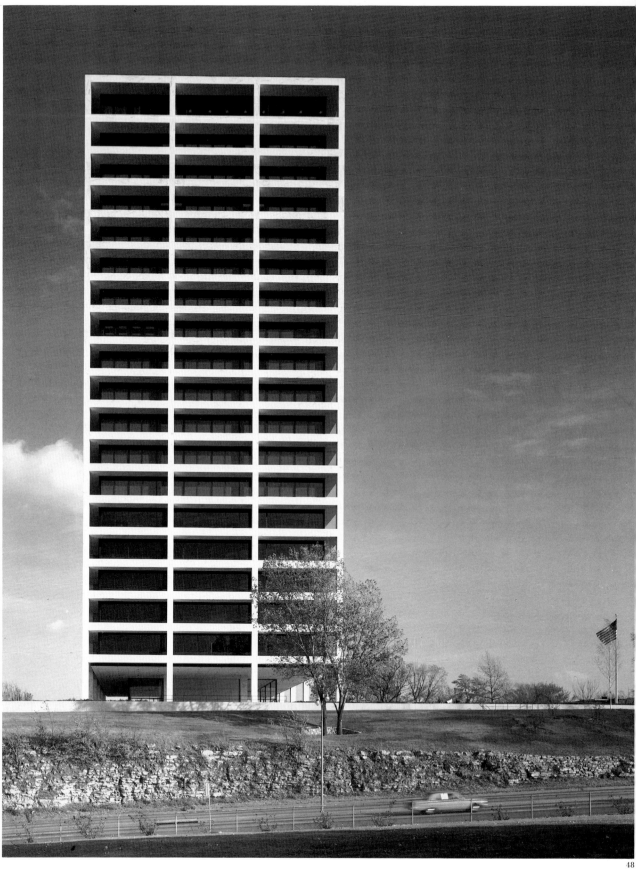

49, 50. Board room and executive suite

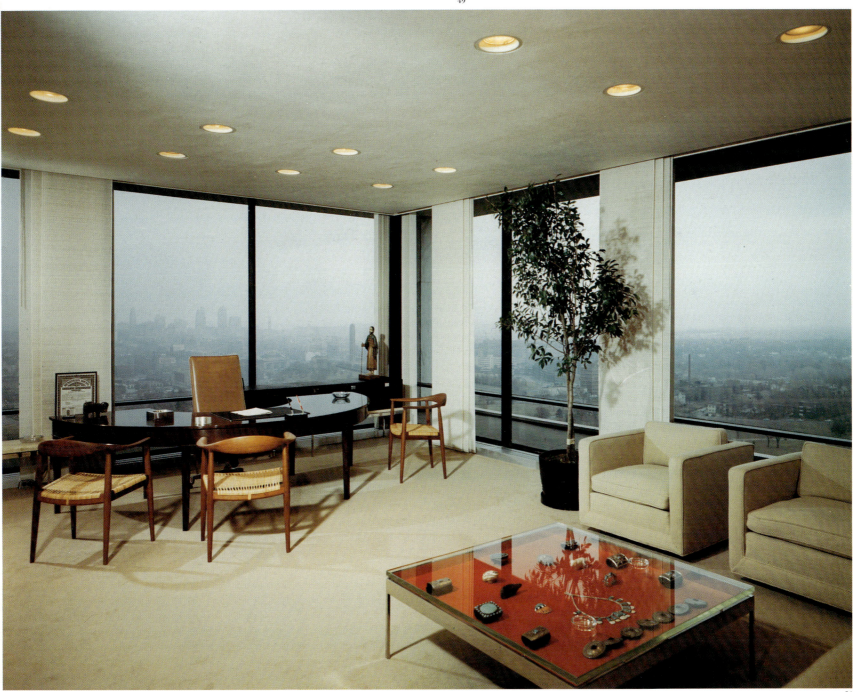

1965 Brunswick Office Building and Richard J. Daley Center

Brunswick Office Building
City: Chicago, Illinois
Client: Washington-Dearborn Properties, Inc.
Thirty-seven story reinforced concrete office building with annex
Exposed painted concrete structure; tinted glass windows

Richard J. Daley Center
Associate Architects: C.F. Murphy Associates and Loebl, Schlossman and Bennett
City: Chicago, Illinois
Client: Chicago Public Building Commission
Thirty-one story civic building
Exterior clad in Cor-ten steel; bronze-tinted glass

The Brunswick Office Building was instigated by SOM partner William Hartmann. We searched for a new kind of structure and with Faz Khan came up with a tube structure—the first one of its type. Originally conceived of as a steel Cor-ten building, we changed the Brunswick to a concrete tube structure so as to reserve that noble material for the Daley Center across the street, where a very large bay was used to express the dignity of the palace of justice. That idea was then picked up by Picasso in the Cor-ten lady which has become the queen of Chicago.

Brunswick Office Building

The thirty-seven story Brunswick office building is located directly opposite the Richard J. Daley Center (Chicago Civic Center). This reinforced concrete building is 168 × 111 feet in plan and employs a "tube-within-a-tube" structural system that provides much flexibility in office layout. The outer tube consists of perimeter columns placed 9 feet, 4 inches apart while the inner tube is formed by the interior core walls. The two tubes span a distance of thirty-seven feet. A two-story concrete girder at the building's base transfers the perimeter columns onto ten columns that distribute the weight of the building. As the building rises in height, a reduction of the column size and wall thickness decreases the structural load.

Bibliography: *Architectural Forum*, April 1966; *Architectural Record*, October 1972; *Chicago Architectural Journal*, 1981; *Chicago Real Estate Advertiser*, 6 April 1962; 11 September 1964; *Chicago Sun-Times*, 24 August 1962; *Chicago Tribune*, 1 December 1961; *Consulting Engineer*, October 1964; *International Association for Bridge and Structural Engineering Structures* C-23/82, November 1982; *Kenchiku Bunka*, November 1966 *Progressive Architecture*, August 1966.
C. Woodward, *Skidmore, Owings & Merrill*, Simon and Schuster, New York 1970.

Richard J. Daley Center

The thirty-one story Daley Center houses offices and courtrooms for the Circuit Court of Cook County, the Supreme Court and the Appellate Court of Illinois. The structural bays of this Cor-ten steel building are 87 × 47 feet.

Bibliography: *American Institute of Architects Journal*, June 1968; September 1969; *Architectural Design*, November 1966; *Architectural Forum*, October 1966; *L'Architecture d'Aujourd'hui*, December 1967-January 1968; *Bauen & Wohnen*, January 1967; *Fortune*, December 1966; *Interiors*, April 1966; *Lotus*, 1967-1968; *Progressive Architecture*, October 1966.

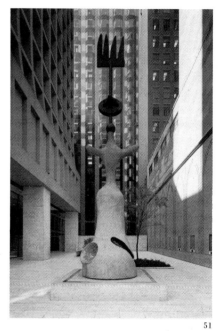

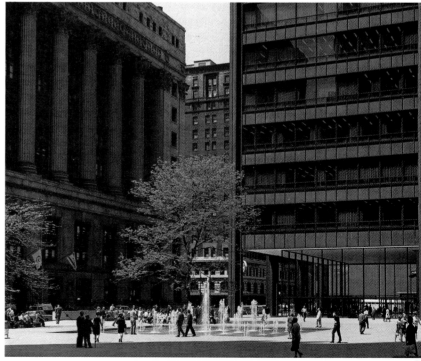

51. *Miro sculpture to north of Brunswick Building*
52. *Richard J. Daley Plaza*
53. *High-rise floor plan*
54. *Plaza level floor plan*

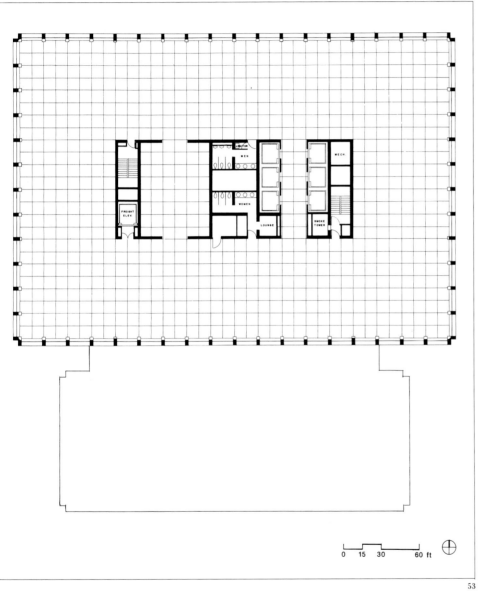

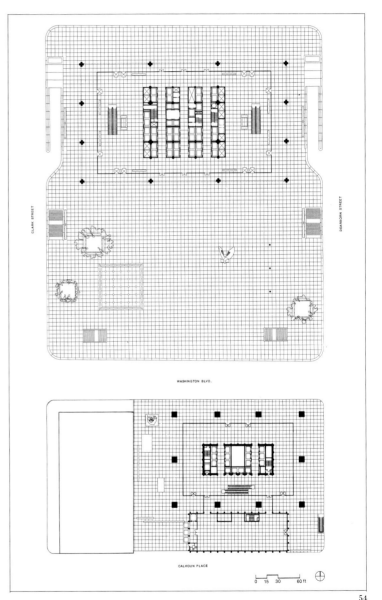

Brunswick Office Building

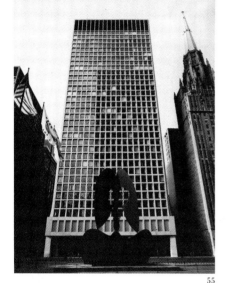

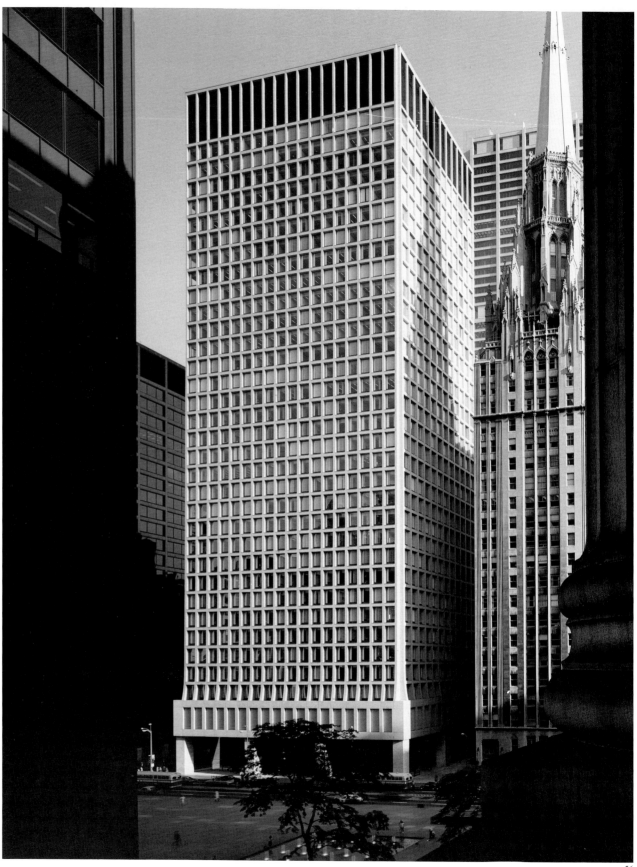

55. North facade seen across Daley Plaza from behind the Picasso sculpture
56. Exterior from northeast
57. Interior, executive offices
58. Dining room

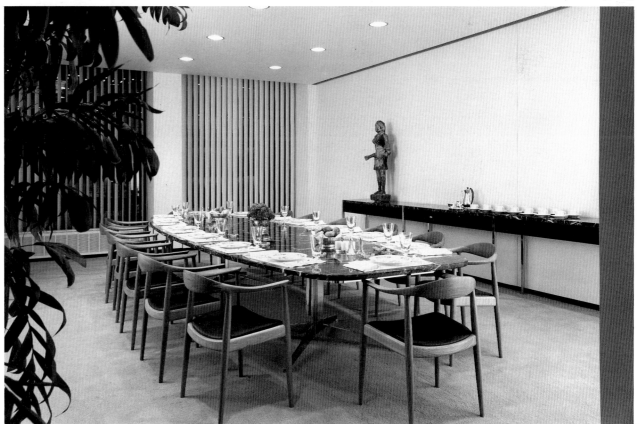

Richard J. Daley Center

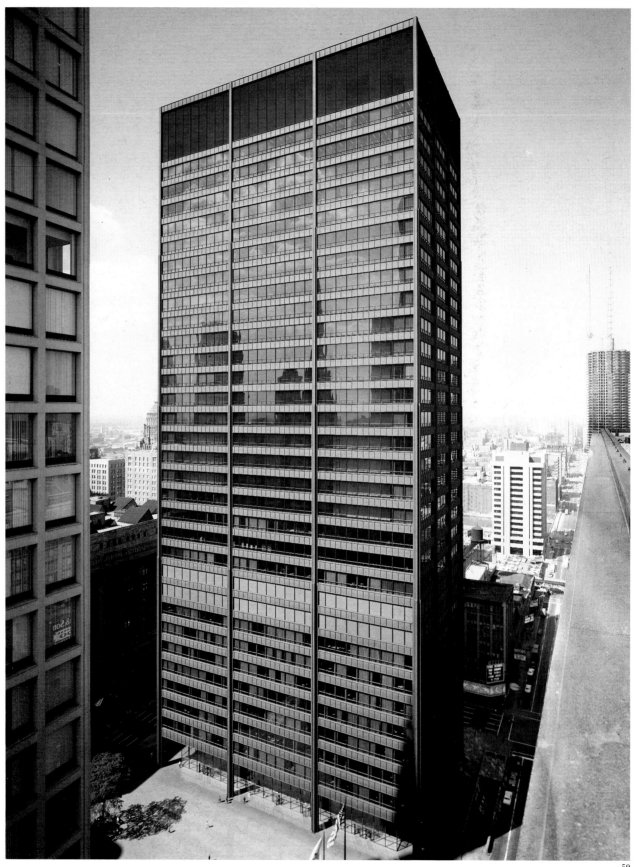

59. Exterior from southeast

60. Daley Center, Daley Plaza and the Picasso sculpture. Corner of the Brunswick Building is visible to left

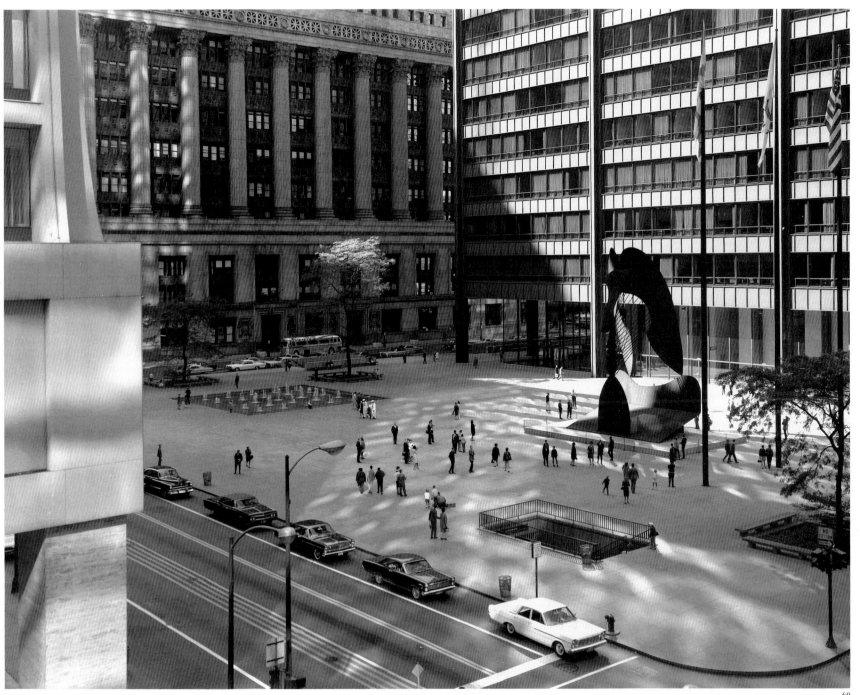

1968 Boots Pure Drug Company, Ltd., Corporate Headquarters

Associate Architects: Yorke Rosenberg Mardall, London
City: Nottingham, England
Client: Boots Pure Drug Company, Ltd.
Exposed one-story steel structure surrounding a sunken courtyard
Bronze anodized aluminum window wall; painted black steel; grey granite

Boots Pure Drug in Nottingham, England was my first experience with building outside of the United States. While it is located in a highly industrial complex, British traditions were kept in mind in designing the frame. The strength of the frame is yet another elaboration of structure, in this case reminiscent of British lofts within which accommodations for a variety of different lifestyles can be effected without violating the definition given by the steel long span frame.

The two-story corporate headquarters is designed around a central, interior courtyard. The main floor is below grade so that the exterior reads as a low-slung, single-story mass. The upper floor surrounds the interior courtyard and provides both individual executive office spaces and an open-plan office area. Key elements of the flexible interior are free-standing carrels with 5 foot, 8 inch partitions and interchangeable parts. The building is enclosed by a bronze anodized aluminum window wall and painted black steel framework. The base is clad in grey granite.

Bibliography: Architectural Record, April 1969; *Architect's Journal*, January 1969; *Building*, 17 January 1969; *Deutsche Bauzeitschrift*, April 1969; *Financial Times*, 6 January 1969.

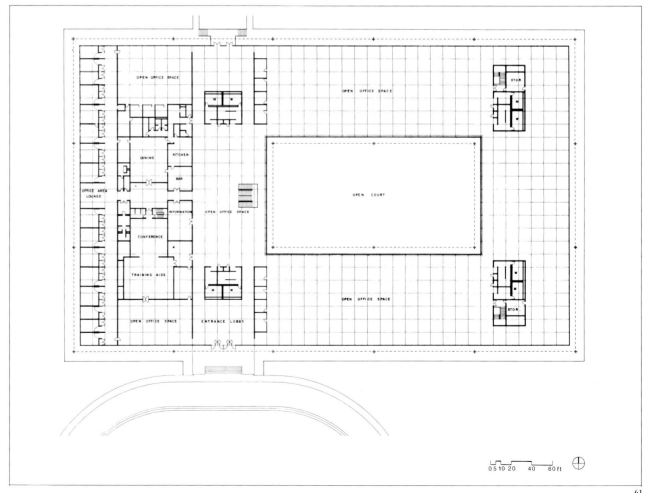

61. Upper floor plan 62. Exterior of Corporate Headquarters

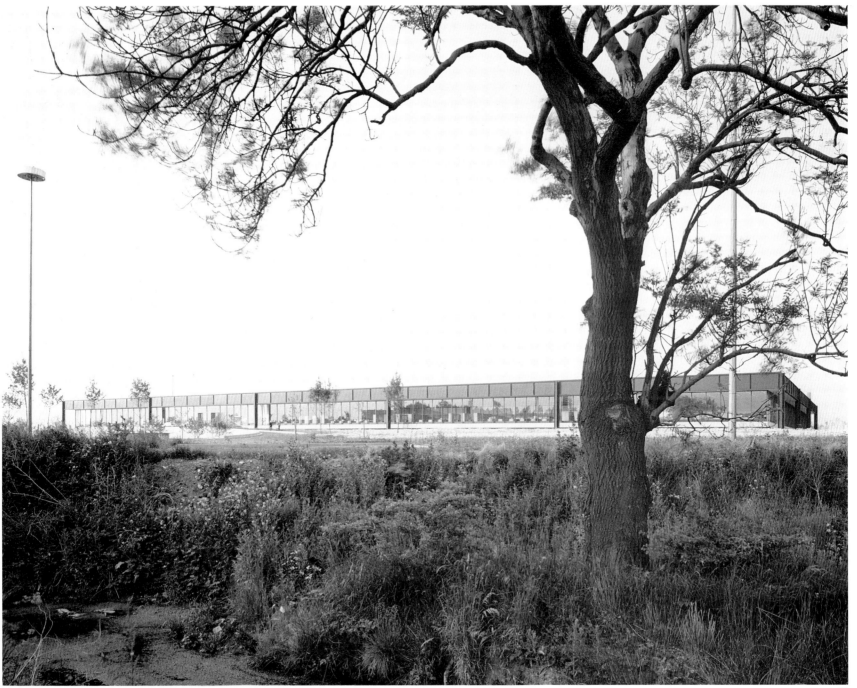

Boots Pure Drug Company

63-65. Interior views

63

64

66. View of interior court and main stairs
67. Detail of window wall

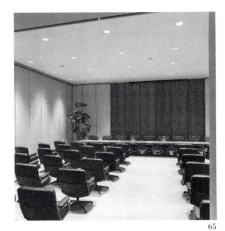

65

66

67

1970 John Hancock Center, Multi-Use Complex

City: Chicago, Illinois
Client: John Hancock Mutual Life Insurance Company
One-hundred story steel structure tower: Floors 1-5 Commercial; 6-12 Parking; 13-41 Office; 44-92 Apartment; 93-100 Television, Observatory, Restaurant, Mechanical

The design of the John Hancock Center, in Chicago, was influenced by its unique site. Just off Lake Shore Drive, it is surrounded by huge, residential high-rise buildings and yet faces one of the city's most attractive commercial streets. John Hancock insisted on producing a tall building with residences above, offices and commercial uses below. The search for a new kind of structure which would accommodate multiple uses and also express the scale and grandeur of a one-hundred-story tower, lead Dr. Khan and me to the diagonal tube. It was as essential to us to expose the structure of this mammoth as it is to perceive the structure of the Eiffel Tower, for in Chicago, honesty of structure has become a tradition.

Situated on prestigious North Michigan Avenue, the one-hundred-story, multi-use tower tapers from bottom to top in order to accommodate the different floor space requirements of a variety of uses. Commercial spaces occupy the base of the tower while parking, office, and residential zones rise above. The tapered form provides structural as well as space efficiency. The exterior columns and spandrel beams, together with the diagonal members and structural floors, create the steel tube. The diagonals, spandrels and columns are clearly articulated to depict the primary elements of this tube. Less than thirty pounds of steel per square foot of floor area were used in the building, equalling that of a forty- to fifty-story traditional tower. The exterior cladding is black anodized aluminum with tinted bronze glass.

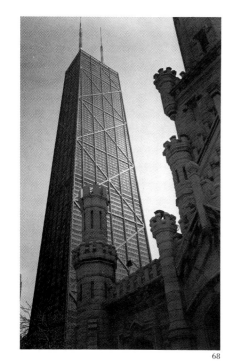

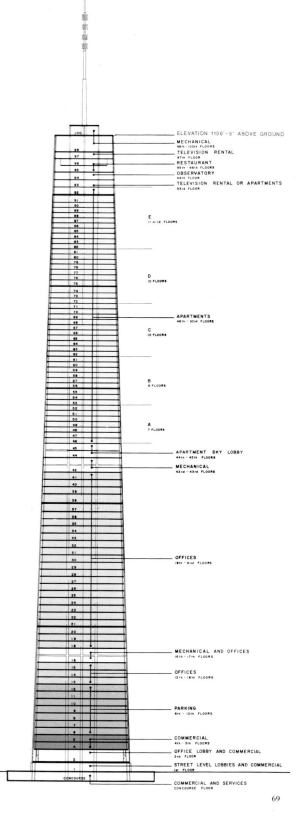

46

68. *Exterior of the Hancock Center from the Water Tower*
69. *Section*
70. *Skyline of North Michigan Avenue from Lake Michigan*

Bibliography: American Institute of Architects Journal, October 1980; *Architectural Forum*, June 1968; July/August 1970; *Architectural Record*, January 1967; October 1972; *Architectural Review*, April 1972; *Architecture and Urbanism*, January 1974; *Arkitektea*, 1967; *Building Design & Construction*, March 1986; *Business Week*, 2 April 1966; *Chicago Architectural Journal*, 1981; *Chicago Daily News*, 16 August 1967; *Chicago Sun-Times*, 17 September 1972; *Chicago Tribune*, 12 September 1965; 23 January 1966; 3 September 1967; 5 August 1984; 12 October 1986; *Commerce*, April 1965; *Design Book Review*, Fall 1988; *Fortune*, February 1973; *Inland Architect*, July 1966; *Interior Design*, November 1987; *Journal of the American Institute of Architects*, October 1980; *Los Angeles Times*, 31 January 1977; *National Geographic*, vol. 175, no. 2, February 1989; *New York Times*, 8 May 1983; *Perspecta*, 1967; *Real Estate Forum*, November 1969; *Scientific American*, February 1974; *Time*, 2 April 1965.

N.A. Owings, *The American Aesthetic*, Harper & Row, New York 1969.

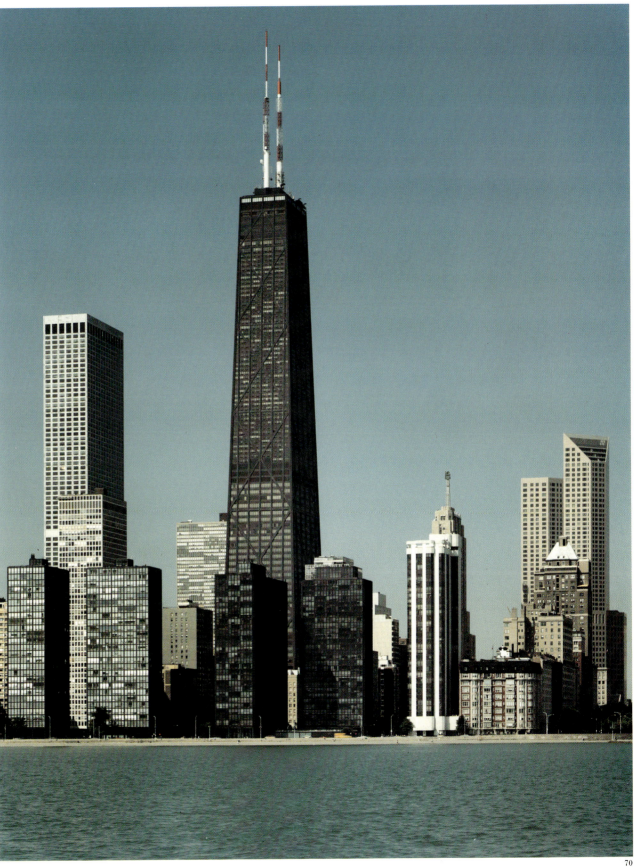

John Hancock Center

71. Sky lobby on transit floor between offices and apartments

72. Exterior looking up from plaza

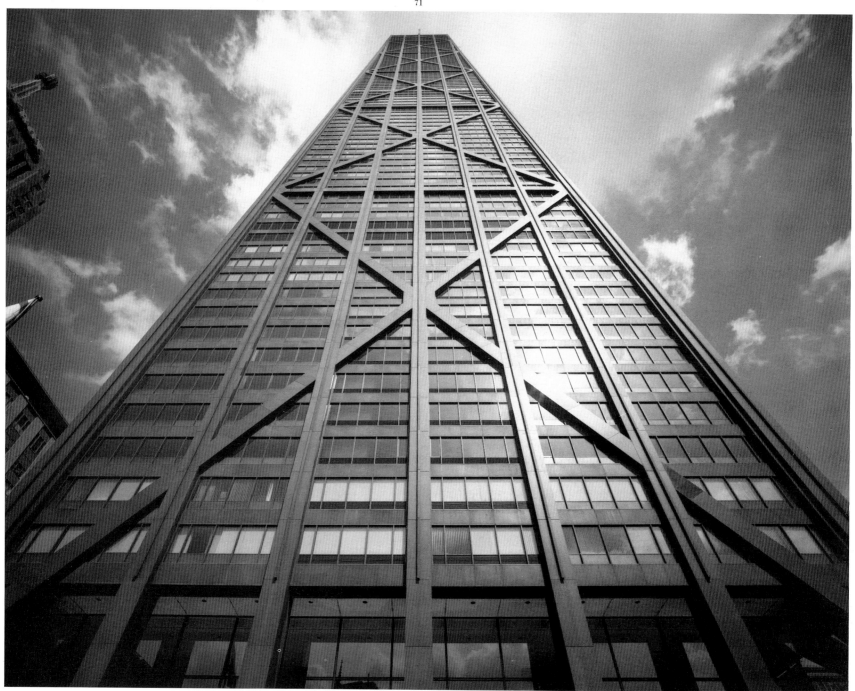

73, 74. Exterior from southeast and southwest on Michigan Avenue

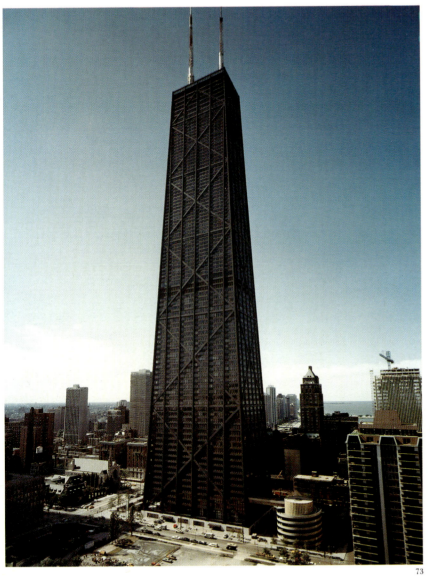

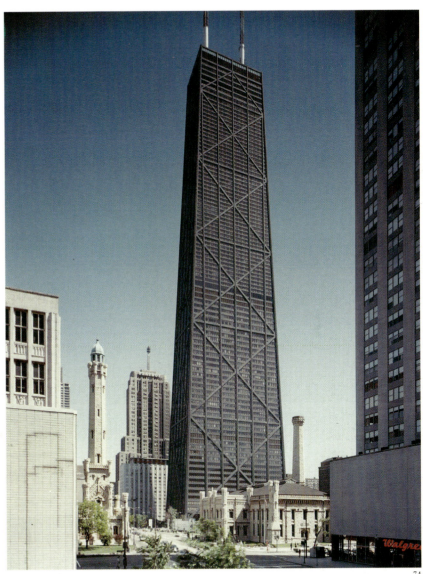

John Hancock Center 75. *View of skyline across lake from Olive Park* 76. *Detail of base* 77. *South facade of building with the spiral ramp leading to the parking garage*

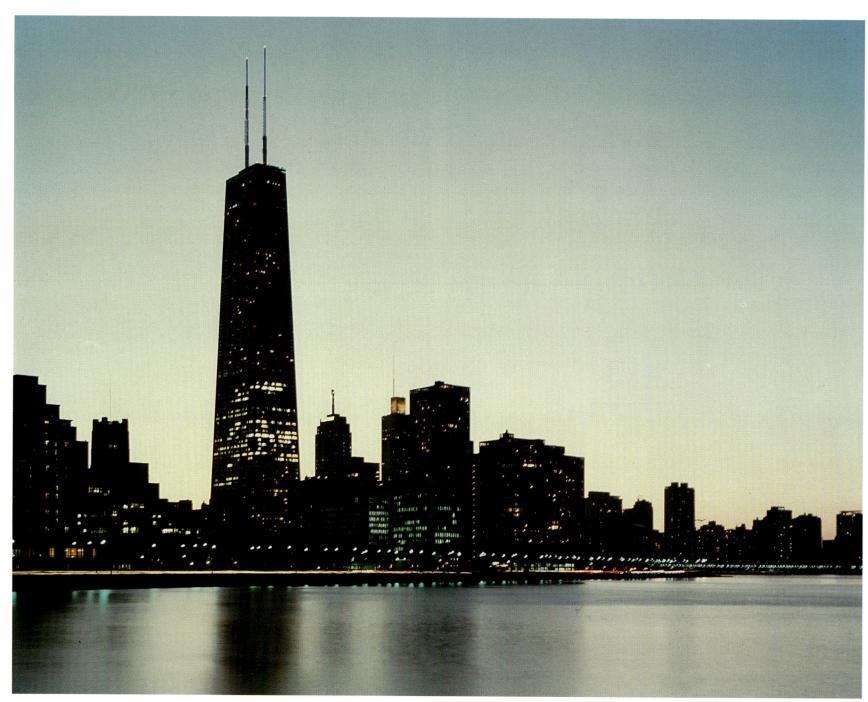

76

77

1972 One Shell Plaza

City: Houston, Texas
Client: Gerald D. Hines Interests
Fifty-two story office tower
Travertine cladding; bronze-colored glass

One Shell Plaza in Houston occurred when that city was made up of sand-colored buildings and had a sense of urbanism, which it has since lost. The concrete tube, with its forces of gravity clearly articulated on the exterior, served the same purpose as the diagonals of John Hancock; however, the materials were selected to fit in with the green Pin Oaks and sandy Texas travertine.

When completed in 1971, the fifty-two story One Shell Plaza was the tallest lightweight reinforced concrete structure west of the Mississippi River. The building rests on a raised podium and faces City Hall Park. Parking areas and a shopping mall extend beneath the podium as well as a connecting tunnel to the city's existing network of downtown, subsurface shopping arcades. The building's reinforced concrete structural system follows the "tube-within-a-tube" concept with a shear wall core forming the interior tube. The travertine-clad exterior is framed by closely spaced columns which create a load-bearing rectangular tube. The increased depth of columns at eight points, while acting as supplementary wind-bracing, gives the impression of a softly undulating exterior wall. An approximately eight-foot thick concrete "floating" pad supports and distributes the weight of the tower. Windows are glazed with bronze colored glass.

Bibliography: *Architectural Design*, January 1972; *Architectural Forum*, April 1972; *Architecture and Urbanism*, January 1974; *Fortune*, February 1973; *L'Industria Italiana del Cemento*, May 1974,
D. Guise, *Design and Technology in Architecture*, New York 1985.

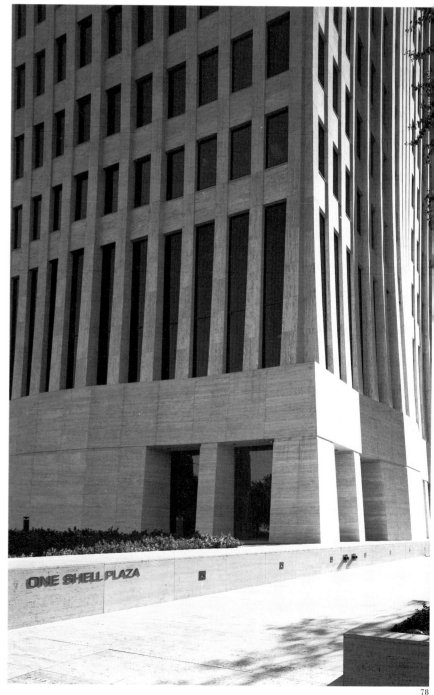

78. Detail of base
79. Mid-rise floor plan and mezzanine floor plan

One Shell Plaza

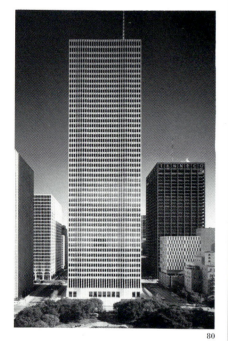

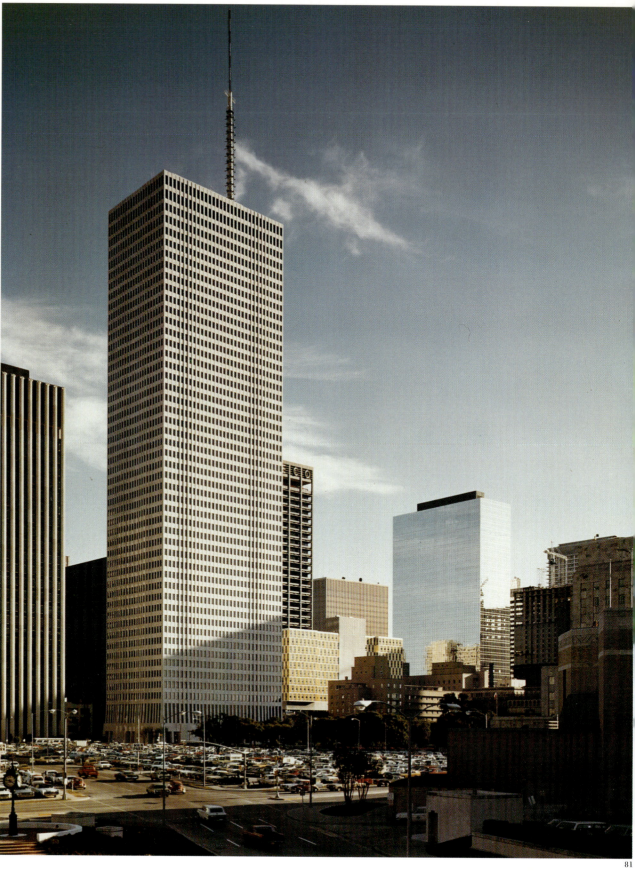

80, 81. Views of exterior
82. Detail of base to show wind bracing

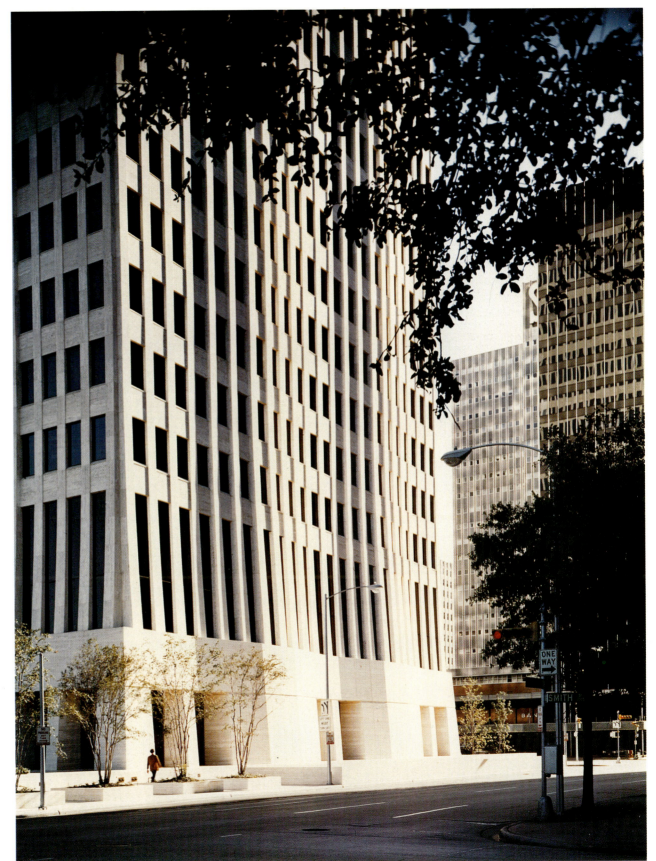

1974, 1985

Sears Tower, Corporate Headquarters and Sears Tower Revitalization Project

City: Chicago, Illinois
Client: Sears, Roebuck and Company
110-story steel structure; 75 × 75 foot clear span bays
Black aluminum window wall; bronze tinted glass

Tall buildings are man-made. Towers have historically been not only the pride of their temporary owners, but of their cities as well. So the Sears Tower, one more mountain, was created for this city on the plains. Sears is very direct in its structural solution, a new concept of cluster tubes, originally fifteen, reduced to nine when the hotel was eliminated from the plan. The Sears Tower itself is much like the idea behind San Gimignano, but unlike most tall buildings in New York, it is a tower of the people, not the palace of a bank.

The Sears Tower is the world's tallest building. The stepback geometry of the 110-story tower was developed in response to the interior space requirements of Sears, Roebuck and Company. The configuration incorporates the unusually large office floors necessary to Sears' operation along with a variety of smaller floors. The building plan consists of nine 75 × 75 foot column-free squares at the base. Floor sizes are then reduced by eliminating 75 × 75 foot increments at varying levels as the tower rises. A system of double-deck express elevators provides effective vertical transportation, carrying passengers to either of two skylobbies where transfer to single local elevators serving individual floors occurs. The tower is clad in black aluminum and bronze-tinted glass. In 1985, the tower lobby and commercial concourse levels were enlarged and reorganized in response to the varied circulation patterns of tourists and workers. Major changes were made to the interior public spaces including a new entrance on Jackson Boulevard and a vaulted, glass-enclosed entrance on Wacker Drive. New commercial areas at ground level were added as well as below-house boutiques, dining facilities and a Chicago-oriented visitor's center.

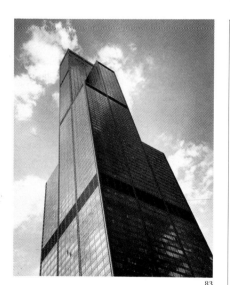

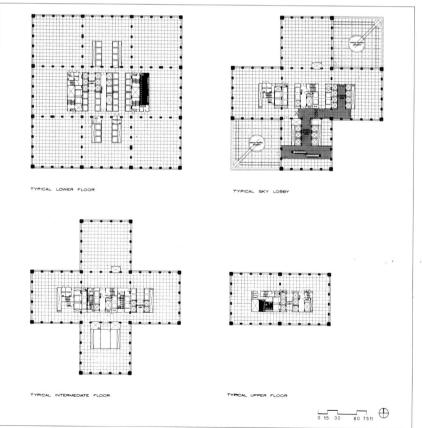

Bibliography: American Institute of Steel Construction Architectural Awards of Excellence, 1975; *Architect and Builder*, December 1970; *Architectural Forum*, January/February 1974; *Architectural Record*, October 1972; *Architecture Plus*, August 1973; *Building Design*, 20 April 1984; 27 April 1984; *Chicago*, November 1987; *Chicago Architectural Journal*, 1981; *Chicago Sun-Times*, 28 July 1970; 23 August 1970; 31 December 1972; 4 December 1977; 1 February 1984; 30 May 1985; 17 June 1985; *Chicago Tribune*, 28 July 1970; 24 June 1973; 3 February 1974; 31 July 1974; 14 November 1983; 19 February 1984; 17 November 1985; *Civil Engineering-ASCE*, November 1972; *Crain's Chicago Business*, 6 February 1984; 22 April 1985; *Domus*, May 1974; *Engineering News Record*, 26 August 1971; *Forbes*, 1 October 1974; *Form & Function*, 1975; *Fortune*; February 1973; *Historic Preservation*, June 1985; *Inland Architect*, November 1976; May-June 1985; *Interior Design*, December 1974; *Interiors*, February 1975; *International Association for Bridge and Structural Engineering*, November 1982; *New York Times*, 8 April 1984; *Progressive Architecture*, May 1986.

American Iron and Steel Institute, *Contemporary Structures*. Consultant, Vincent Scully, Jr., Washington, D.C.

83. *Exterior*
84. *Typical floor plans at different levels*
85. *Section showing elevator system*
86. *View of exterior from the southeast*

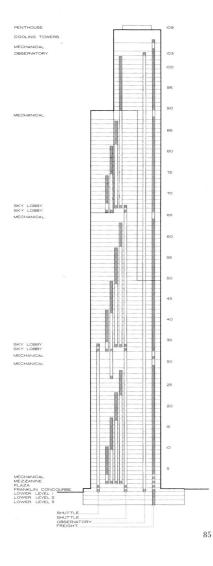

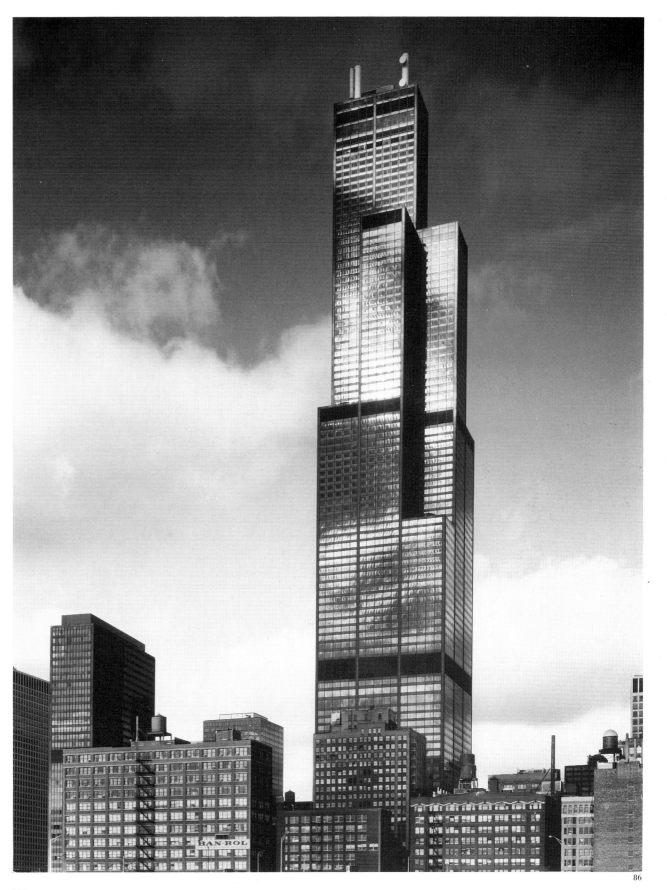

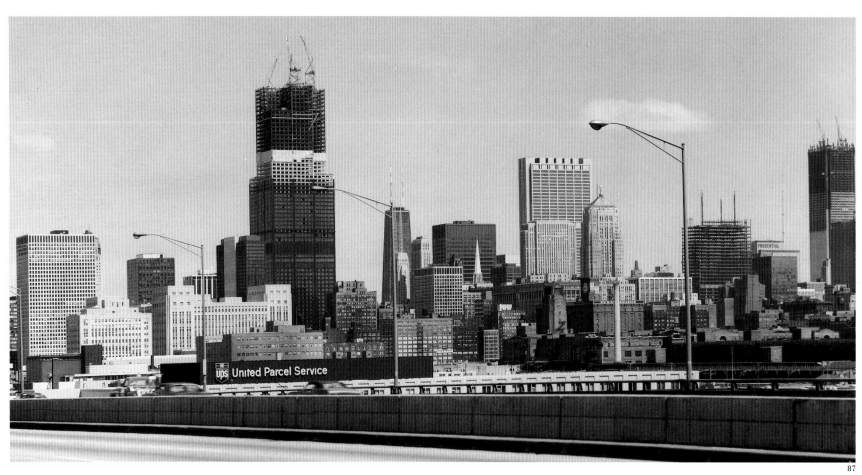

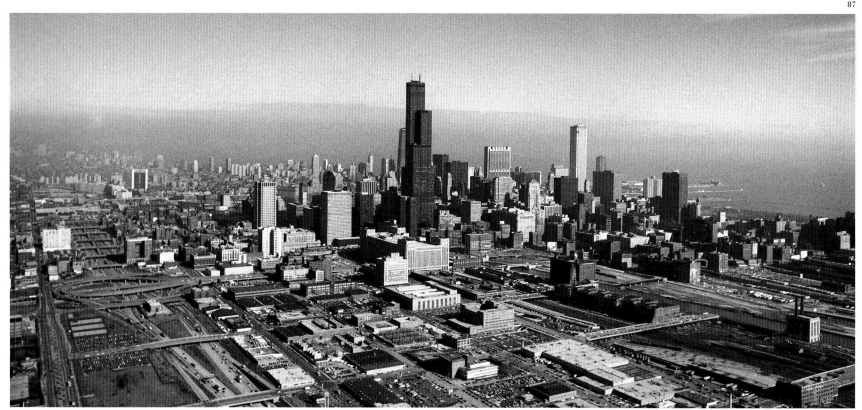

Sears Tower

87. Tower under construction
88. Aerial view from the southwest
89, 90. Views of tower from south and north

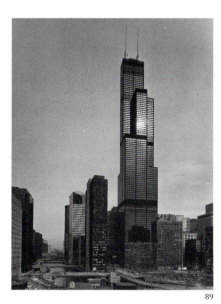

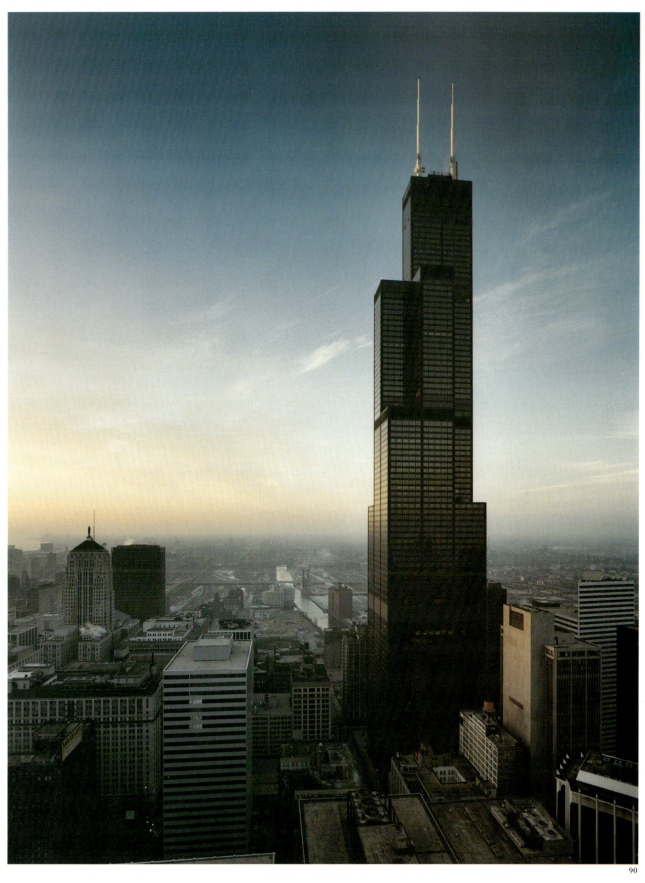

Sears Tower

91. Exterior of atrium lobby addition looking north up Wacker Drive
92. Calder mechanical mobile in lobby
93. Interior of atrium lobby

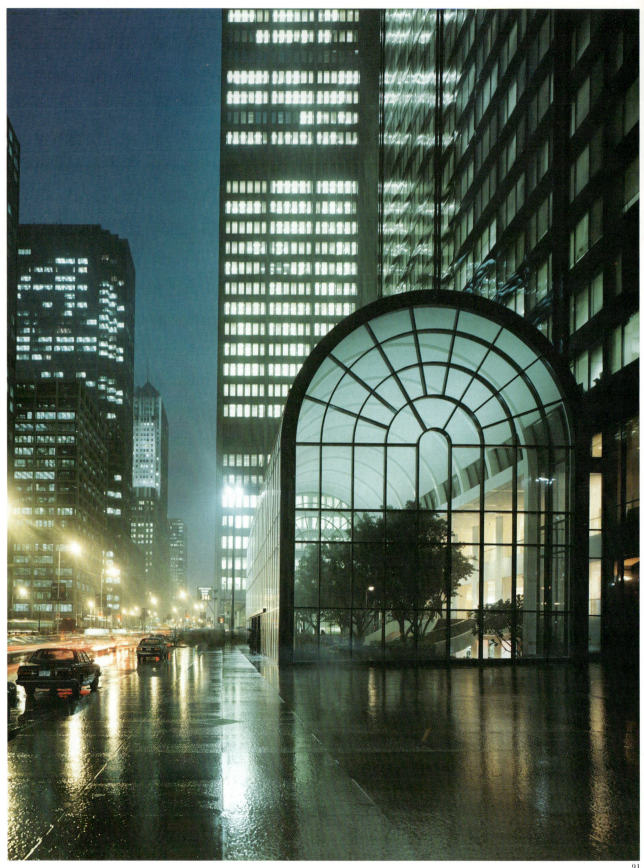

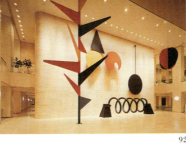

92

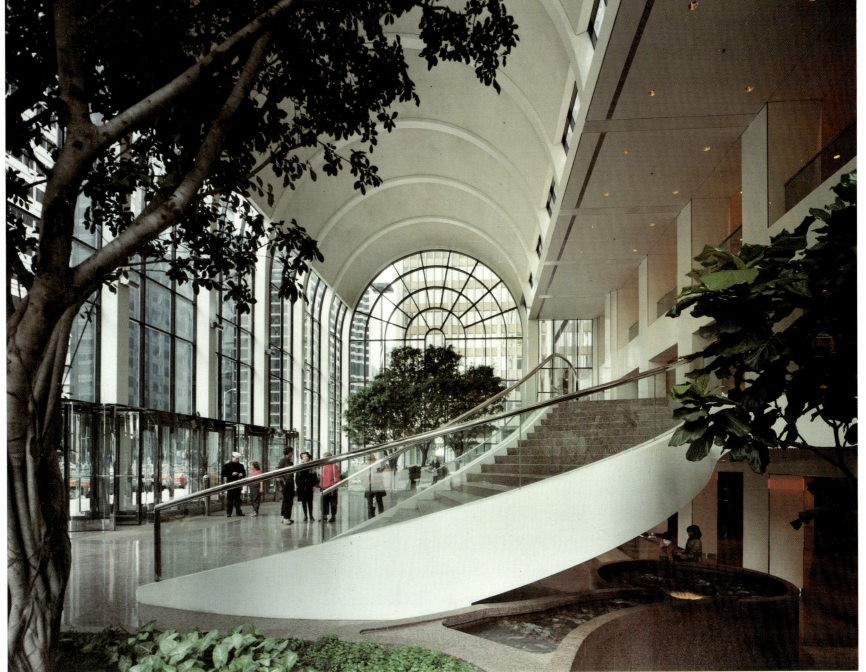

93

61

1974 Fourth Financial Center

City: Wichita, Kansas
Client: Fourth Financial Bank and Trust Company
Ten-story structure of reinforced concrete pylons with 80 × 80 foot clear span steel decks
Exposed painted concrete and painted steel; bronze

Certain cities demand towers and in other cities such powerful elements should not exist—Wichita, Kansas is such a place. Life in this small mid-western town is at the ground, vistas do not exist. The harshness of the wind and climate demanded the creation of an internal space. The solution was to construct a grand civic plaza inside the building, framed by purely expressed structural elements.

Fourth Financial Center, headquarters of the Fourth National Bank and Trust Company, was an important contribution to central urban renewal in Wichita, Kansas. Perceived as a catalyst for the future development of the community, Fourth Financial was one of the first elements in the planned renewal of the city's Central Business District. Four giant skylights illuminate the nine-story entrance lobby and the 160 square foot interior landscaped courtyard. Interior clear glass walls separate the lobby from banking, office and retail spaces which form a deep L-shape within. Two bronze-tinted street walls provide year-round temperature and solar control. The reinforced concrete pylons rising between eighty-foot spans house the mechanical and electrical systems as well as the firestairs. A glazed pedestrian bridge on the second level connects the building to a downtown walkway system.

Bibliography: *American Institute of Architect's Journal,* October 1977; *American Institute of Steel Construction Architectural Awards of Excellence,* 1975; *Baumeister,* October 1978; *Deutsche Bauzeitung,* 1980; *Space Design,* May 1979; *Wichita Eagle and Beacon,* 15 January 1972; 13 October 1974.

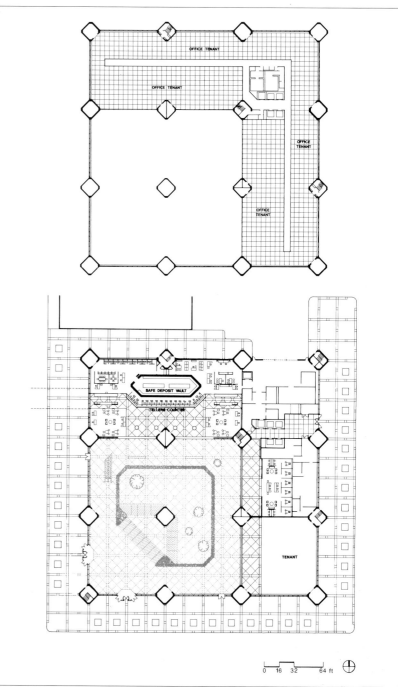

94. Ground floor plan and typical upper floor plan 95. Exterior

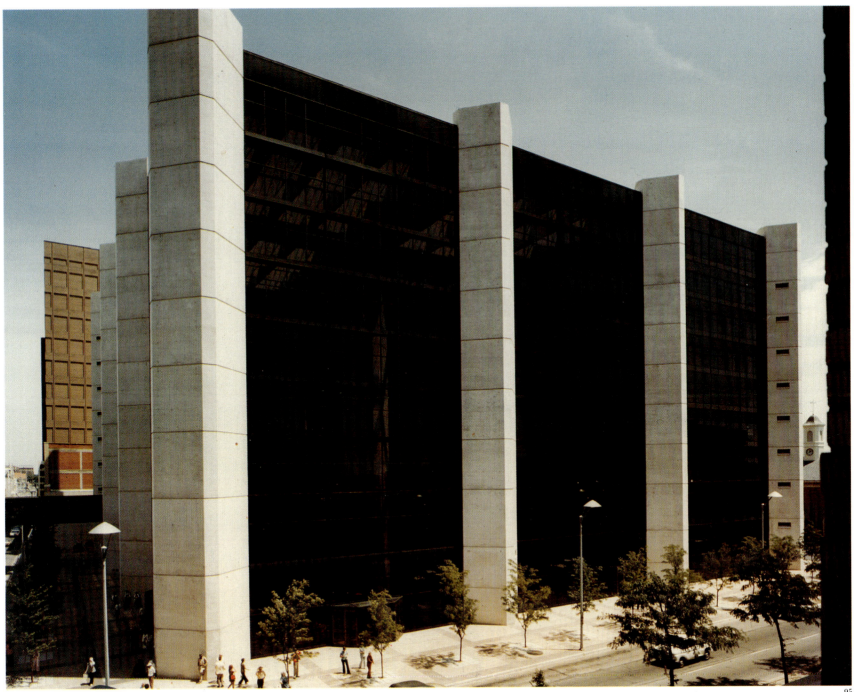

Fourth Financial Center

96. *View from exterior into lobby showing Calder mobile*
97, 98. *Interiors of lobby*

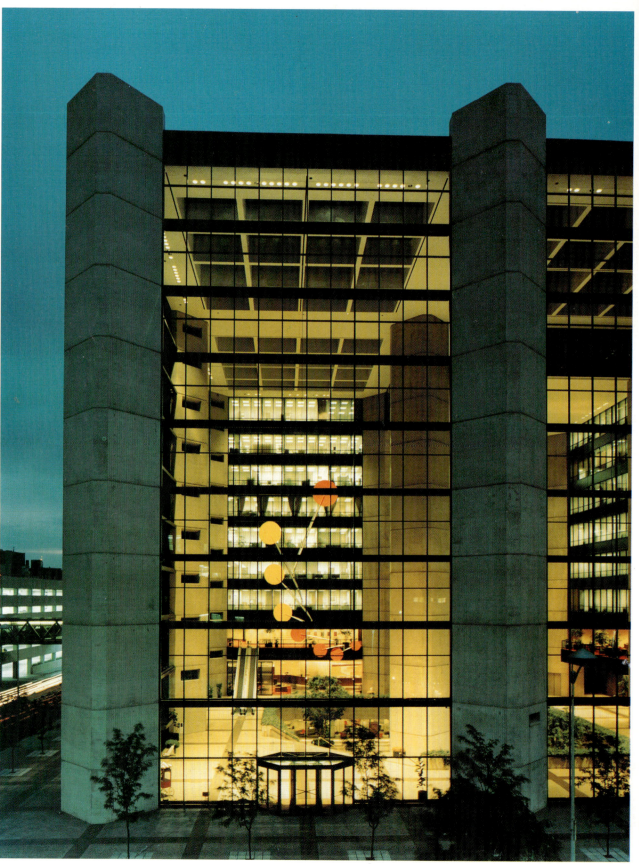

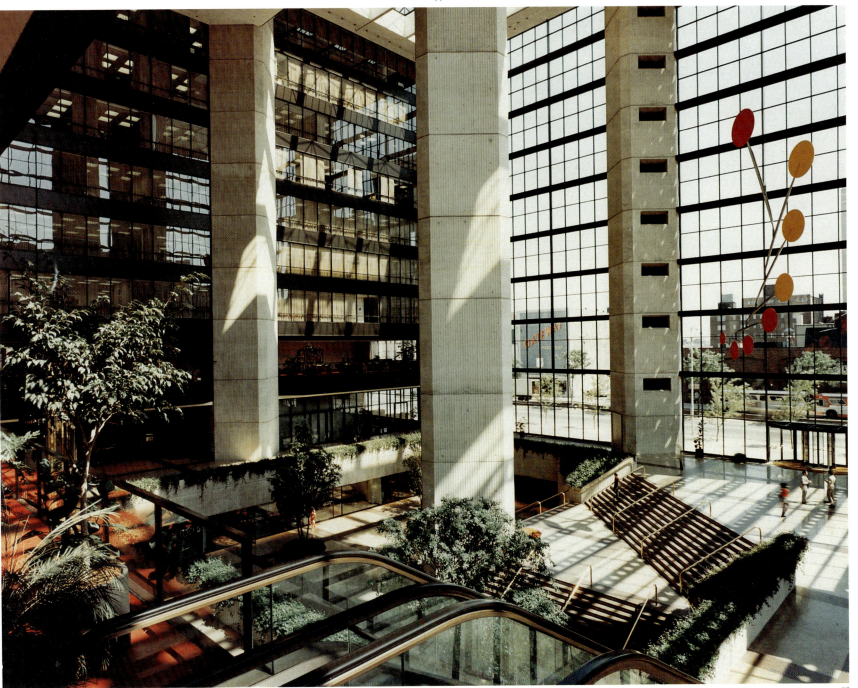

Fourth Financial Center

99. View looking down into lobby

100. Calder mobile

101. Glazed pedestrian passage to parking garage

102. View of lobby from offices

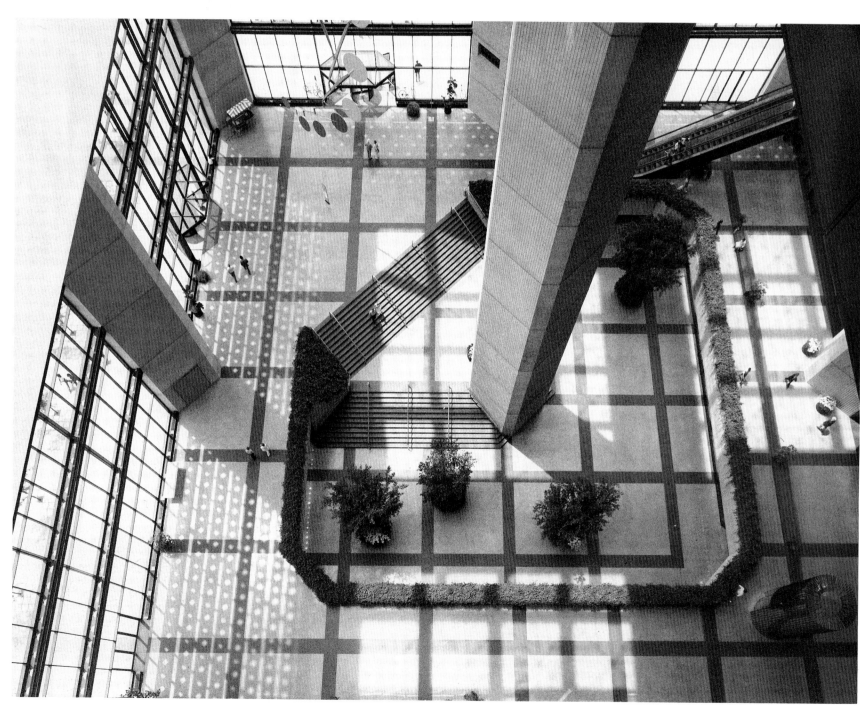

100

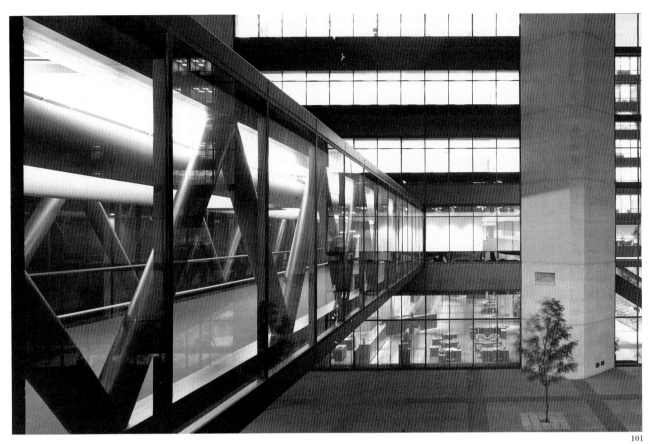

101

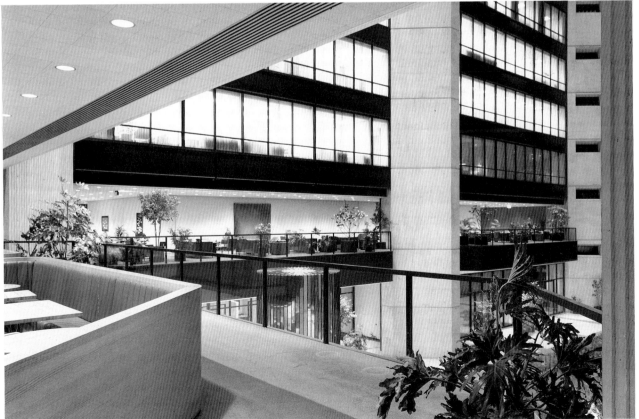

102

1974 — First Wisconsin Plaza, Bank and Office Building

City: Madison, Wisconsin
Client: First Wisconsin Development Corporation
Nine-story office building
White painted aluminum mullions; double-glazed clear glass

First Wisconsin Plaza in Madison, Wisconsin presented another opportunity to create a large volume of protected space containing a building. Serving as a prototype, it became rather popular and was labeled as an "atrium" building. We, however, were more concerned with the urban relationship of the exterior wall and its ability to define the public square and Wisconsin State Capitol. First Wisconsin Plaza is one of those buildings that is a fragment of what might have been. It was my dream that the entire Capitol Square be circumscribed by a gallery of glass which would serve as a green space in winter, and as a public square in summer. Obviously, energy is saved in this building, and the building is put to the larger purpose of an architectural experience.

This nine-story bank and office building in downtown Madison was the first building constructed in an area designated for redevelopment. The all-glass structure incorporates expansive internal open space and is oriented toward the adjacent Capitol Square and Wisconsin State Capitol building which was designed by George B. Post and completed in 1917.

The back of the building is a straight, nine-story wall of glass, while the front steps down with sloping glass roofs to the first floor. The banking facilities, located on the lower, ground and first levels, penetrate deep into the building, providing generous space for the thirty-foot high atrium. Offices on the upper floors wrap around a fourth floor roof garden on three sides and have unobstructed views of the centrally located Capitol Square. The Wisconsin climate dictated the spacious, airy, internal environment of the building. The use of a high-tech curtain wall eliminated the need for typical spandrel panels and provided an economical solution for the building's skin of white painted aluminum mullions and double-glazed glass in 3 × 5 foot panels. All structural and mechanical elements are exposed and expressed as design elements. A series of air risers and induction units painted blue and water risers painted yellow are visible and are set behind an outer grid of white mullions. Five murals designed by Valerio Adami integrate the open banking space of the main floor with the bright color scheme of the internal garden areas, while the rather informal quality of the exposed structure is given a sense of grandeur by the clear views of the Wisconsin State Capitol building.

Bibliography: Baumeister, April 1978; *Connaissance des Arts*, April 1977; *Deutsche Bauzeitung*, January 1980; *Interiors*, September 1975.

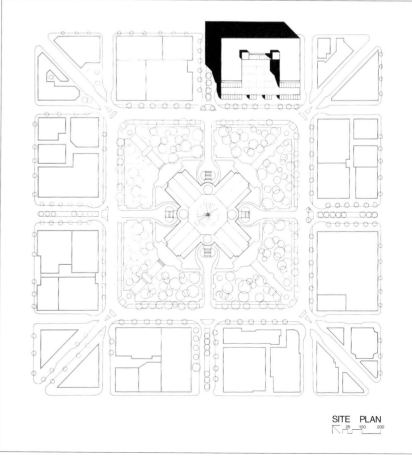

SITE PLAN

103. *View into bank lobby*
104. *Site plan*
105, 106. *Exterior*

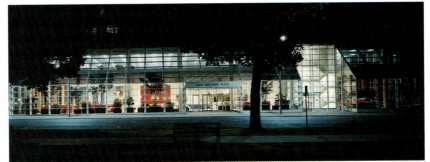

105

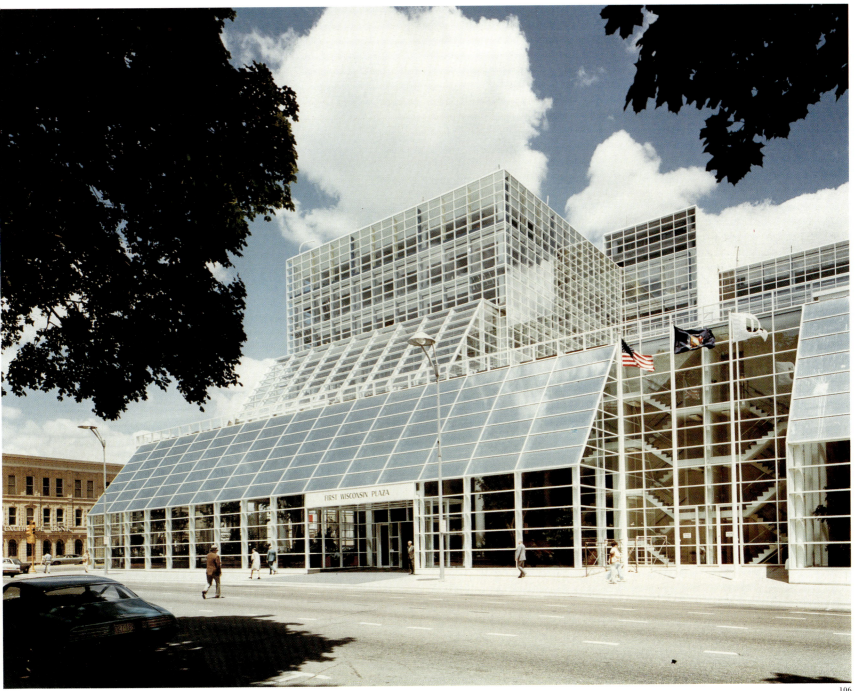

106

First Wisconsin Plaza

107. Exterior view of north elevation and Wisconsin State Capitol

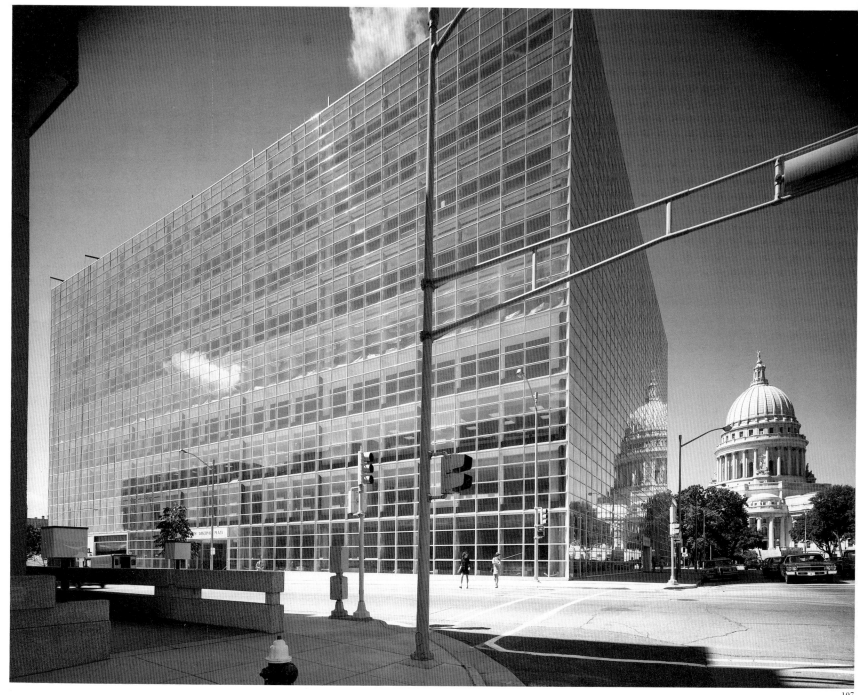

108. Interior of bank

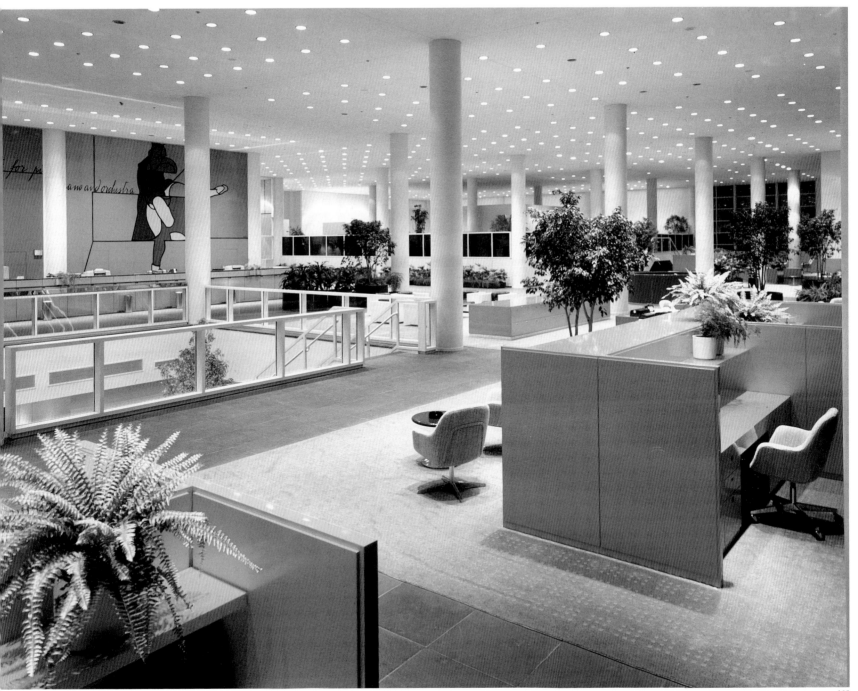

1974 — W.D. & H.O. Wills, Tobacco Processing Plant and Corporate Headquarters

109. Detail of Cor-ten structure
110. Site plan

City: Bristol, England
Client: Imperial Tobacco Group, Ltd.
300 × 700 foot column-free production space; seven-story office building
Exposed Cor-ten steel and tinted glass

W.D. & H.O. Wills continued our preoccupation with structure, but in this case we were influenced by Isambard Brunel's grand Clifton Suspension Bridge. The trusses above the roof of Wills, therefore, while functional, were a compliment to the grand engineering tradition of that country. Collaboration with YRM of London was rewarding and immensely helpful in that it gave a new perspective both to my work in the U.S. and to my understanding of the root forces of our society.

The Tobacco Processing Plant and Corporate Headquarters office building for W.D. & H.O. Wills are located on a gently sloping fifty-seven acre site. The plant contains a 300 × 700 foot, column-free production space, thereby providing maximum flexibility for the processing machinery. The seven-story office building sits upon a two-story base that houses support facilities, while the headquarters space occupies the remaining five stories. The buildings surround an artificial lake located on the site, and the buildings are all clad in Cor-ten steel with bronze windows.

Bibliography: Architect's Journal, 6 May 1987; *Architectural Review*, October 1975; *Building Design*, 23 March 1973; *Deutsche Bauzeitschrift*, July 1977; *Financial Times*, 15 October 1975; 11 November 1976; *Progressive Architecture*, June 1976; *Royal Institute of British Architects Journal*, August 1976; *The Times*, 13 September 1976.

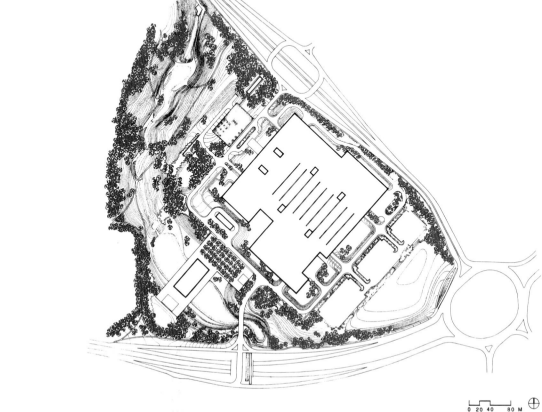

111. Aerial view of complex
112. Overall view of plant and surrounding country with Brunel's Clifton Suspension Bridge in distance

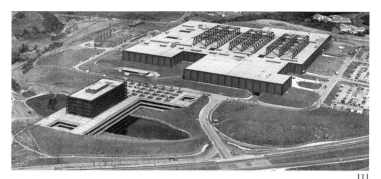

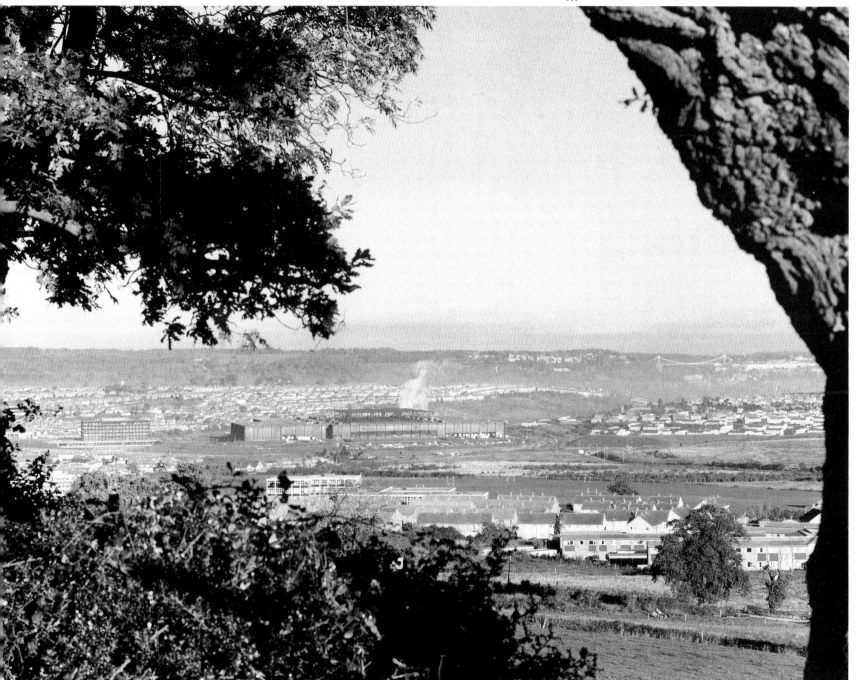

Wills Tobacco

113. Exterior of office and headquarters building

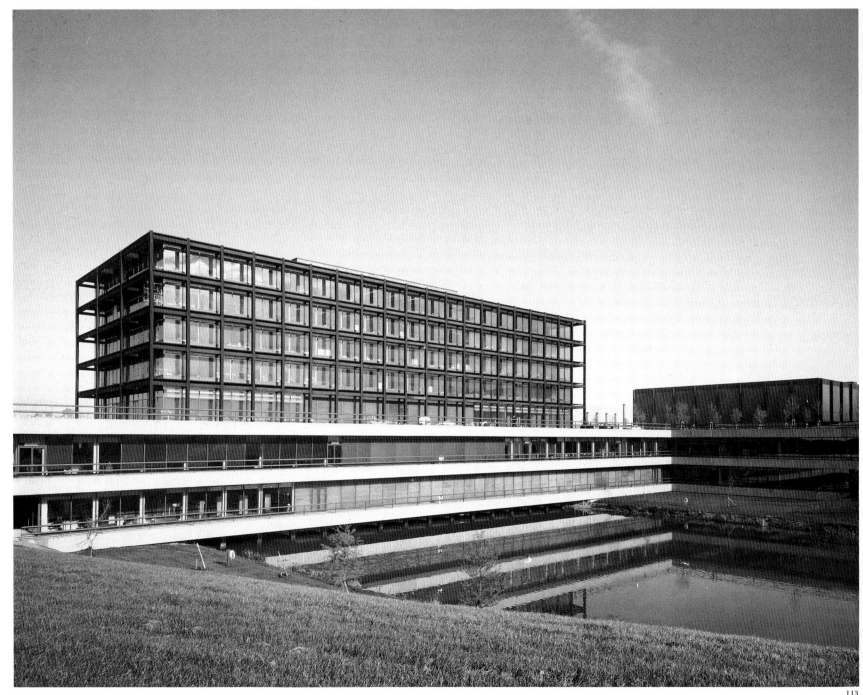

114. Interior of tobacco processing plant

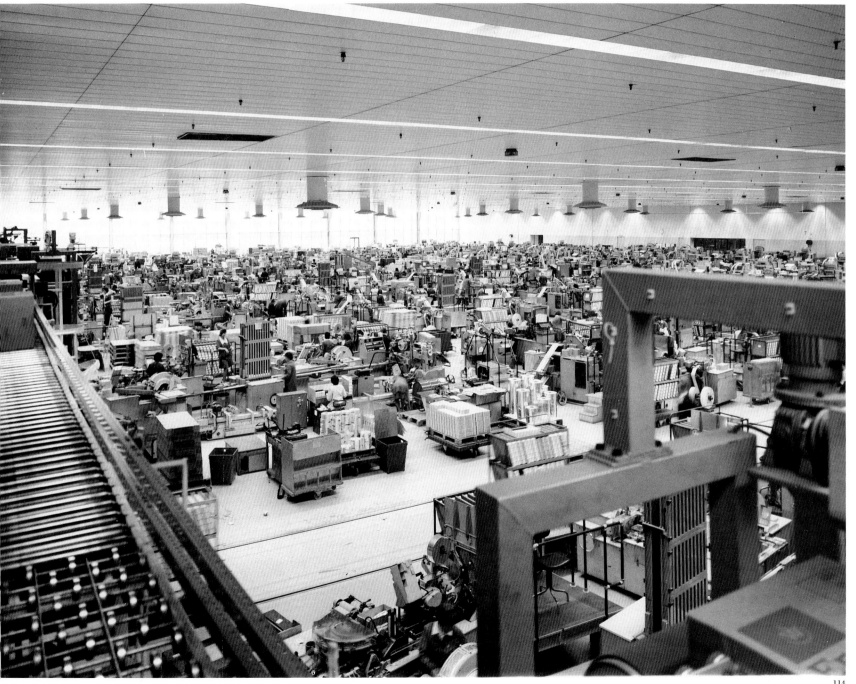

1975-1985

Baxter Travenol Laboratories, Inc., Corporate Headquarters

City: Deerfield, Illinois
Client: Baxter Travenol Laboratories, Inc.
One-story central facility building; four general office pavilions; two double-helix stepped-steel garages; entire complex connected by second-level bridges

In the plains of Illinois, the idea behind Baxter Travenol was of buildings that expand as nature expands and a master plan that would be complete at each stage of expansion. The central building was intended as a building, not for management, but for employees as a symbol of their endeavors, and as a place where work would be dignified.

The cable structure for the large roof was not only efficient, but also, by its presence, created a grand space that appears as a very gentle captive of the endless expanse of the Middle West. Detailing, by this time in my life and that of SOM, had reached a degree of sophistication we did not foresee in earlier work. The group of architects and engineers with whom I have had the pleasure of working had become master craftsmen and as such were able to apply high technology where necessary and simple ideas where appropriate.

The Corporate Headquarters for Baxter Travenol, Inc. is situated on a rolling 179-acre site northwest of Chicago. A master plan was designed to guide the company's ongoing reorganization and expansion. The complex consists of a central facilities building, four general office pavilions, which flank the north and south sides of the central building, an executive office building, and two double-helix, stepped-steel garages concealed from view by natural plantings. The entire development is linked by an underground pedestrian network and by second-level bridges. The twin masts of the central facilities building stayed-cable, suspended roof not only provide a focus for the site, but also create a local identity. The building's large free span interior houses an auditorium, training center and one-thousand-seat, twenty-four-foot high cafeteria. The connecting two- and three-story office pavilions are organized for open-plan work stations and take advantage of daylight and expansive views of the site. These pavilions constitute a flexible cluster of modules that can easily accommodate expansion through the addition of a similar long span steel structure.

The exterior cladding of the buildings is an off-white painted metal with infill panels of full-height, semi-reflective dual glazing set in stainless steel mullions.

Bibliography: American Institute of Steel Construction Architectural Awards of Excellence, 1975; *Architectural Review,* October 1977; *Architettura,* December 1977; *Building Design & Construction,* January 1976; *Deutsche Bauzeitung,* December 1977; *Inland Architect,* November 1976; *International Association for Bridge and Structural Engineering,* November 1982.

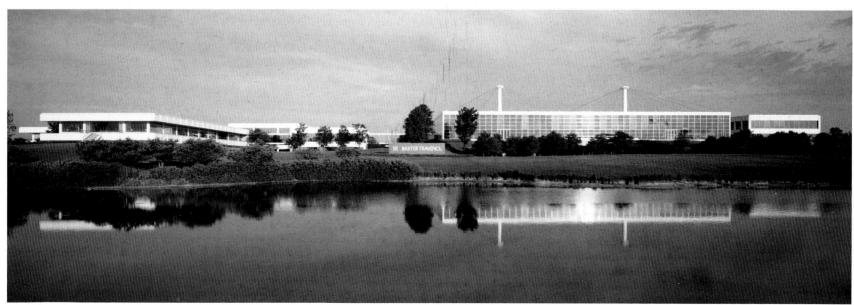

115, 116. Exterior views
117. Site plan

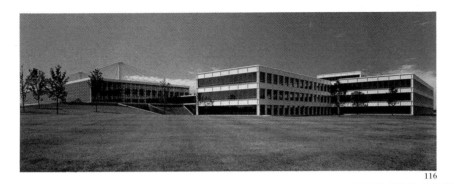

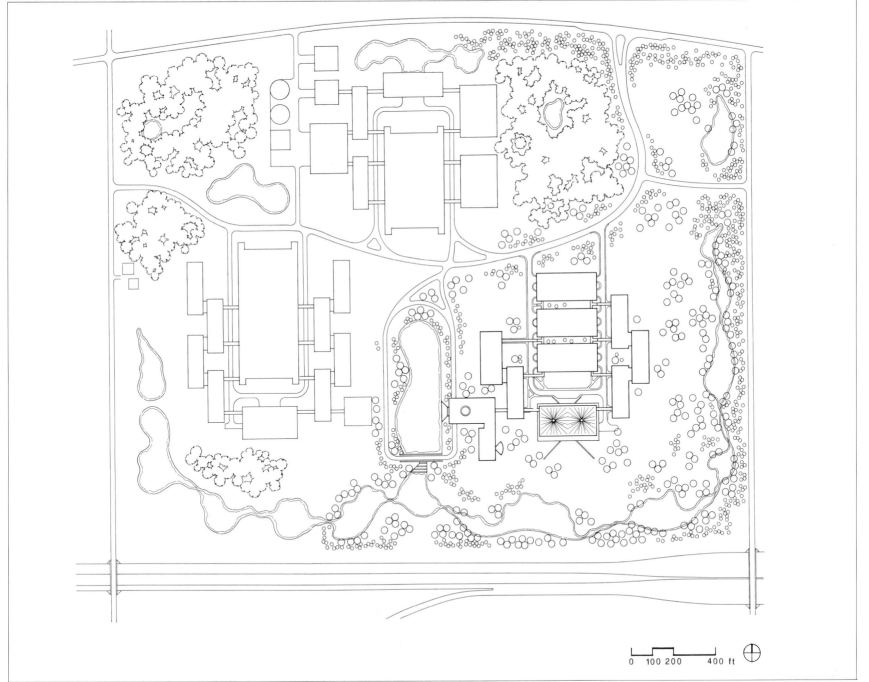

Baxter Travenol

118-121. Exterior views showing connecting glazed pedestrian bridges

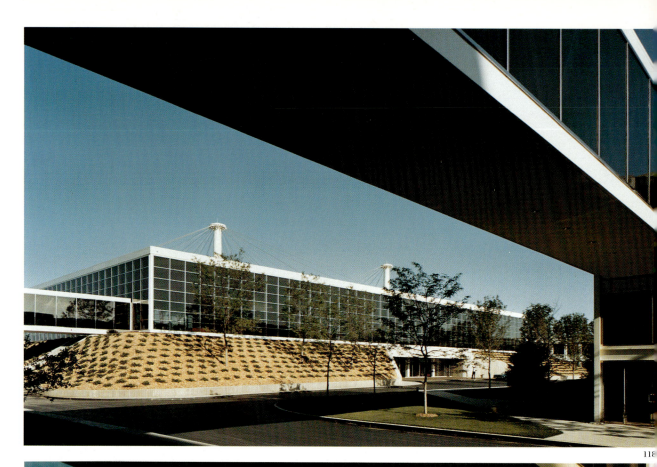

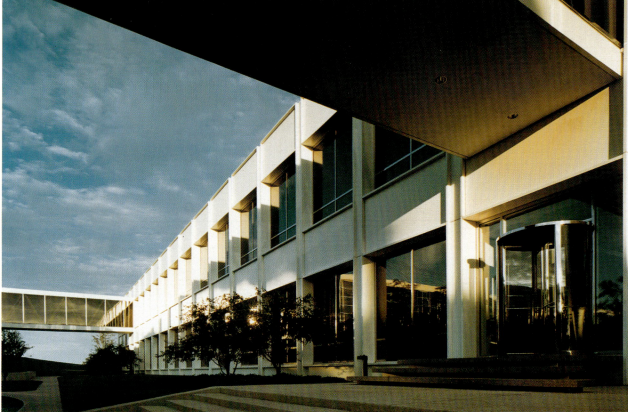

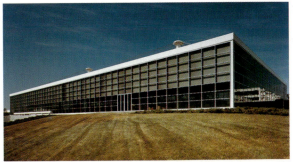

120

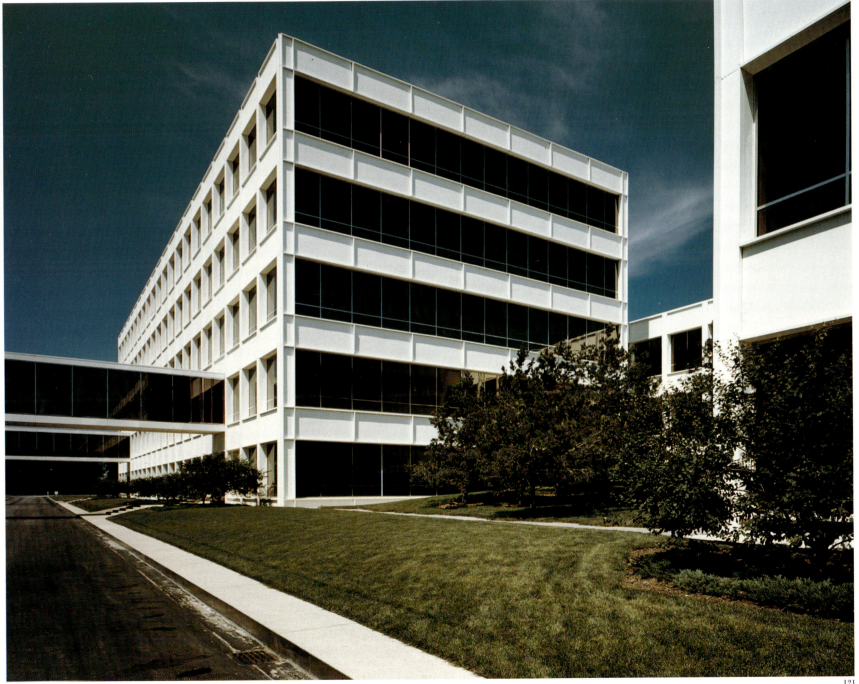

121

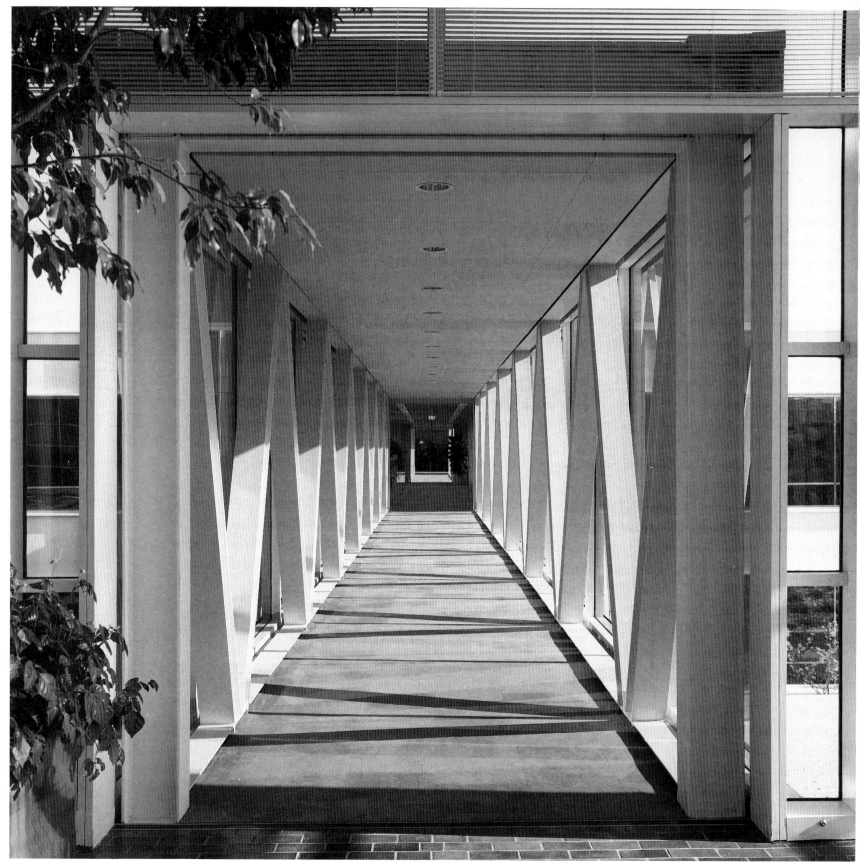

Baxter Travenol

122. Interior of glazed pedestrian bridge
123, 124. Pedestrian walkways

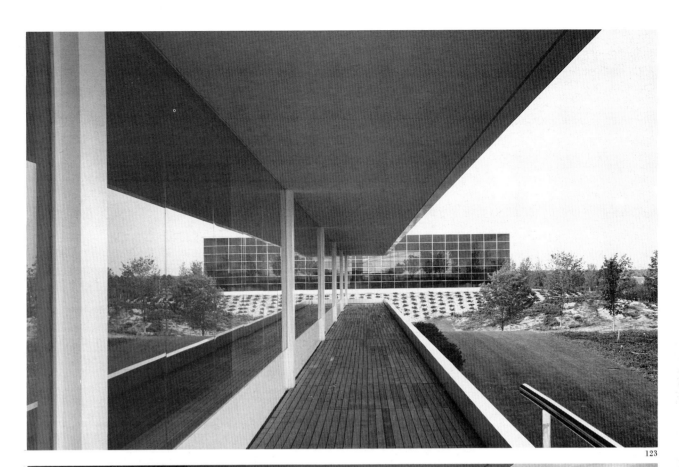

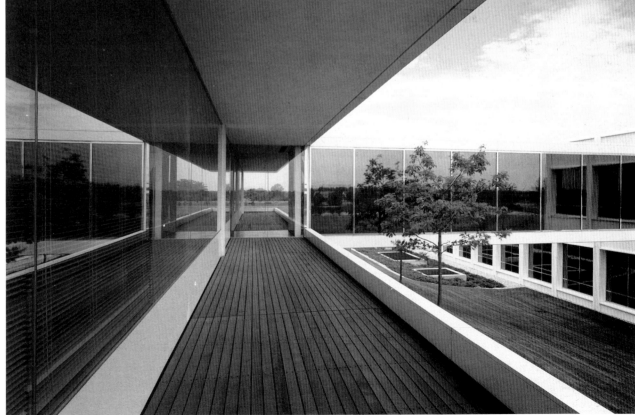

Baxter Travenol

125

126

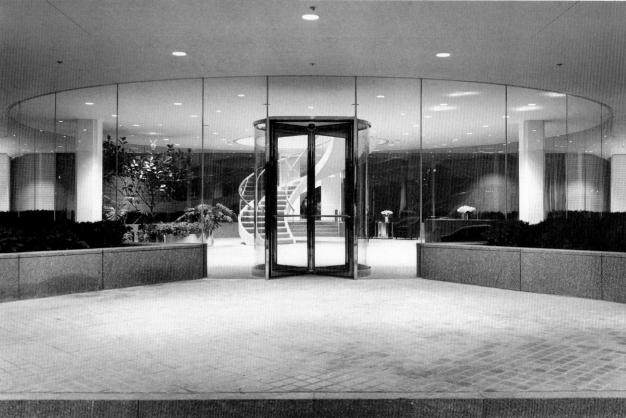

127

125-127. Interior views showing curved stairs and etched glass screen
128, 129. Views of cafeteria

128

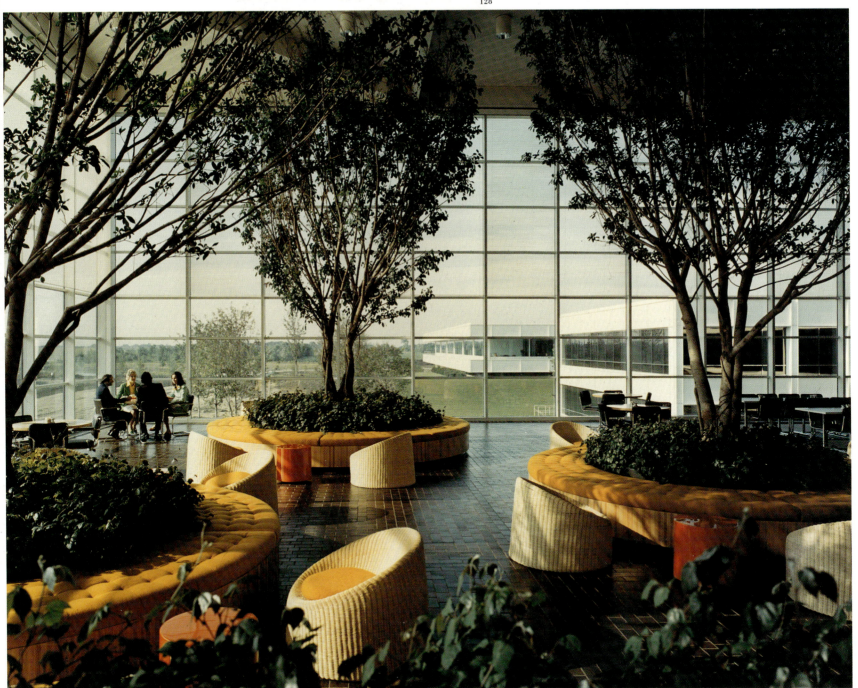

129

1978 Banco de Occidente, Banco de Occidente Zone 1 and Montufar

City: Guatemala City, Guatemala
Client: Banco de Occidente

Banco de Occidente in Guatemala City was done around the same time as Baxter Travenol. We used materials particular to Guatemala and the structure, in this case, was a bearing wall. The use of native tiles and natural ventilation captured the benign climate of that city. Each building's sense of enclosure and their public and private spaces are not in the tradition of Chicago, but of Guatemala City.

The Banco de Occidente headquarters and branch banking facilities were constructed for one of the oldest banking institutions in Guatemala. The largest of the three, Zone 1, is the original headquarters and is located in the center of the city's oldest section, while the remaining two are suburban branch banks. Designed to relate to the surrounding contextual influences of traditional Guatemalan architecture, each of the three buildings responds to its unique program and site constraints. Architectural continuity is retained in each through the use of traditional and indigenous colors, textures, materials and patterns of light and shadow. A common design was used for banking elements such as the teller counters, check writing stands, platform office, work stations and interior furnishings. Local materials such as stucco, mahogany and volcanic stone pavers, and local architectural concepts of open courtyards, terraces, walled-in gardens, fountains and trellises were used throughout to reinforce the relationship of these buildings to their Guatemalan context. Furniture and fabrics designed by SOM were manufactured in Guatemala City for use in the bank buildings.

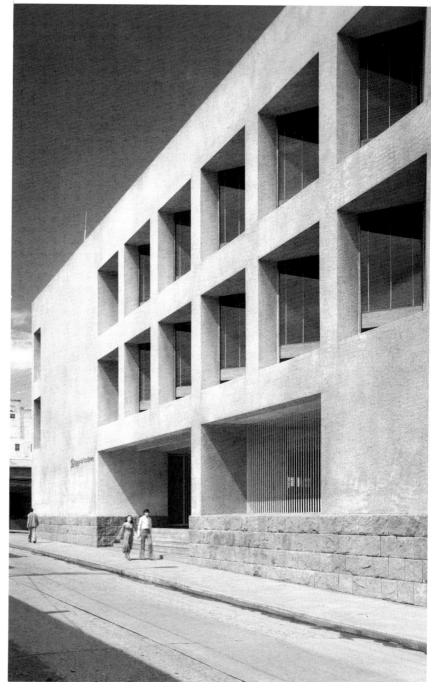

130. Exterior
131. Section and ground floor plan

Banco de Occidente Zone 1

The headquarters office consists of public facilities at level one, executive offices and semi-public facilities at level two, and employee and non-public uses on level three. The building is designed around an interior/exterior courtyard which is covered with a translucent fabric roof that allows soft light to enter, but also reduces the impact of solar heat. A clear spatial relationship exists between the courtyard space, the two-story banking hall, the office functions and the exterior terrace on the third floor. Terrace and setback openings control light while wood louvers modulate ventilation. The exterior consists primarily of textured stucco, and a stone base provides a durable surface for this highly frequented area.

Montufar

This eight-teller branch bank is completely surrounded by party walls, and entrances occur at two points within an existing shopping center. Natural light and ventilation enter the bank through skylights. A spacious sky lit courtyard and a reflecting pool enliven and lend a sense of openness to the small bank.

Bibliography: American Institute of Architects Journal, Mid-May 1981, AIA Honor Awards; *Architectural Record,* May 1981; August 1981; *Chicago Tribune,* 21 June 1981; *Proq. Arquitectura Piseno Urbanismo Industrias,* April 1984; *Space Design,* February 1985.

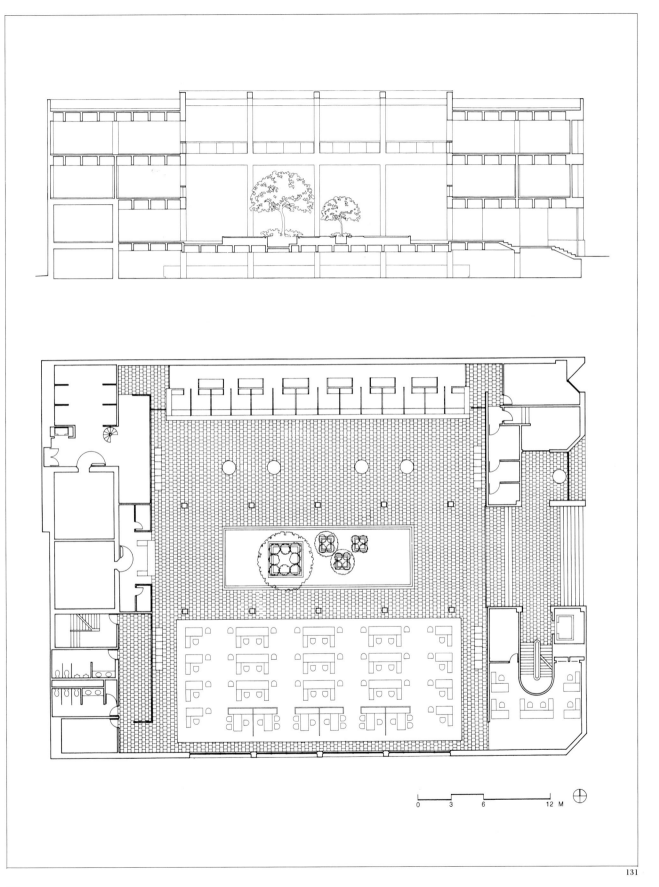

Banco de Occidente, Zone 1

132-135. Views of courtyards and interior spaces

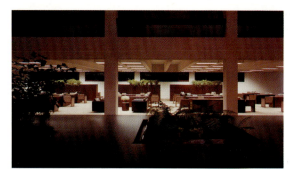

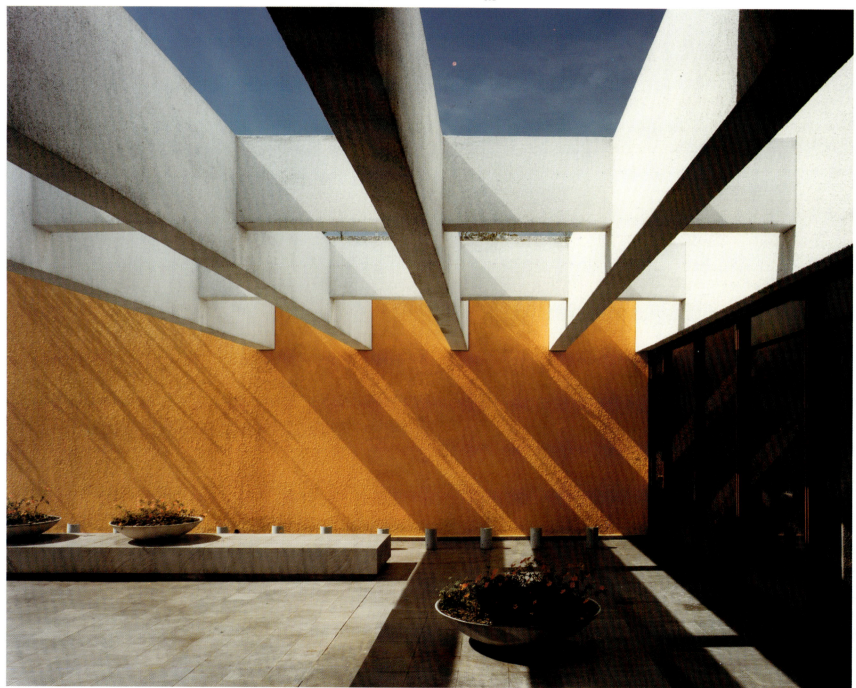

134

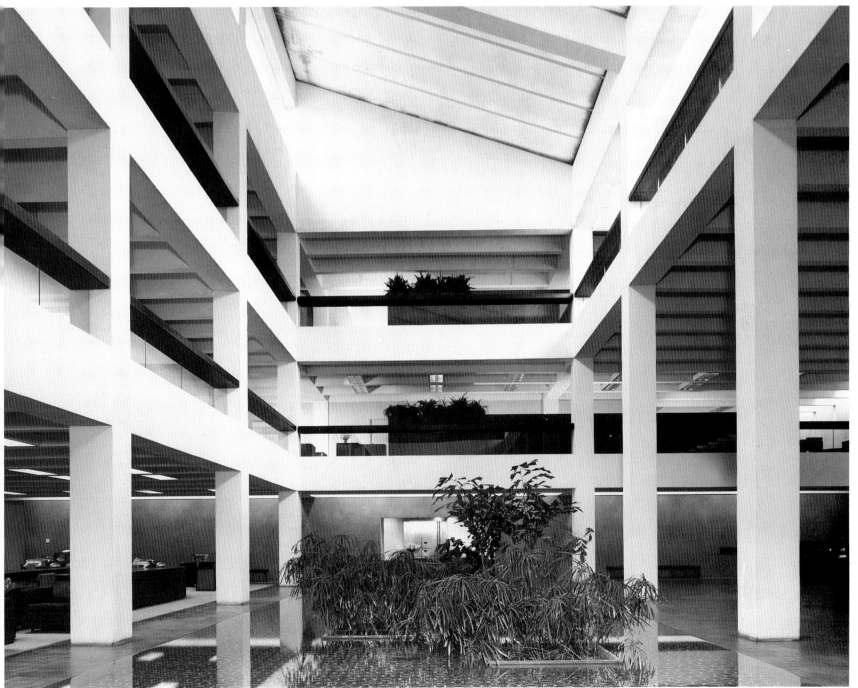

135

87

Banco de Occidente, Montufar Facility *136-138. Interior and courtyard*

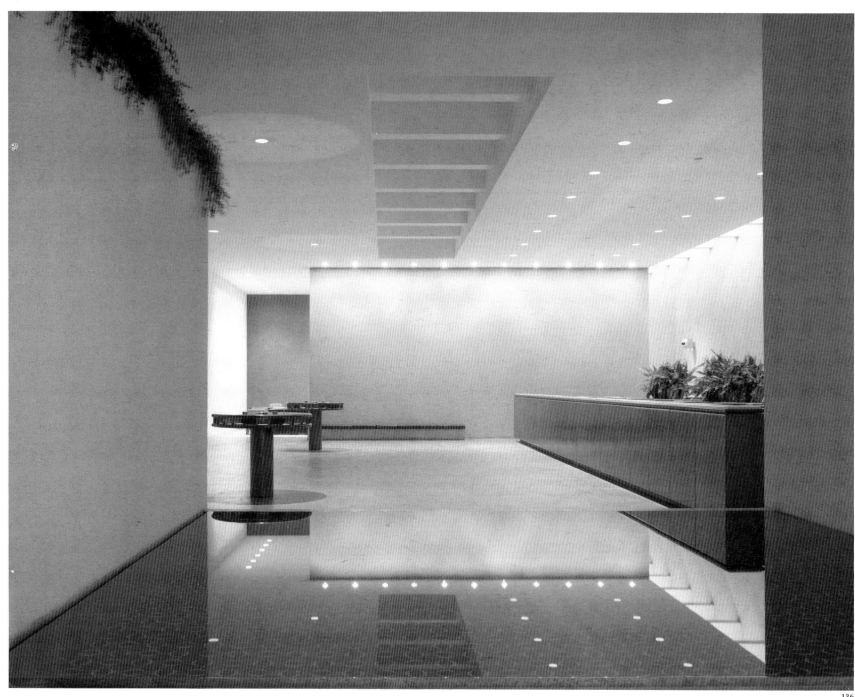

137

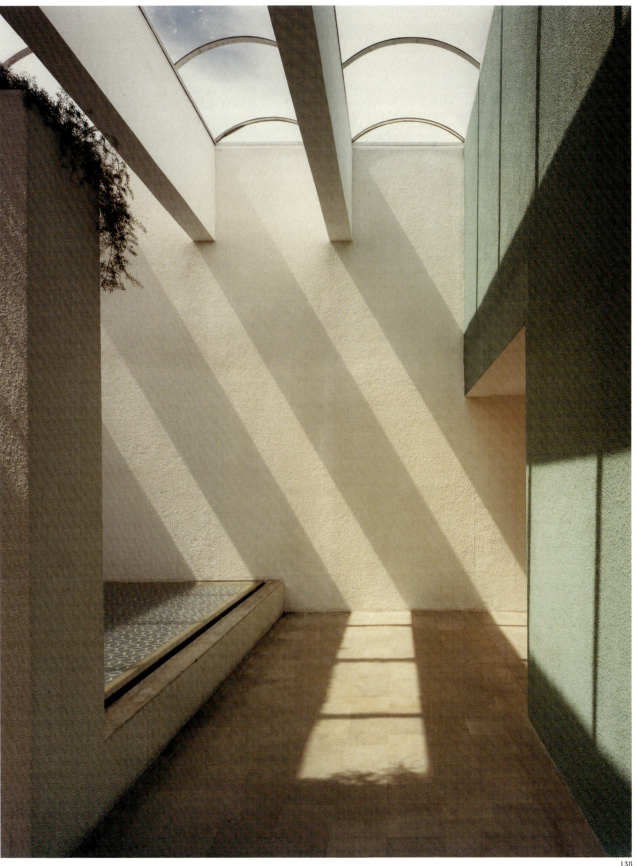

138

1978-1980 **King Abdul Aziz University**

139. Plan of women's university

City: Makkah, Kingdom of Saudi Arabia
Client: King Abdul Aziz University
Unbuilt project

Despite the desire of Saudi Arabia to reproduce American buildings, we took a direction not only related to the spatial and architectural tradition of the Mid-East, but also forced by the aridity of the land, heat of the sun, and unforgiving character of all other aspects of the natural environment. It was natural that the master plan and design of the buildings take on the quality of a desert village, for survival in those villages came through experimentation over centuries. We reproduced those experiments in laboratories in forms and shapes very similar to those of the past. No attempt was made to create traditions which never existed, but similarity of forms arose out of pragmatic considerations and translation of those considerations into an architectural vocabulary responsive to the lifestyle and psyche of desert dwellers.

The 467-acre site for the university is located in a valley surrounded by low, barren mountains west of the holy city of Makkah, in the Kingdom of Saudi Arabia. The Makkah-Jeddah Road, which is the principal highway to Makkah for thousand's of annual Haj pilgrims, provides a natural separation of the site into two distinct sections: one for the academic complex, the other for dependent housing. The academic complex was intended to reflect the social, cultural, and historic pattern of Saudi Arabian life, and was itself separated into two campuses, one for men, the other for women. Full enrollment was expected to reach fifteen thousand with an estimated ten thousand men and five thousand women.

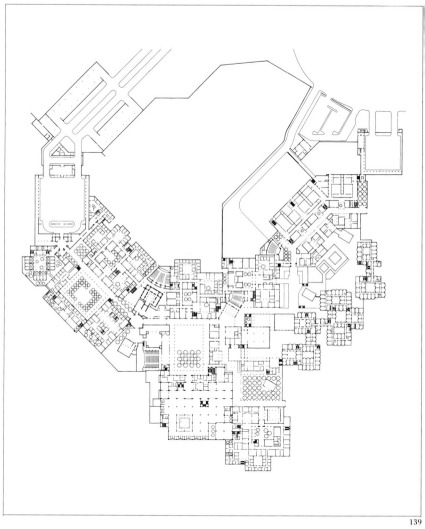

139

The master plan for the University reflects traditional Islamic urban settlements. Like those communities, the campuses were to consist of tightly clustered low-rise buildings; a vehicle-free, pedestrian-oriented environment was a primary objective. Buildings were designed to respond to Makkah's extreme climate and to maximize air ventilation and natural light.

Bibliography: *Albenaa*, 1982; *Architectural Review*, January 1979; *Building News*, August 1979; *Middle East Construction*, October 1981; *Montgomery Journal*, 25 April 1979; *Progressive Architecture*, October 1982; U.S. Department of Commerce. *An Evaluation of Thermal Energy Conservation Schemes for an Experimental Masonry Building*, NBS Building Science Series, no. 137.

140. Model of women's library
141. Plan of courtyard and pedestrian areas around ceremonial mosque
142. Central library courtyard

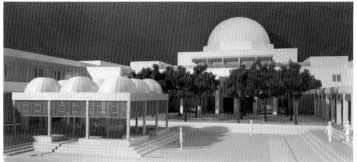

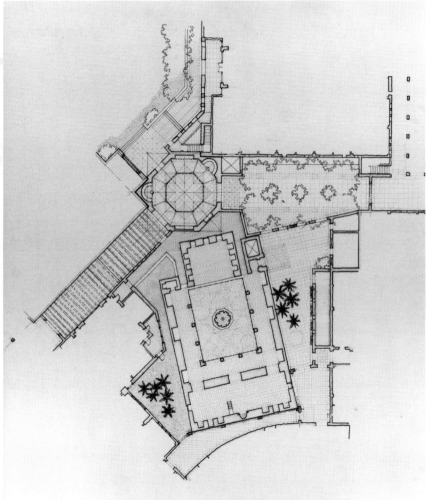

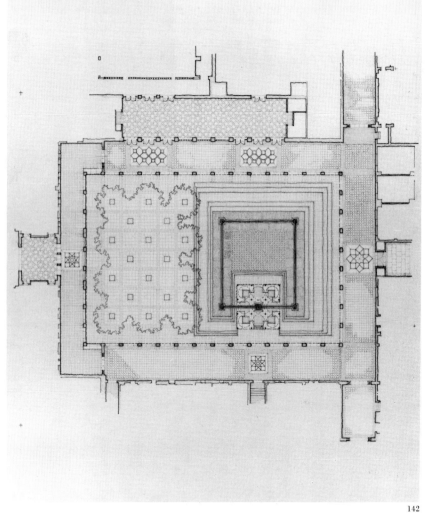

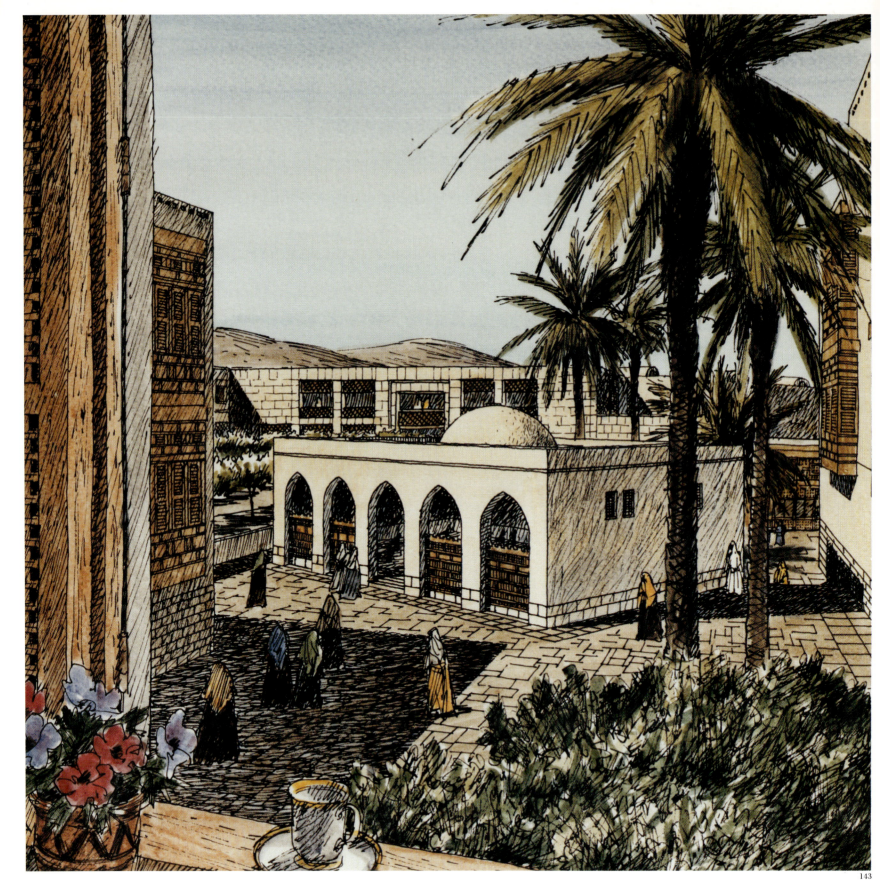

King Abdul Aziz University

143. Rendering of preliminary plan for ceremonial mosque

144. Patterns for tile

145. Rendering of administrative courtyard
146. Rendering of academic courtyard
147. Rendering of student pavilion
148. Rendering of student housing

144

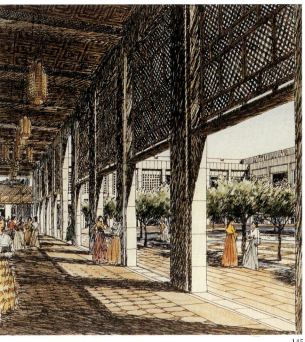
145

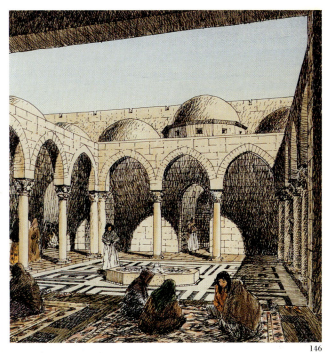
146

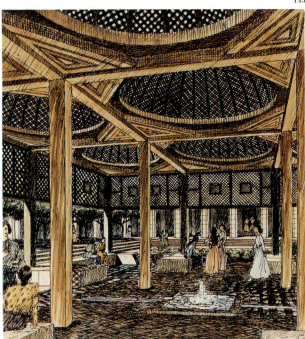
147

148

1981 **Three First National Plaza, Office Building**

149. Second floor plan
150. Exterior in context of skyline

City: Chicago, Illinois
Client: Gerald D. Hines Interests, Houston, Texas
Fifty-seven story office tower; nine-story glass enclosed entry lobby
Steel structure; granite cladding; tinted glass

As we began to master the tube structures for tall buildings, we gained the ability of setting up rules and breaking them without violating the structure, without compromising integration. We were in search of an expression that would allow these uncompromised structures to land on earth gently and yet celebrate the romance of towers. Three First National was one of many such adventures. The grid is preserved but broken down so as to articulate movement from street to building.

The fifty-seven story tower is located between the financial center and downtown commercial district of the Chicago Loop. The granite-clad building is entered through a nine-story glass-enclosed atrium and is linked to the neighboring First National Bank building by a second-level walkway. Rising above the atrium, the tower's sawtoothed setback design minimizes the disruption of views from nearby buildings, provides multiple corner offices, and affords tenants abundant natural light and a variety of views. This same configuration is accentuated on the top six levels by stepped greenhouses facing Lake Michigan. The tower's tubular structural system provides strong wind resistance and allows column-free interior spaces. Office areas and mezzanine balconies look onto the central atrium. A stepped steel truss structure repeats the sawtooth geometry on an inclined plane and supports the clear glass enclosure. The atrium lobby provides protected pedestrian access to Chicago's underground arcade network and to the city's rapid transit system.

Bibliography: Architecture and Urbanism, March 1983; *Chicago Architectural Journal*, 1981; 1982; *Chicago Sun-Times*, 8 May 1983; *Proq. Arquitectura Diseno Urbanismo Industrias*, April 1984; *Space Design*, May 1979.

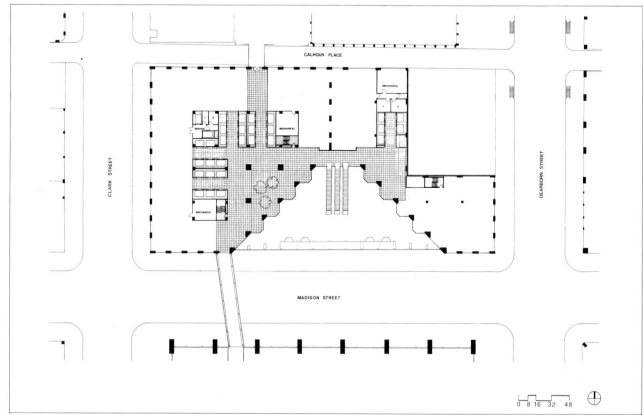

149

Three First National Plaza

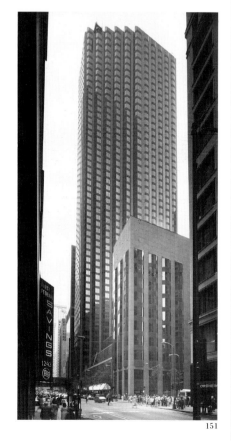

151

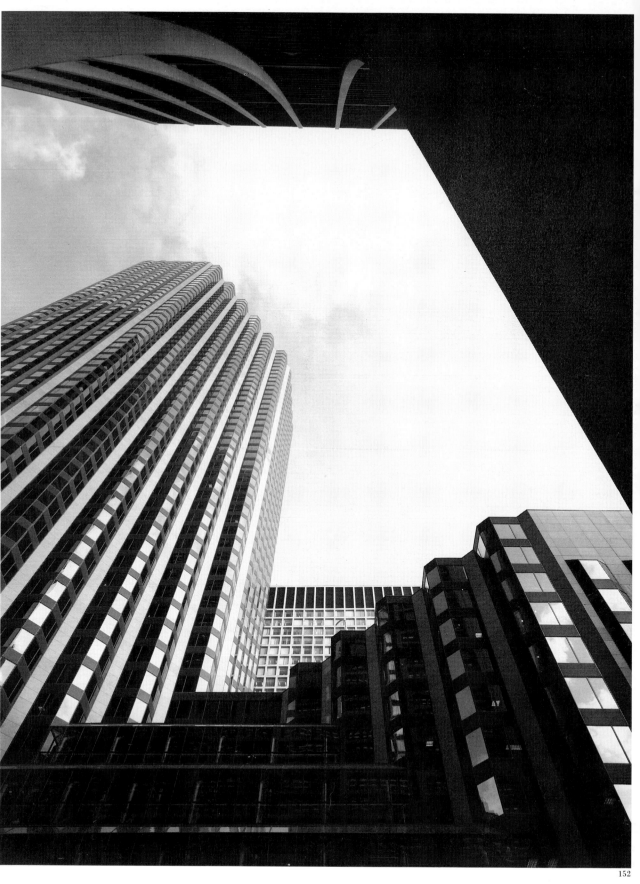

152

151, 152. Exterior views 153. Entrance on Madison Street 154. Interior of lobby

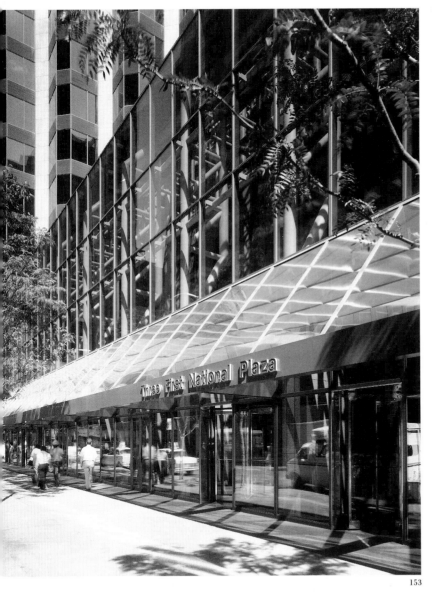

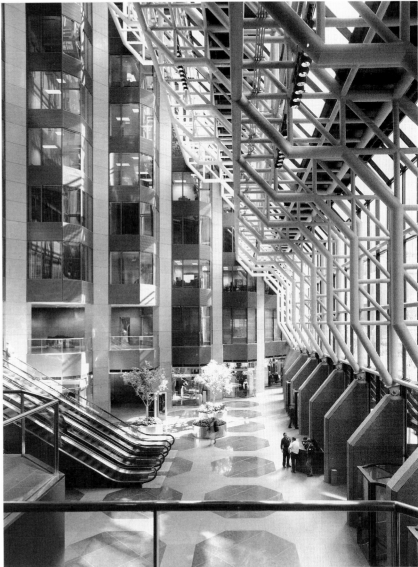

1982 Madison Plaza, Office Building

155. Exterior from southeast
156. Floor plan at high-rise level and ground floor plan

City: Chicago, Illinois
Client: Miglin-Beitler Developments
Forty-five story office building
Structural steel tube; grey polished granite; silver reflective glass; polished stainless steel trim

Madison Plaza is another such tower, simpler, and yet more powerful. A raised triangular entry plaza, paved in a grid pattern, at the corner of the block, enhances the quality of the intersection. I can well imagine four such buildings at an intersection, creating a space that signifies the gateway or crossing, such as those found in Barcelona.

Unique office spaces are provided in this forty-five story office building. The glass front elevation is a sawtooth form which rises from the entrance plaza to the sloped roof of the thirty-ninth and forty-fourth floors. The steel tube structure is clad with bands of silver reflective glass and light gray polished granite. Window sizes vary to provide optimum views of the surrounding city and to respond to energy considerations. By setting the building back from the street, a triangular elevated entry plaza was formed to buffer the building entrance from the heavy street traffic and the adjacent elevated rapid transit tracks. The plaza also provides an appropriate setting for a sculpture by Louise Nevelson.

The lobby is finished in statuary Bettogi marble with polished stainless steel trim. Stainless steel elevator doors are etched with a subtle grid. The elevator interiors are mahogany paneled with a custom ceiling of stainless steel and luminous panels. Individual tenant floors provide a maximum of eight corner offices, all offering views to the central Loop business district and the lake beyond.

A structural steel system was chosen to respond efficiently to cost and construction requirements as well as to the unique architectural

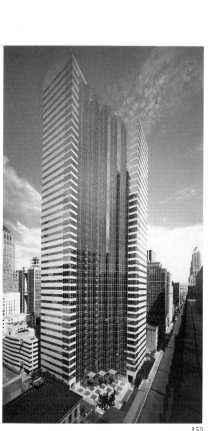

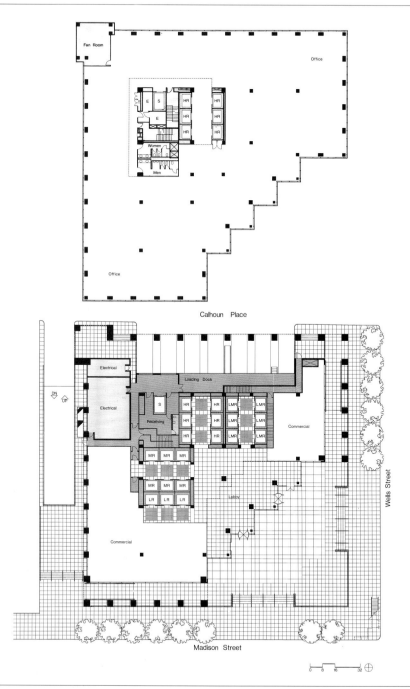

157. Southeast facade showing saw-tooth profile and silver glass reflecting image of the Sears Tower

configuration of the building. The structural steel superstructure has an exterior framed tube interacting with a full-height braced steel core. The framed tube system was developed using fifteen-foot-wide shop fabricated "tree" units which were welded and field bolted at the middle of the spandrel beam span. These tree units eliminated most of the field welding, industrialized the production of the tree units in the shop, and, therefore, resulted in a high erection speed of three to five floors per week.

Bibliography: Architecture and Urbanism, March 1983; *Chicago Tribune*, 3 May 1981; 22 July 1985.

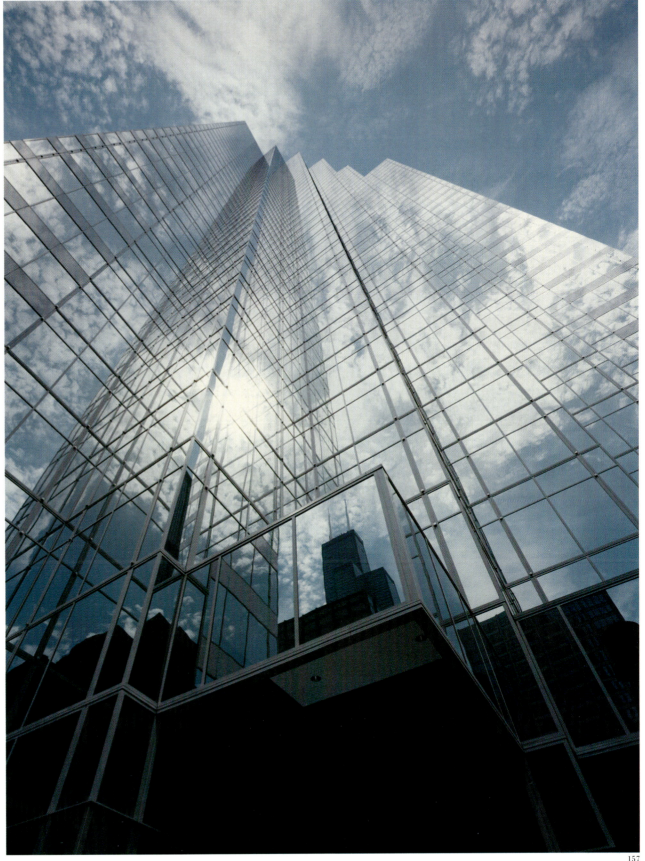

Madison Plaza

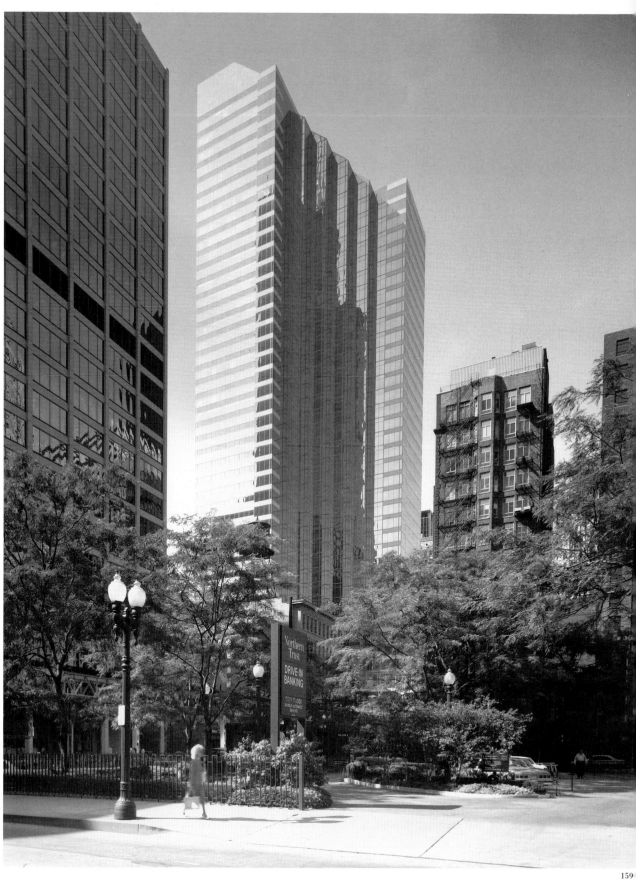

158. Model showing unbuilt second phase
159. Exterior from the southeast

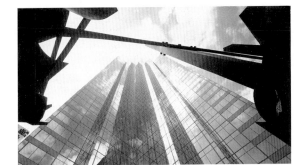

160. Plaza with Louise Nevelson sculpture
161. Exterior looking up through sculpture
162. Entrance lobby

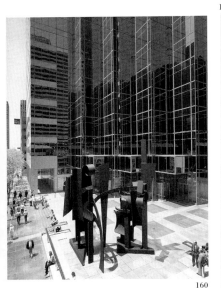

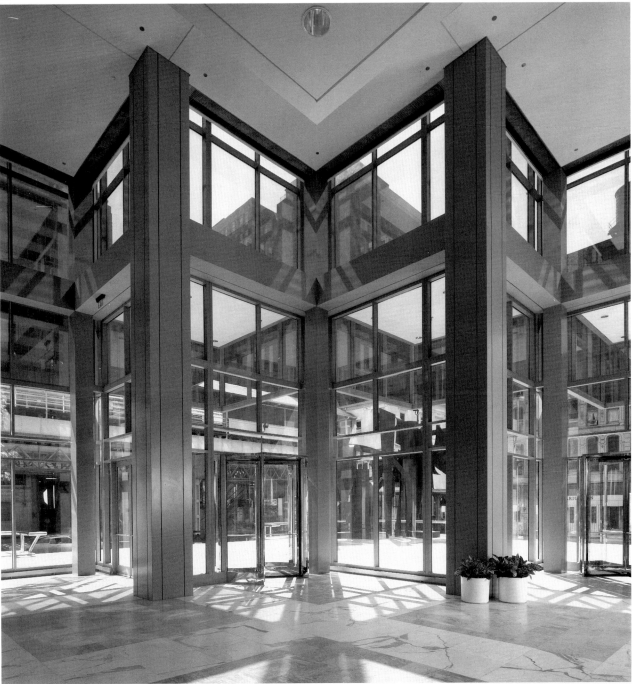

1981

Grupo Industrial Alfa, Corporate Headquarters

City: Monterrey, Mexico
Client: Grupo Industrial Alfa
Concrete structure finished in stucco

Grupo Industrial Alfa in Monterrey, Mexico was a response to an entirely different situation. The city is dynamic, but struggling for survival in a country that is exciting, but fraught with its troubled identity. The language so clearly set by Luis Barrágan gives hope where there should be none. Into that language we incorporated what was now my tradition—structural viability. Mexico's climate, while not as intense as Saudi Arabia, approximates that lack of hospitality, so public spaces were enclosed in a gallery that became the public room for employees.

Situated at the foot of the Sierra Madre Oriental Mountains on a twenty-five-acre wooded site, the Grupo Industrial Alfa headquarters facility was designed to take advantage of the natural setting and mountain views. The complex includes executive offices, general offices, a large auditorium and employee cafeteria all united by a barrel-vaulted galleria. In keeping with the traditions of Mexican landscape design, the facility features planted courtyards, formal open courts, and a large garden court with trellis. Exterior sunshades, both horizontal and vertical, are found throughout the building and are used for energy control over the setback windows. The punched windows are glazed in clear glass and provide light penetration into the building's interior zones. The concrete structure is finished in stucco.

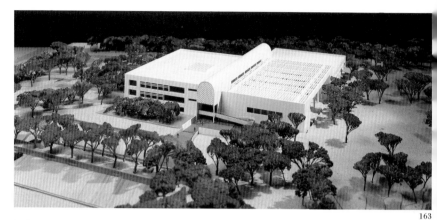

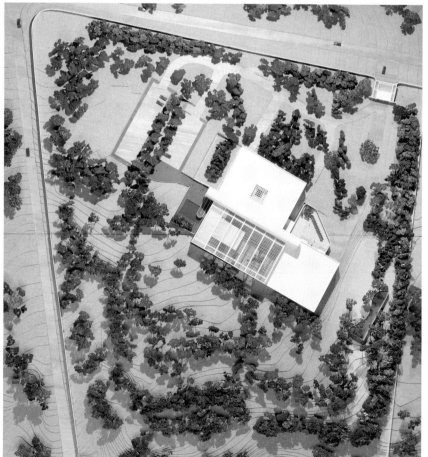

163-165. *Views of model*
166, 167. *Elevations*
168. *Lower level and main level plans*

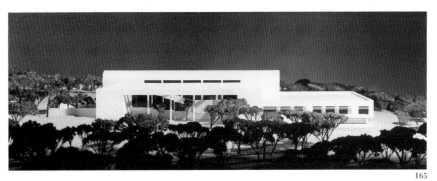

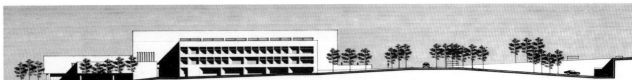

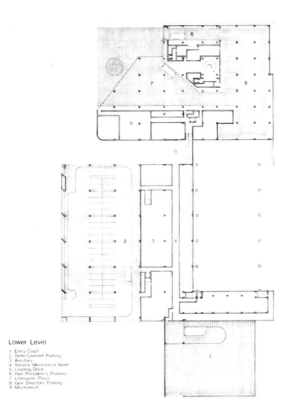
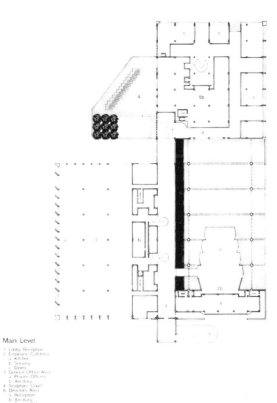

Building Plans

Grupo Industrial Alfa

169. Barrel-vaulted galleria

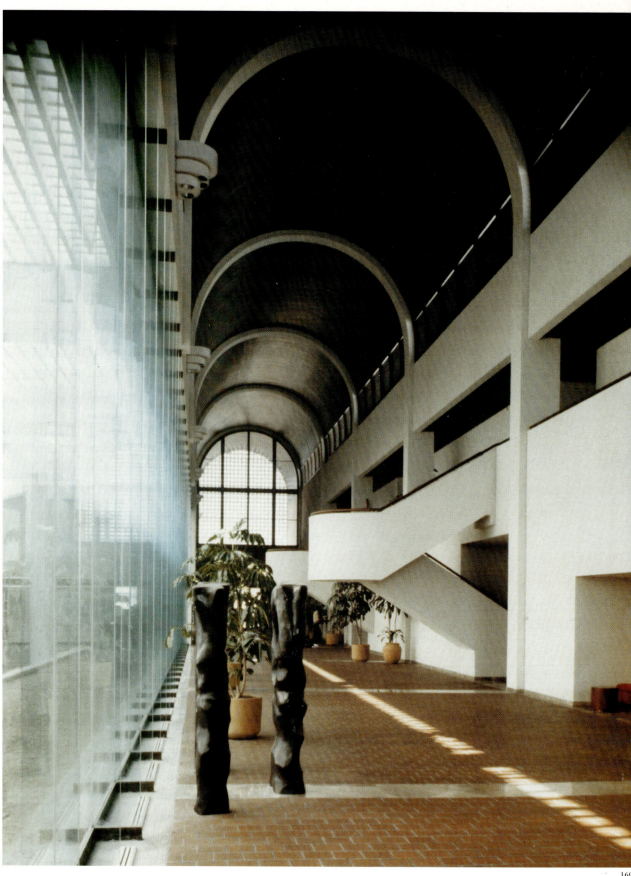

170. View of exterior from south

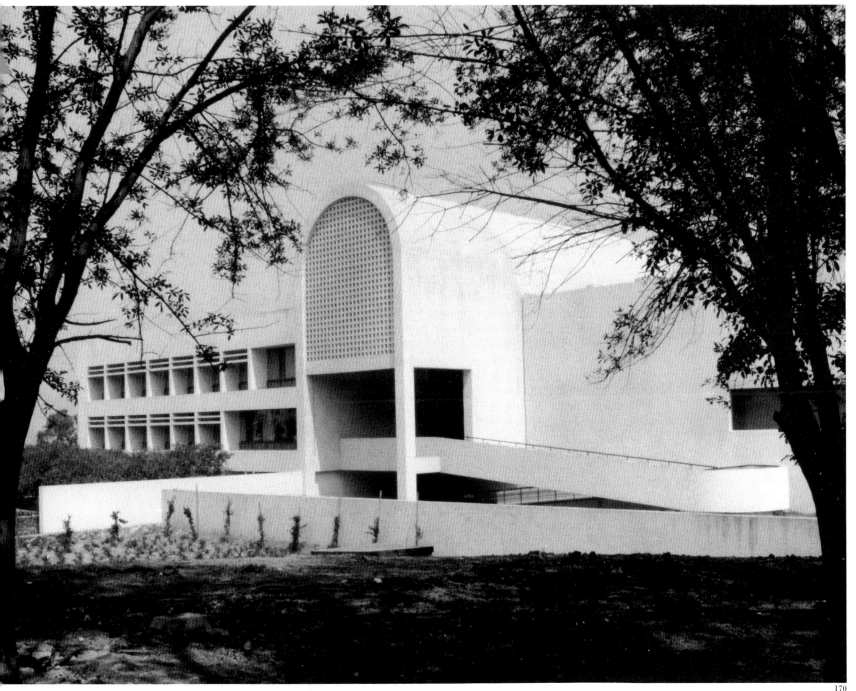

1982 — National Gallery Extension, Design Competition

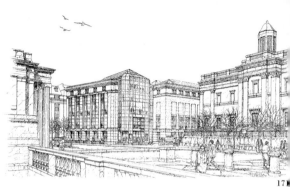

City: London, England
Client: London Land Investment and Property Company, Ltd.

The National Gallery Extension was my first major experience with the weight of tradition that began centuries before America's discovery. The approach was that of filling in a void. London is a medieval city that has endured intervention over the centuries without the destruction of its inherent character. The proposed solution for the Gallery was, first and foremost, one of respect for the grand collection of art, and therefore, an extension of the grandness of these works into the building design. We also proposed to express the whole of the Gallery in sympathy with the buildings of Trafalgar Square. In order to do so, our materials were Portland Stone and bronze yet in a modern vernacular that included both the scale and texture of the surrounding architecture. The subtle moves of previous architects had to be complemented, not destroyed, in this national square of London.

The design for the new extension respects the building line of the existing facade while also recognizing the overall axial dynamics of Trafalgar Square. The height, texture, and massing of the new extension are consistent with the surrounding buildings and restate their scale, while its facade, like those of the neighboring Canada House, the United University Club building, and the National Gallery, is clad with Portland stone and articulated with granite and bronze detailing.

On the interior, the new gallery is formally linked to the existing gallery by means of an axial progression of interconnecting galleries running east to west. A north-south

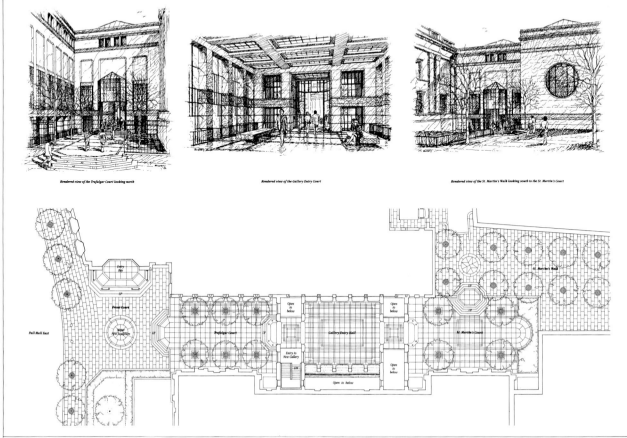

Rendered view of the Trafalgar Court looking north Rendered view of the Gallery Entry Court Rendered view of the St. Martin's Walk looking south to the St. Martin's Court

71. *Rendering of exterior*
72. *Plan and renderings of entrance*
73. *Plans of lower and ground floor levels; renderings of gallery shop and coffee shop; elevation and section of new gallery*
74. *Ground floor plan; elevation of National Gallery with new extension*

axis of galleries establishes the new gallery's own planning and architectural identity, allowing for set pieces, displays, and terminating vistas for principal and monumental works as well as more intimate spaces for smaller-scale works. The formal arrangement of spaces establishes a logical sequence of movement through the rooms of the new gallery to the major room fronting Trafalgar Square, allowing the visitor to the new gallery glimpses of the surrounding architectural environment.

The central rooms of the new gallery maintain the Renaissance theme of order, not only through their hierarchy of spaces and the progression of movement from gallery to gallery, but also through a careful choice and ordering of materials and design elements. The tone and texture of the materials used throughout remains elegant and uncluttered, so as to place the main visual emphasis on the works of art displayed. Thus, the walls and floors of the central rooms are of travertine marble, and the main flanking galleries feature plaster walls with a travertine marble base and polished oak floors bordered in travertine.

Bibliography: Apollo, January 1985; *Architect's Journal*, October 1982; *Architectural Review*, December 1982; *Chicago Tribune*, 14 December 1982; *Financial Times*, 24 August 1982; *Skyline*, November 1982; *The Standard*, 23 August 1982; 25 August 1982.

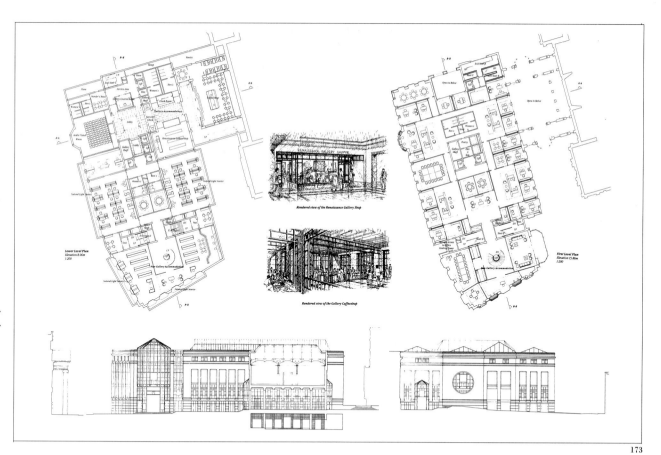

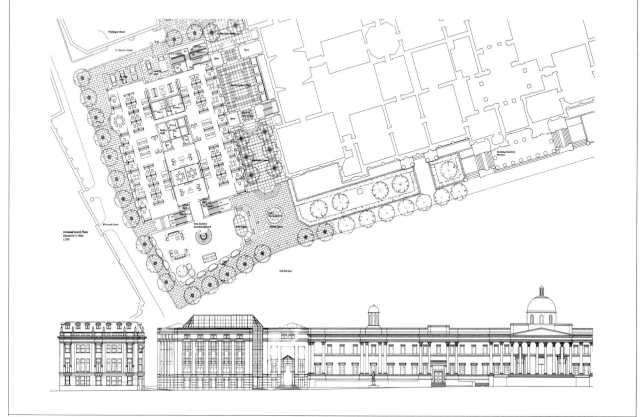

National Gallery Extension, Design Competition

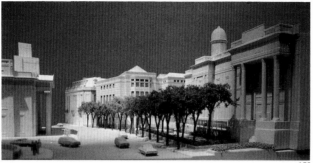

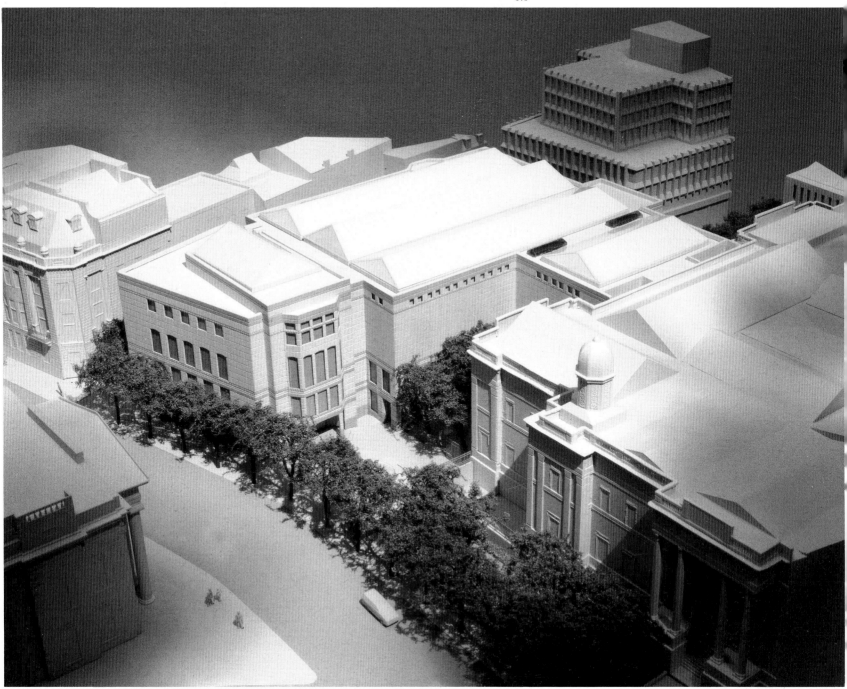

175, 176. Model, exterior 177. Model, interior gallery space

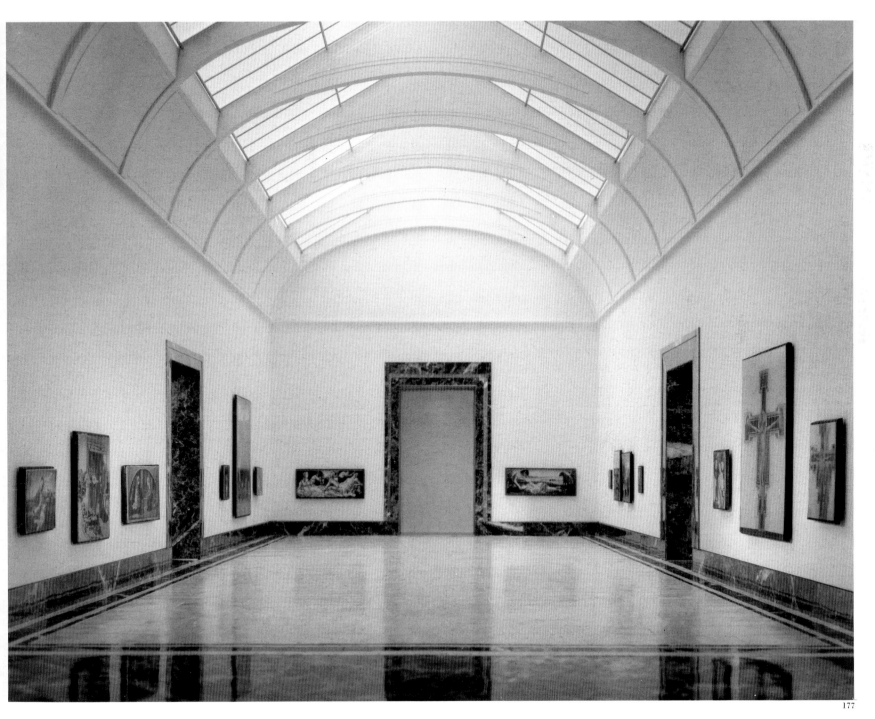

1985 Huntington Center, Office Building

City: Columbus, Ohio
Client: Gerald D. Hines Interests
Thirty-seven story office tower
Steel structure with granite cladding

Huntington Center in Columbus, Ohio, was inspired by the existing State Capitol Building on the State House Lawn, which reaches out toward the Scioto River. Our goal was to split the tower in order to make a visual gateway, while at the same time create an entry and multi-storied atrium that would turn a box-like quality of office space into poetic spaces for those who spend more than half their waking hours in such buildings.

The thirty-seven story Huntington Center office tower is situated along an axial corridor that originates with the Ohio State Capitol building to the east and terminates at the Scioto River to the west. The glass and steel multi-atrium core is recessed from the red granite-clad office tower, creating an overall effect of two towers linked by glass. A symmetrical sawtooth plan provides sixteen corner offices on each floor. The top of the tower rises two stories in a series of stepped greenhouses to create penthouse office space. A nine-story lobby affords tenants and visitors an expansive view of the surrounding city. Covered walkways at the second level connect to the existing Huntington National Bank Building to the north and to the Center's attached low-rise hotel and parking structure to the west.

Bibliography: Capitol Magazine, 11 December 1983; *Corporate Design & Realty*, September 1986.

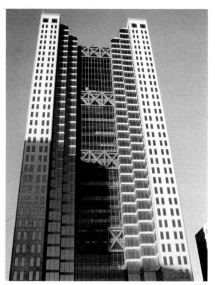

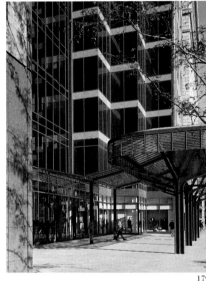

178. Construction photograph of the east facade
179. Detail of facade
180. Typical floor plan
181, 182. Exterior views

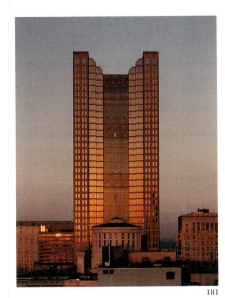

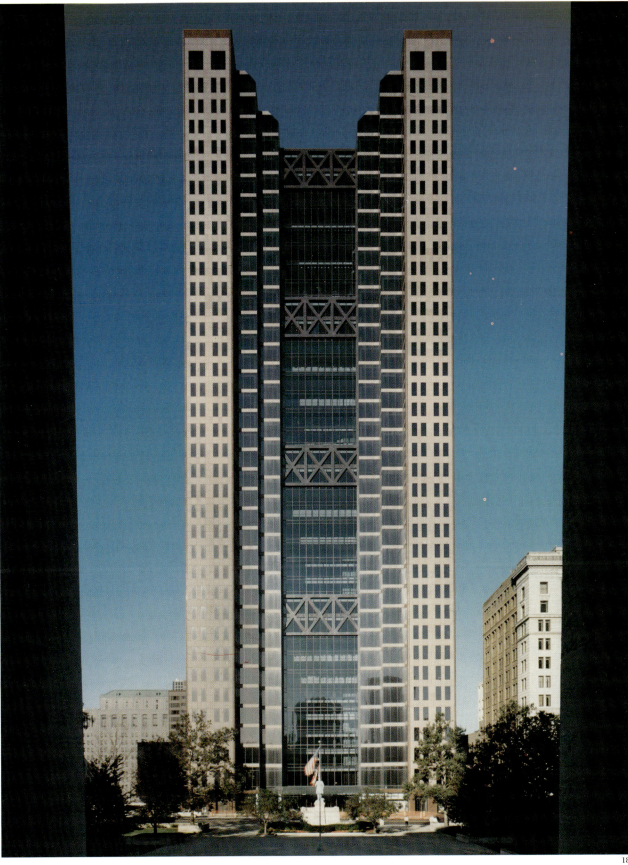

Artigas Foundation Studio

186. Model
187. Site showing pre-existing buildings
188. Detail of artist's studio

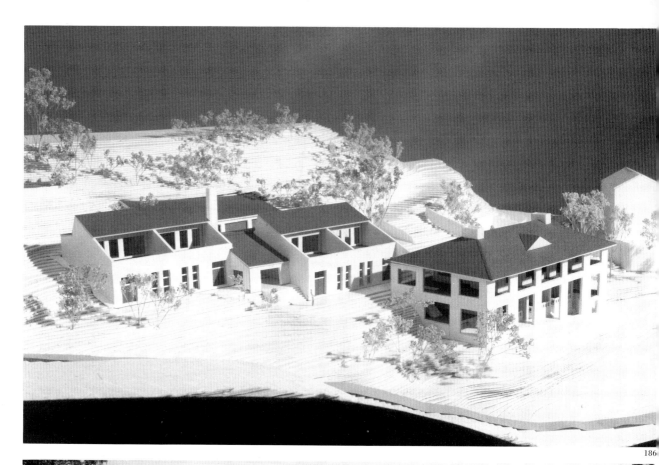

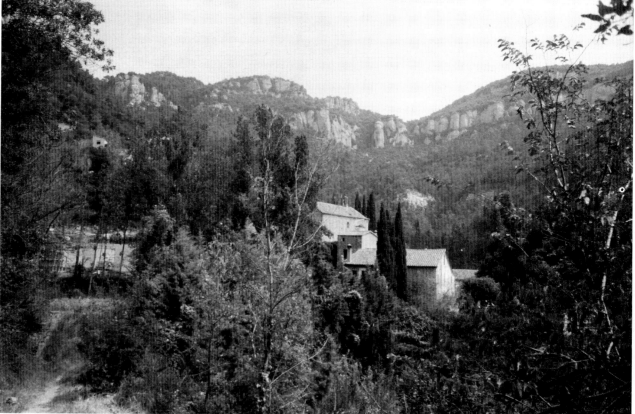

178. Construction photograph of the east facade
179. Detail of facade
180. Typical floor plan
181, 182. Exterior views

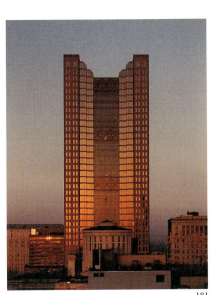

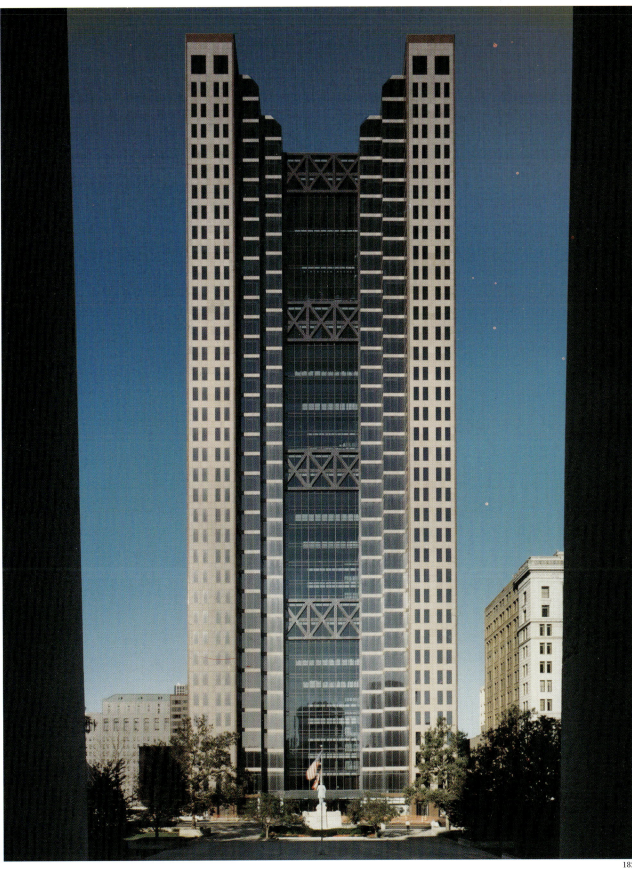

1986 Josep Llorens Artigas Foundation Studio

City: Gallifa, Spain
Client: Joan Gardy Artigas

The Artigas Foundation Studio in Gallifa, Spain is a direct interpretation of the natural materials available to builders in the surrounding mountains and also relates to an ancient chapel and mill on the site. Again, the search for technology does not necessarily mean that power should be used where it is not needed. It was indeed a labor of respect for those who worked here from Artigas to Miro to the younger Artigas.

Set into the sloped and terraced countryside of old vineyards and scattered woods north of Barcelona, the Spanish artist Joan Gardy Artigas commissioned a small complex of artist's studios dedicated to the memory of his father, the famed Catalonian ceramist Josep Llorens Artigas. Recognizing the atmosphere of excitement and insight provoked by international exchange and collaboration, the Josep Llorens Artigas Foundation Studio provides work space and living accommodations for visiting artists from around the world. The Studio includes facilities for work in ceramics, painting, printmaking, and sculpture and provides a commons area for study, conversation, and display.

Linked by a series of stone walkways and simply landscaped courtyards, the complex is composed of two-level buildings resting on separate terrace levels in a manner that complements both the Spanish village tradition and the local landscape. Masonry and concrete bearing walls articulated by wood windows support wood-framed, terra cotta tile roofs. Two structures are divided to create four two-level studios while a third houses four lower-level apartments and an upper-level commons area. The studios flank a communal Japanese stepped kiln.

The deliberately basic and restrained design is devoid of decoration, but provides an abundance of variable daylighting, natural ventilation, passive solar and fireplace heat, and outdoor spaces of varied character and function to create an environment that will encourage each visitor's artistic development. It is hoped that the compound will evolve with each artistic association, eventually becoming adorned with spontaneously placed tiles, murals, and sculptures. Adjacent to a medieval chapel and an ancient mill, the Foundation will take its place among sturdy, ageless structures whose character is shaped by the natural forces of the surrounding countryside.

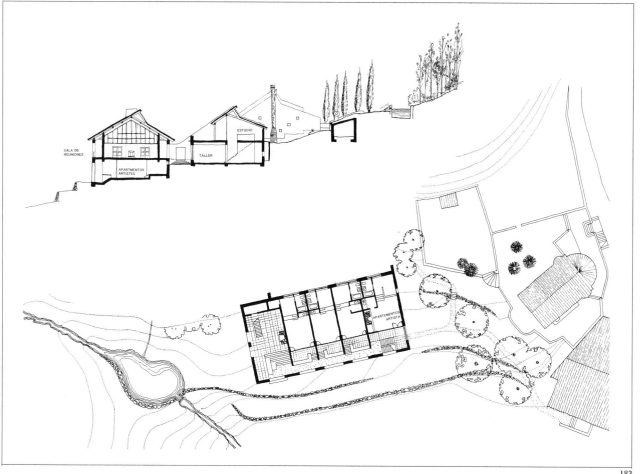

Bibliography: Chicago Architectural Journal 5, 1985.

183. *East-west section and lower level plan*
184. *Upper level*
185. *Site plan*

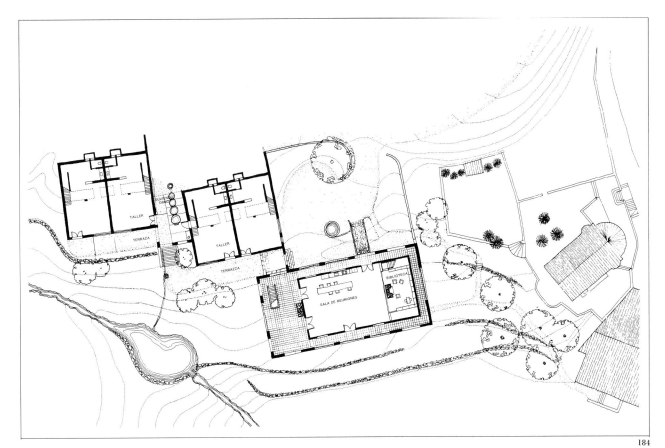

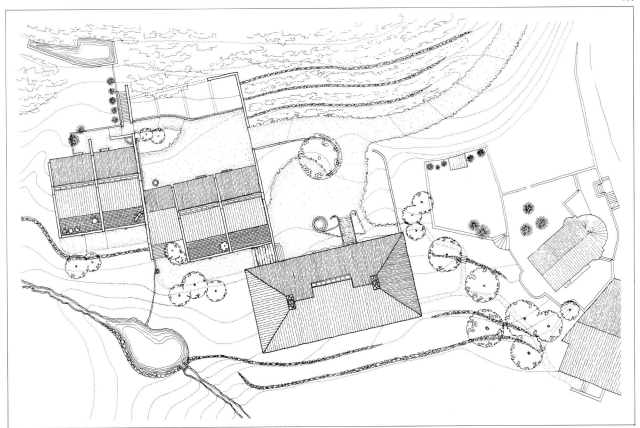

Artigas Foundation Studio

186. Model
187. Site showing pre-existing buildings
188. Detail of artist's studio

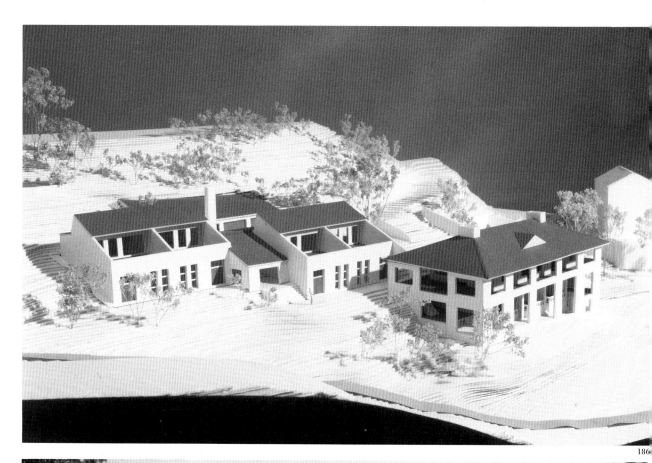

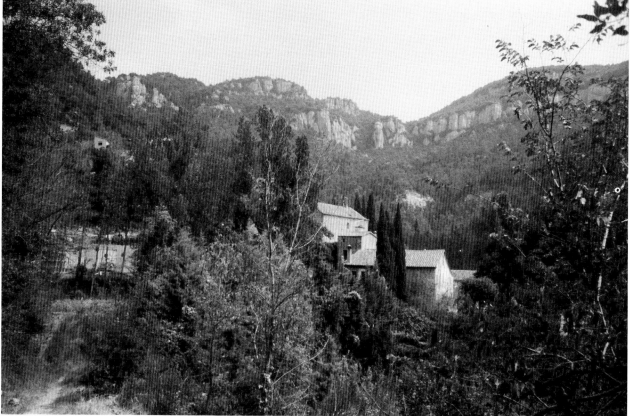

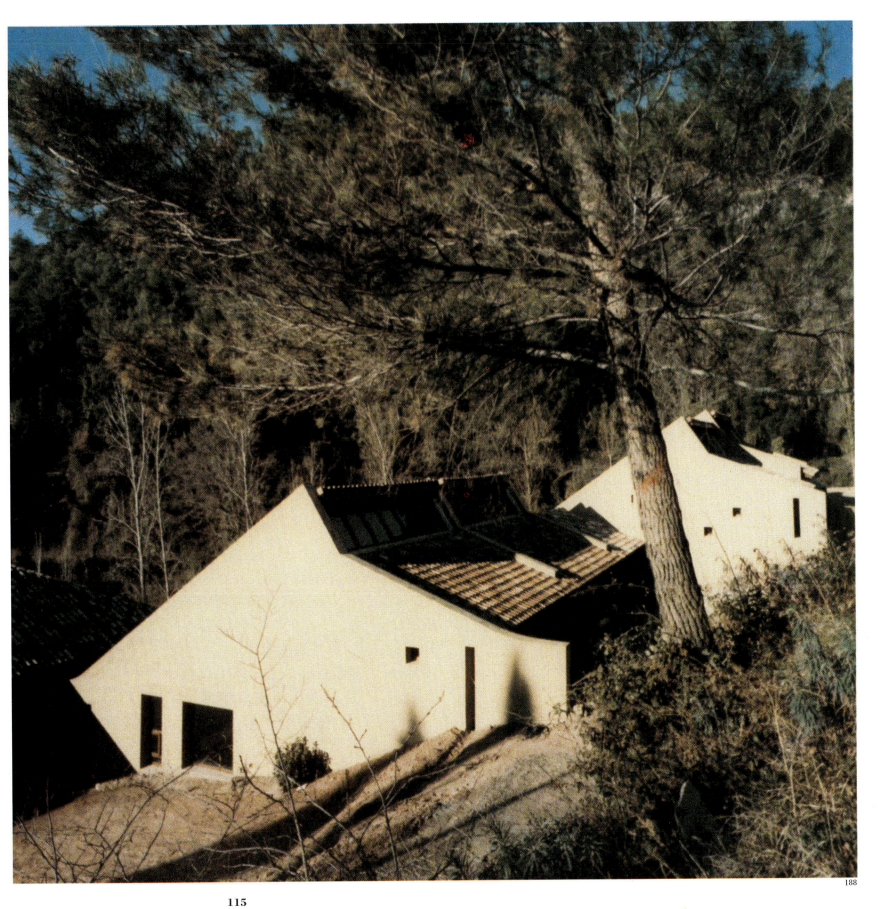

1986

The Terraces at Perimeter Center

City: Atlanta, Georgia
Client: Taylor and Mathis

Two two-phased twin atrium office buildings with terraced, landscaped parking garages
Structural concrete frame, paint coated; clear glass recessed window wall; suspended sunshading. Atria: natural wood windows and railings; glazed ceramic tile fountains and floors

The Terraces at Perimeter Center were an extension of the ideas found in the BMA building in Kansas City. Evocative of a huge Sol LeWitt sculpture, Perimeter Center is gently articulated within a large frame, a frame that captures space not only horizontally, but vertically. The structure is simple and is eroded where it is not required, thereby giving a sense of suspension when you are in fact suspended, and a sense of gravity when you are in fact on the ground. The integration now of more sophisticated environmental-engineering knowledge allowed for the elimination of tinted glass in a climate where that had become a tradition. Instead, we employed clear vision glass protected from direct sunlight by aluminum sun shades so that we were able to keep the views of that marvelous landscape and of the explosions of flowers that make up an endless Georgian tradition.

The Terraces at Perimeter Center are part of an office park development located on five hundred acres of gently rolling countryside north of Atlanta, Georgia. The two-phase project, consisting of twin atrium office buildings and two parking structures, has been carefully sited to complement the surrounding forest and to provide tenants with panoramic views. The wooded landscape of the site has been further enhanced by a series of ponds fed by an existing creek and spanned by a cable-supported pedestrian bridge.

Each ten-story building features two office wings connected at each level by bridges that span the central atria. Visitors enter the

189. Exterior view showing stepped-back frame
190. Elevation and section of parking garage; site plan

buildings from square terraces paved in geometric patterns of red clay brick and gray granite. Copper-roofed wooden canopies provide shelter over the terraces from inclement weather. Deep exterior fountain ponds are continued inside each atrium where they are transformed into shallow pools formed of handmade, glazed ceramic tiles by the Barcelona ceramist Joan Gardy Artigas. These same colorful tiles have been combined with industrial quarry tiles to form rich and exuberant paving patterns in the atria and elevator lobbies. Each office building is composed of a poured-in-place concrete frame finished with a white architectural coating. The upper portion of the frame is stepped-back, creating a series of terraces from the seventh to the tenth floors. The buildings are glazed with clear-vision and insulated spandrel glass that is recessed from the facade and protected from the strong Georgian sunlight by aluminum solar fins. This articulation of the buildings' surfaces maximizes both energy efficiency and views of the surrounding landscape.

Bibliography: Architectural Record, July 1988; Architecture & Technology, no. 9, 1988; The Atlantic Journal, 29 October 1984; The Chicago Architectural Journal, 1983; Inland Architect, November/December 1988.

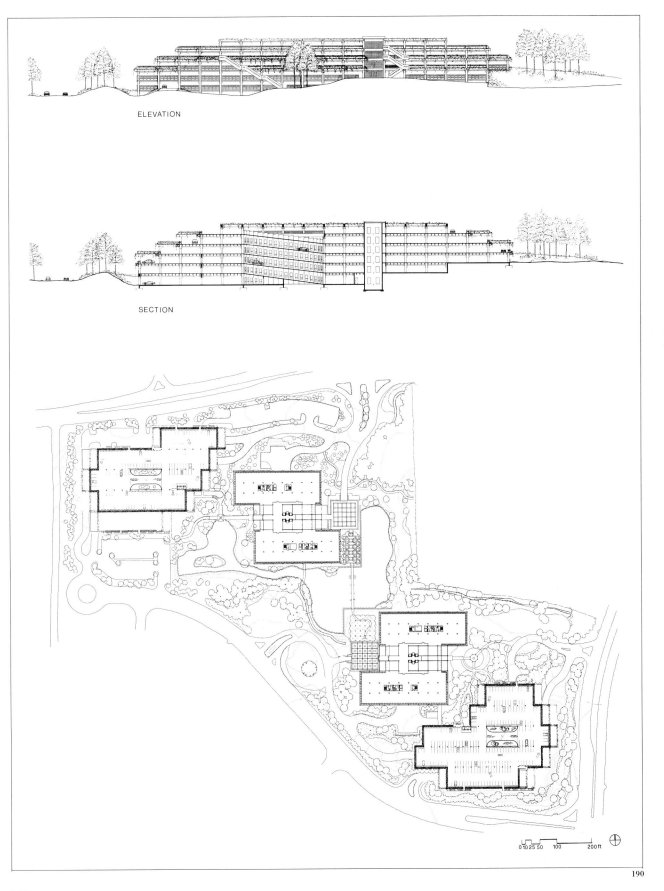

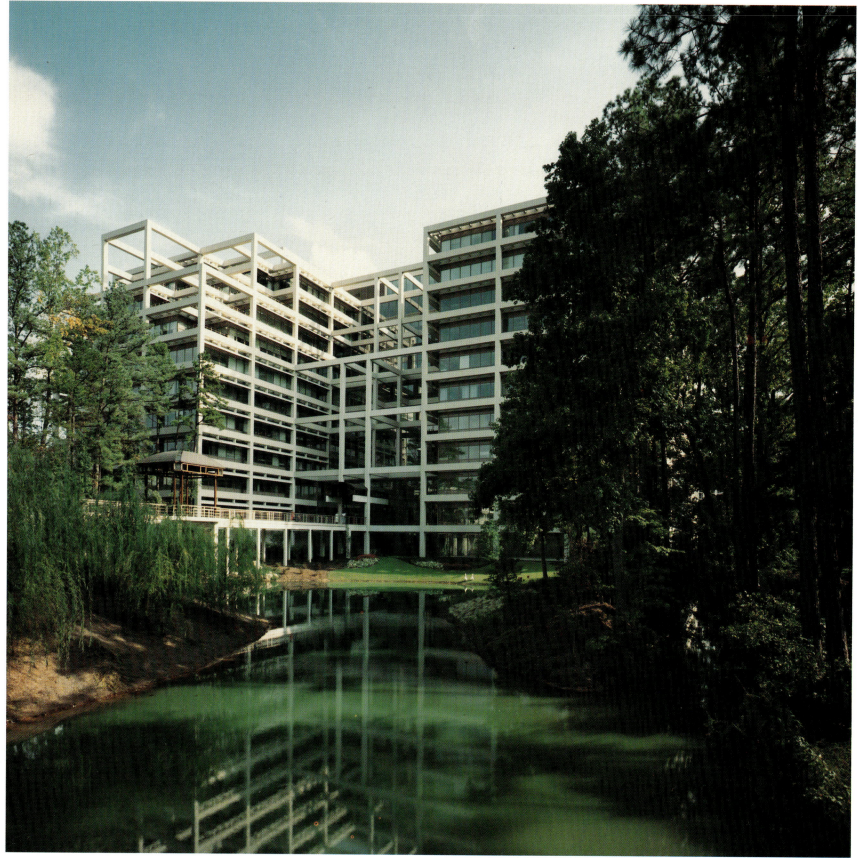

The Terraces at Perimeter Center

191, 192. Exterior views of the buildings in landscape setting
193. Peristyle and parking garage
194. Exterior of north and south buildings with connecting bridge

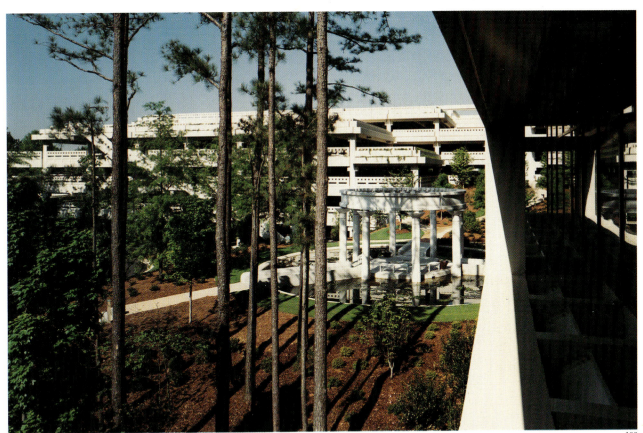

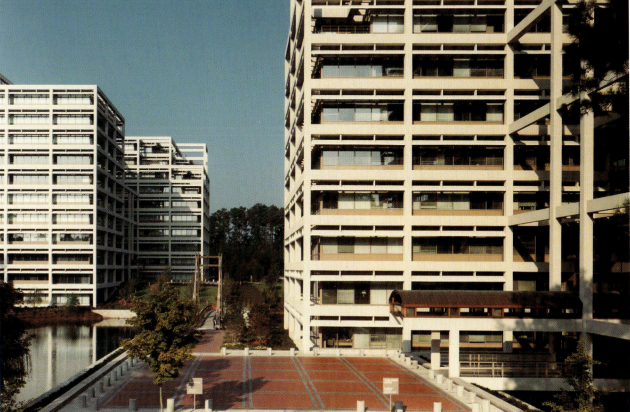

The Terraces at Perimeter Center

195. Peristyle seen from office building
196. View through exposed structure of building to path and gazebo
197. Elevator lobby with ceramic tiles by Artigas
198. Exposed structure of exterior

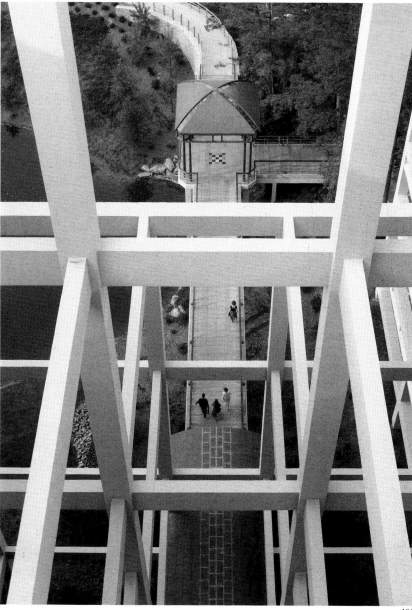

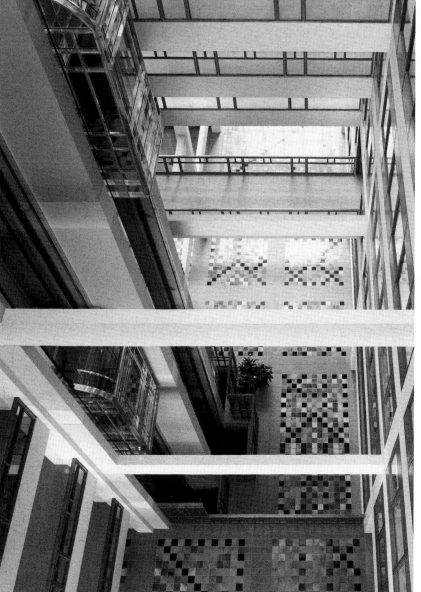

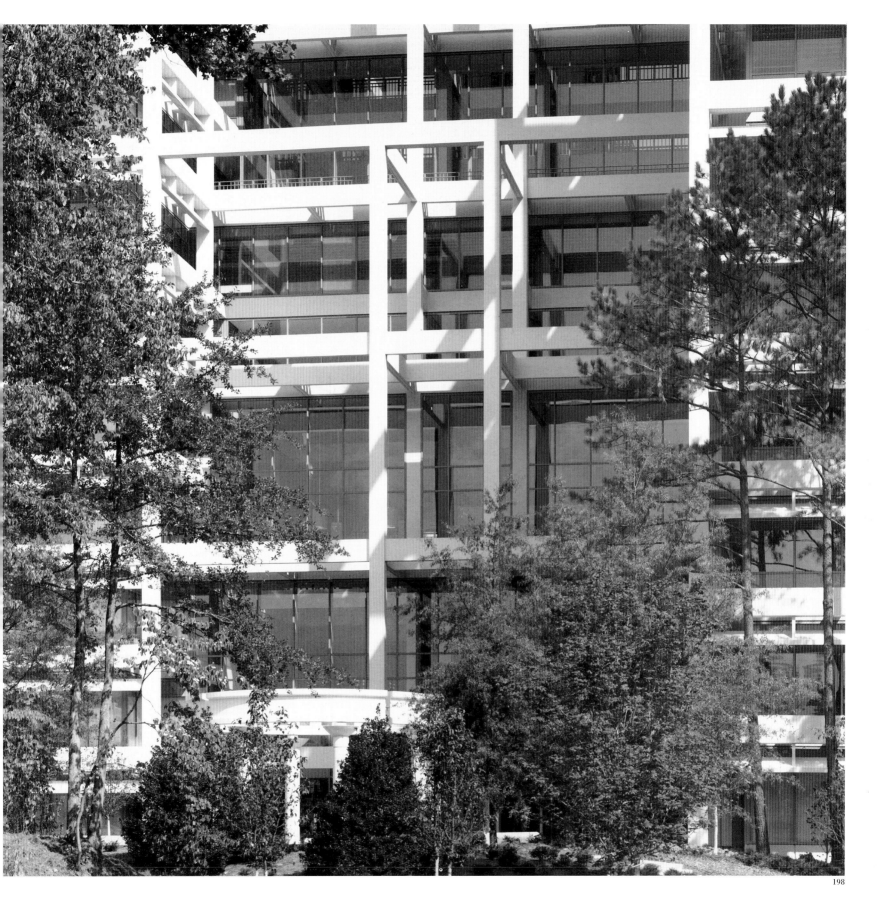

The Terraces at Perimeter Center 199. Lobby 200. View from lobby to gazebo at night 201. Pedestrian suspension bridge

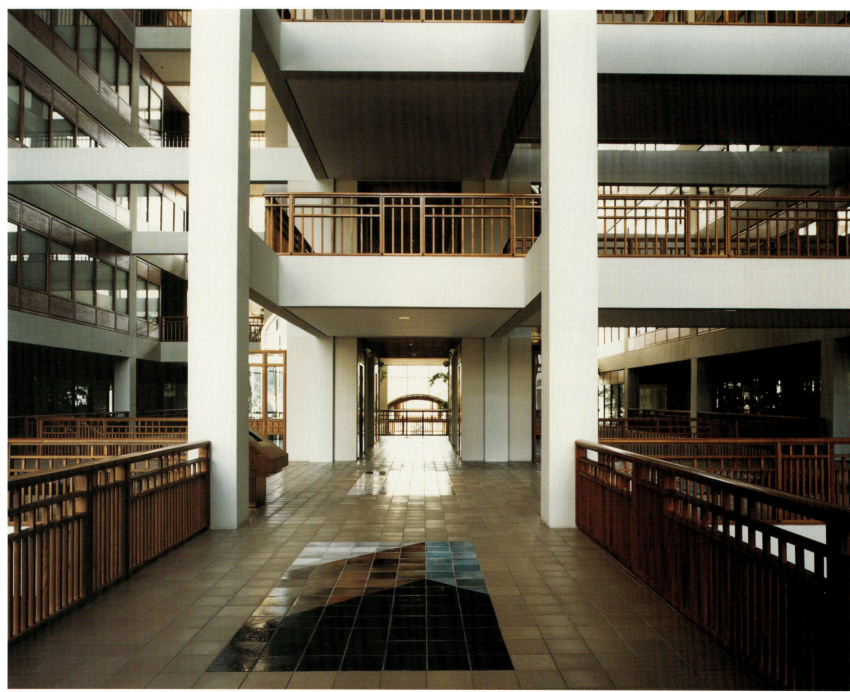

200

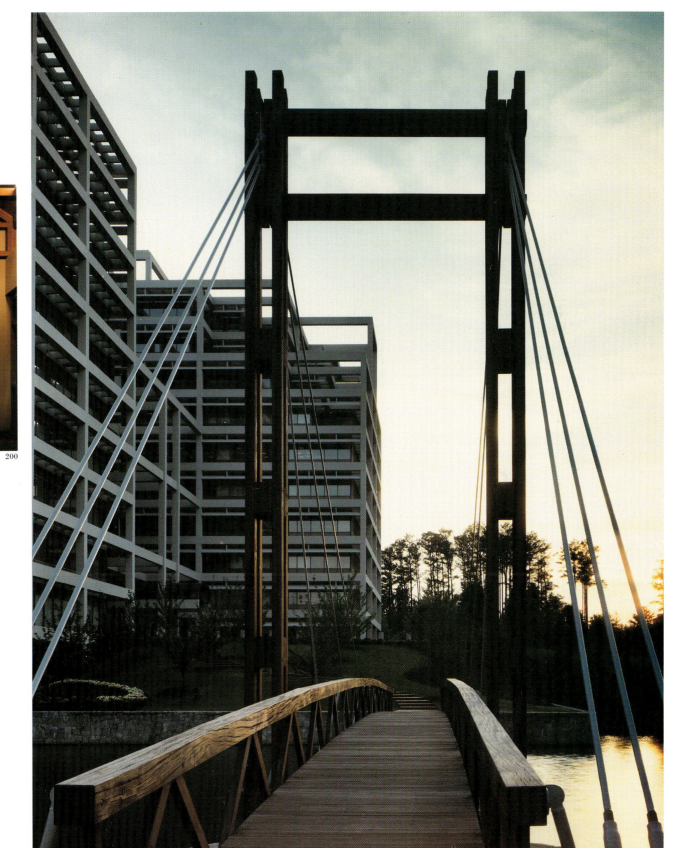

201

123

1986 One Financial Place

City: Chicago, Illinois
Clients: One Financial Place Partnership, Chicago Exchange Building Corporation
Three linked office buildings: Chicago Board Options Exchange (seven stories); One Financial Place (thirty-nine stories); Midwest Stock Exchange (six stories); connected by a glass bridge to the Chicago Board of Trade Complex

One Financial Place is a series of buildings not designed as one, but rather as a sequence of buildings envisioned, prior to commission, as an important piece of the city of Chicago. It is intended to celebrate the primary gate into the city, if not in the way Daniel Burnham conceived, certainly in a way sympathetic to the idea. One Financial Place operates within the realization that buildings are but pieces of cities. The need for architects to collaborate in a common vision and common purpose is more apparent in America than in the already established cities of Europe.

One Financial Place is the central building of a complex comprising the seven-story Chicago Board Options Exchange (CBOE) and the six-story Midwest Stock Exchange. The three-building complex is linked physically and electronically with the Chicago Board of Trade. The thirty-nine story tower provides office space specially designed for the financial community and adjoining exchanges, a health club, restaurants, and a one-story commercial building. The exterior walls of the structural steel building consist of a high performance curtain wall with Imperial Red granite cladding and bronze-tinted vision glass.

A block-long landscaped plaza, including a fountain and sculpture,

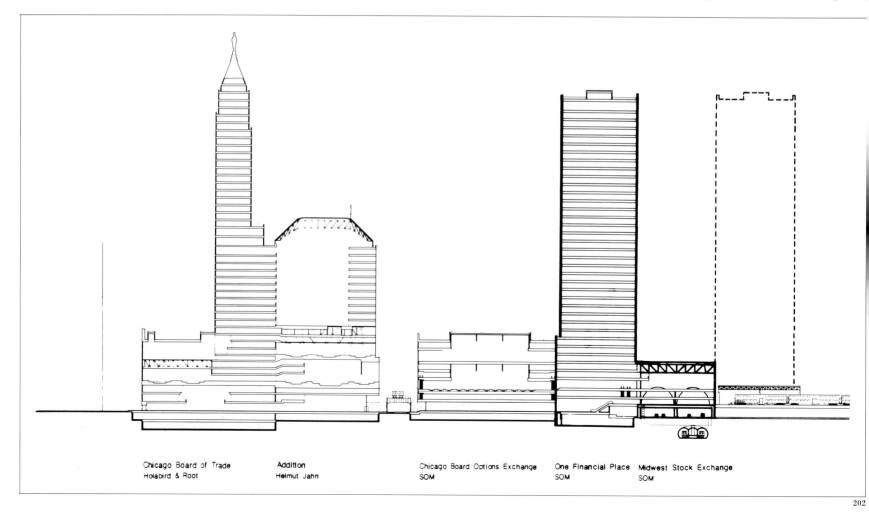

202. Section of whole complex
203. Exterior view of Chicago Board Options Exchange, One Financial Place and the Midwest Stock Exchange

establishes the complex as a gateway to Chicago's south financial district. The granite-clad and paved plaza not only provides two entrances to the complex and underground parking, but also complements the Imperial Red granite used on each of the three structures.

Two covered exterior arcades and a ground level interior concourse link the three buildings, while the complex also provides connections to the subway, elevated and commuter lines. A bridge connects the entire complex to the Chicago Board of Trade, thereby creating the largest contiguous trading floor area in the United States, as well as providing exchange members with controlled interior circulation. The bridge itself is a steel truss structure fabricated as two units at the factory and assembled on-site. While the CBOE building was designed to accommodate the bridge without additional structural support, a large pier was necessary to support the bridge where it attaches to the Board of Trade addition.

Bibliography: *Chicago Sun-Times*, 28 April 1983; 18 July 1983; 20 December 1984; *Chicago Tribune*, 9 July 1982; 4 September 1984; 9 October 1984; 21 October 1984; 19 January 1986; 30 August 1987; *The Christian Science Monitor*, 19 April 1984.

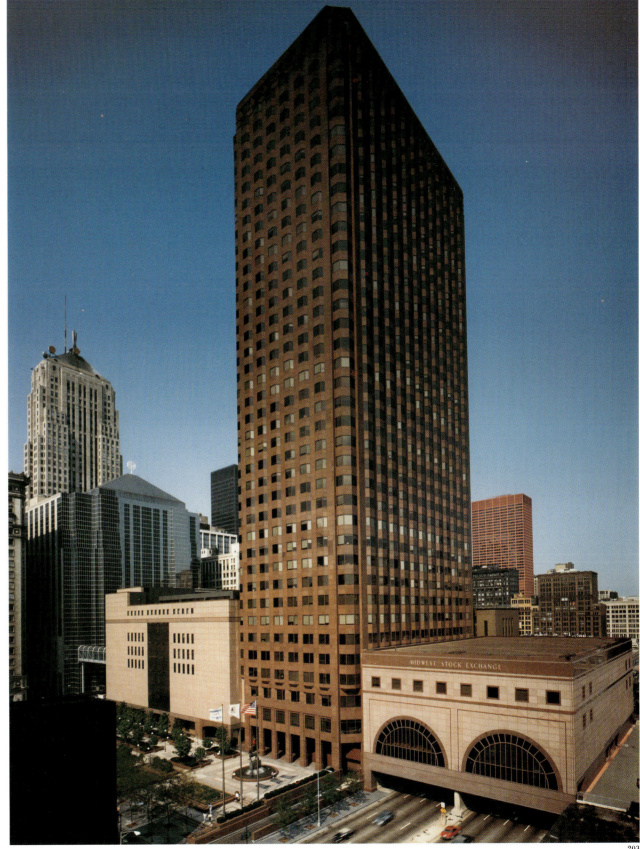

125

One Financial Place

204-206. Plaza and landscaping along west side of the complex
207. Glazed pedestrian bridge over Van Buren Street between the Board of Trade addition and the Chicago Board Options Exchange

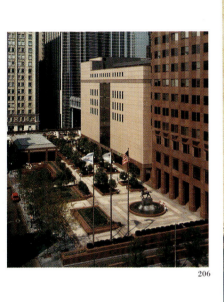

206

207

One Financial Place

208

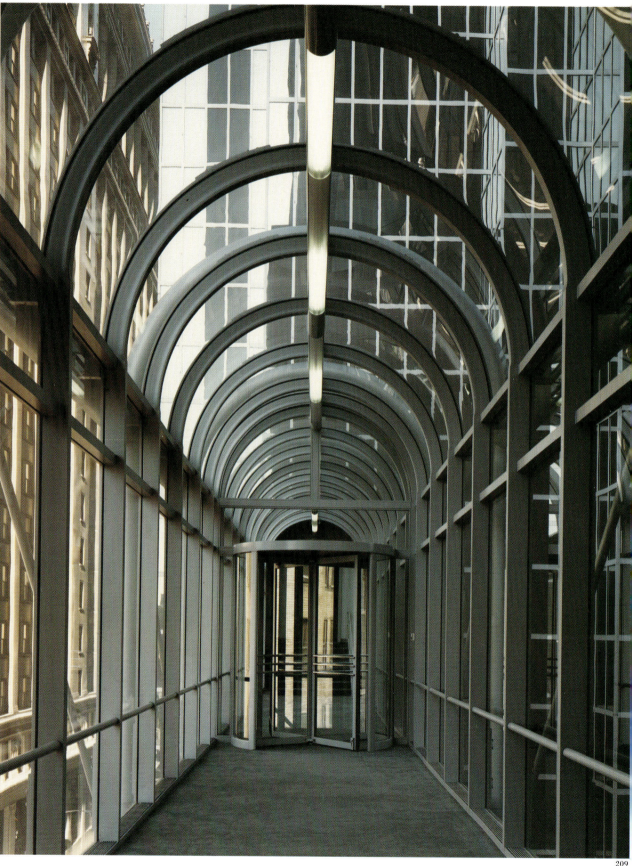

209

208, 209. *Exterior and interior view of glazed pedestrian bridge over Van Buren Street between the Chicago Board of Trade addition and the Chicago Board Options Exchange*

210. *Lobby of One Financial Place*

1986 McCormick Place Exposition Center, Expansion Facility

City: Chicago, Illinois
Client: Metropolitan Fair and Exposition Authority

Twelve pylons on a 120 × 240 foot grid support the 480 × 780 foot cable suspended roof

The McCormick Place Exposition Center, Expansion Facility, is counterpart to the McCormick Place building by C.F. Murphy on Chicago's lakefront. The site is encumbered by active railroad tracks which prohibit casual placing of structural elements. In order to provide a long-span roof system, the simplest solution was to support the large roof by suspended cables which, in turn, are supported by concrete pylons. On the interior, these pylons not only provide support for the roof truss system, but are also equipped with air circulation systems.

For the expression of such a pavilion, and for the selection and design of the exterior walls, we were certainly aware of Mies van der Rohe, but we were much more aware of the existing gigantic facility in black, so white became a natural color for what is, comparatively, a much lighter structure. Light gains entry into the building through roof skylights and through a perimeter band of glazing directly below the roof truss, lending the interior a museum-like quality, so that glare does not disturb the visitors.

The expansion of the McCormick Place Exposition Center Expansion Facility along Chicago's lakefront was prompted by both an increasing demand for space sufficient in size to service large trade shows and the desirability of a convention/exhibition space capable of accommodating two major shows simultaneously. Enclosed pedestrian bridges connect the building to the adjacent exhibition facilities. In addition to the exhibition space consisting of upper level and lower level exhibit halls, the expansion facility provides meeting rooms, food service, enclosed crate storage and other ancillary services. The structural-steel, low-rise building utilizes a cable-supported roof system that allows long, clear spans and solves difficult site constraints related to the existing railroad which traverses the site. A

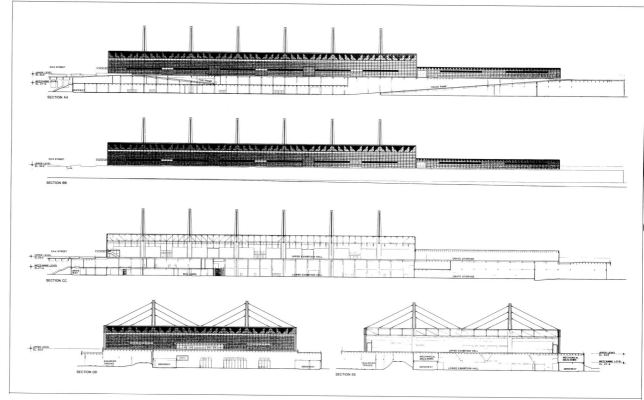

211. Elevations and sections
212. Plans of mezzanine, upper and lower levels

600 × 1,350 foot elevated podium spans the operating railroad lines while the building rises from that podium in two distinct parts: a fifty-five foot high main exhibition hall and a twenty-two foot high crate storage area. The 480 × 780 foot long-span roof over the main exhibition hall is suspended from cables supported by twelve concrete pylons projecting sixty feet above the roof level. Slender tie-downs at the exterior ends of the cable system restrain structural movement. The facade is clad with silver-gray aluminum panels framed by polished stainless steel mullions.

The 375,000 square foot upper level exhibition hall is based on the 120 × 240 foot grid of the twelve pylons. The lower level hall has a structural grid of 30 × 60 foot spans and measures approximately 150,000 square feet.

Bibliography: *Architecture*, March 1988; *Building Design & Construction*, January 1985; *Chicago Architectural Journal*, 1981; *Chicago Sun-Times*, 5 September 1984; 10 March 1985; *Chicago Tribune*, 18 November 1982; 8 March 1987; *Dodge Construction News*, 25 March 1985; *Inland Architect*, January-February 1985; *Progressive Architecture*, February 1989.

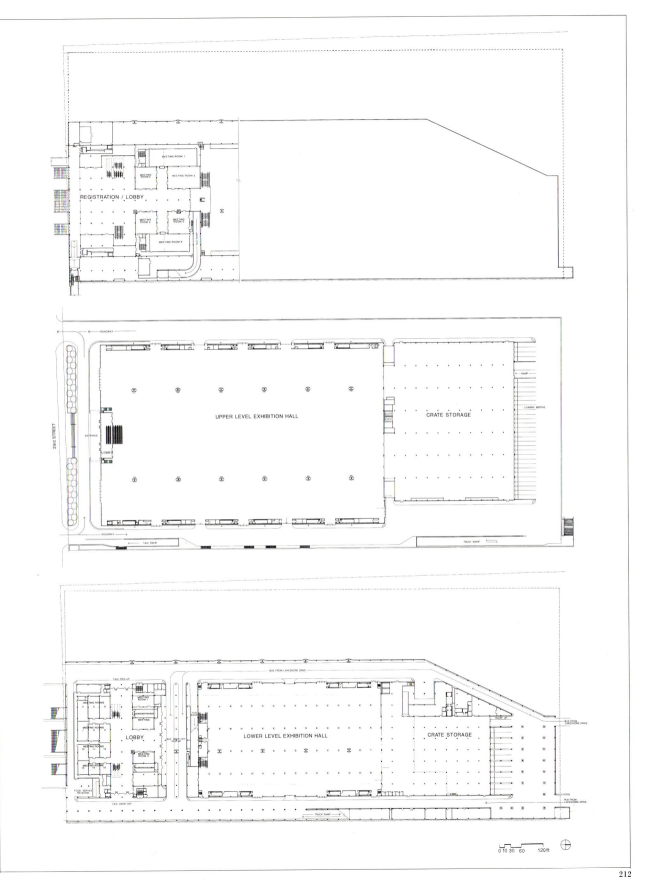

McCormick Place Exposition Center, Expansion Facility

213. View from Lake Michigan
214. View from southeast
215. Entrance
216. Cable support system for roof

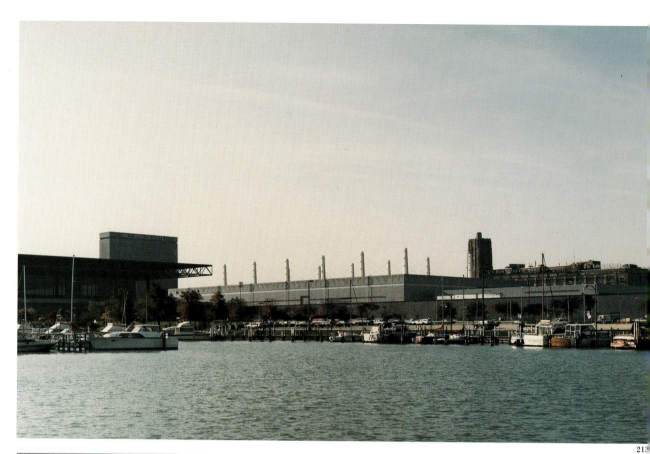

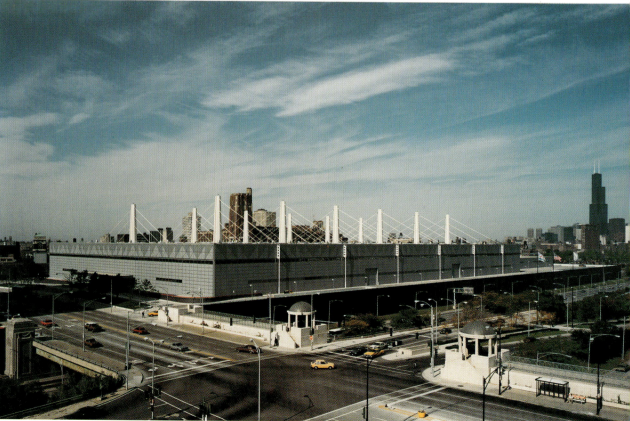

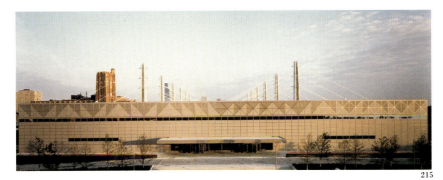

215

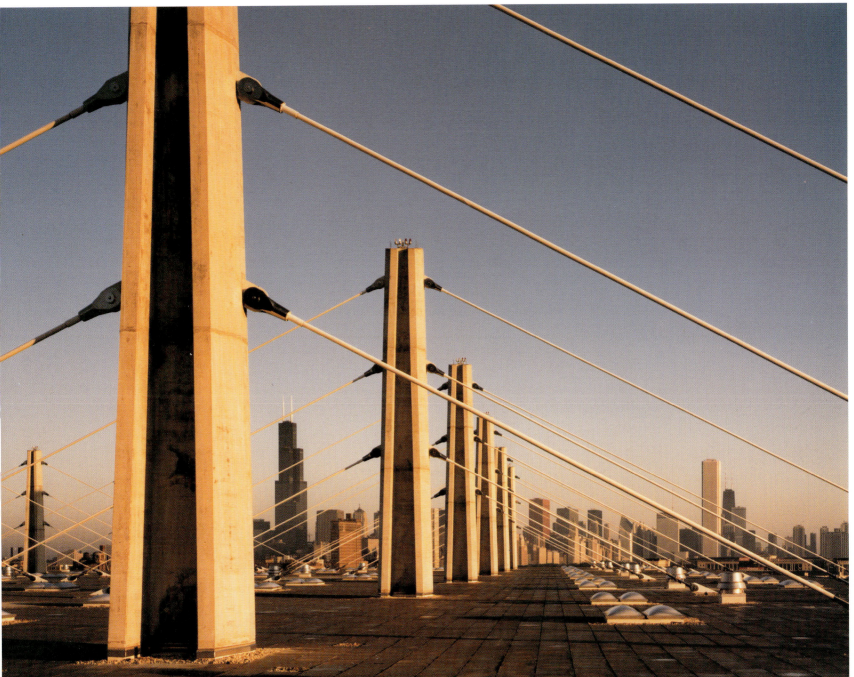

216

McCormick Place Exposition Center, Expansion Facility

217

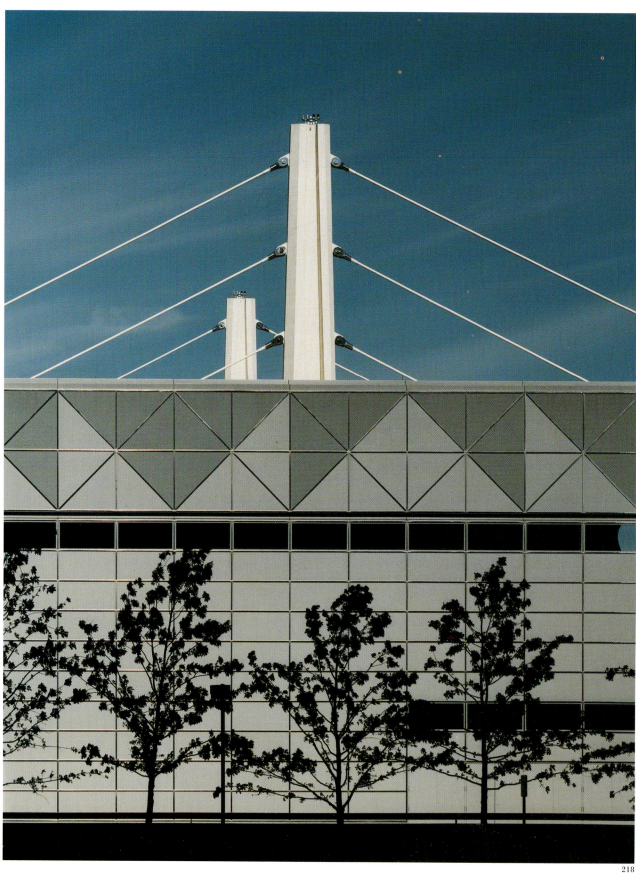

218

217. Tiedowns for roof cables
218, 219. Exterior views
220. Entrance

219

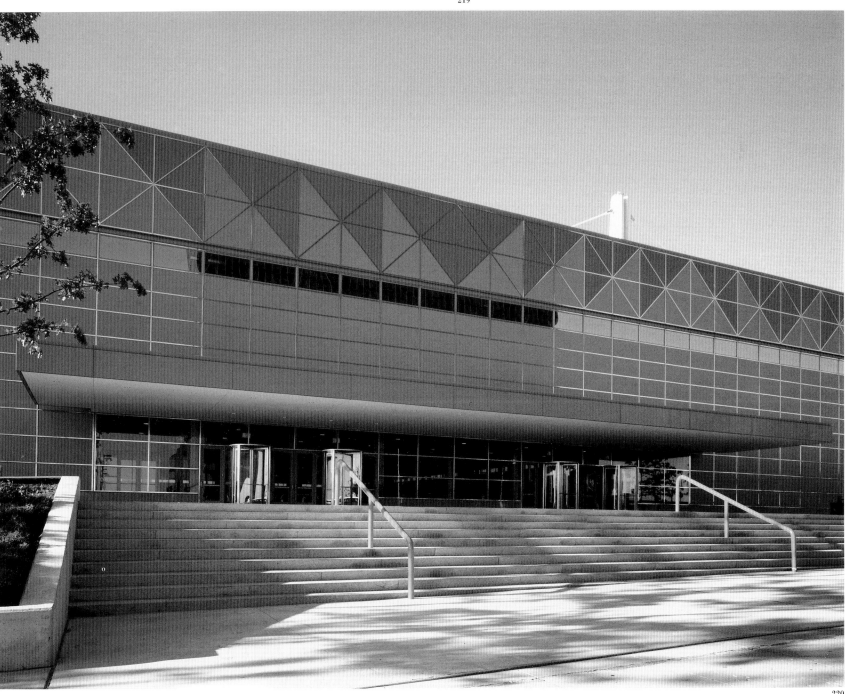

220

McCormick Place Exposition Center, Expansion Facility

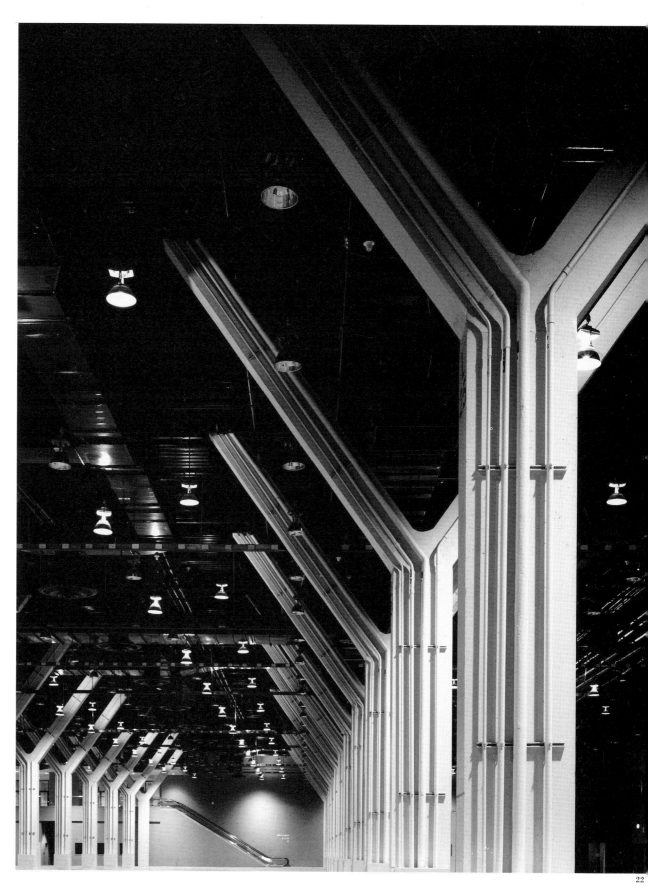

221. Interior of lower level exhibit hall showing Y columns which carry utility cables

222. Upper level exhibit hall

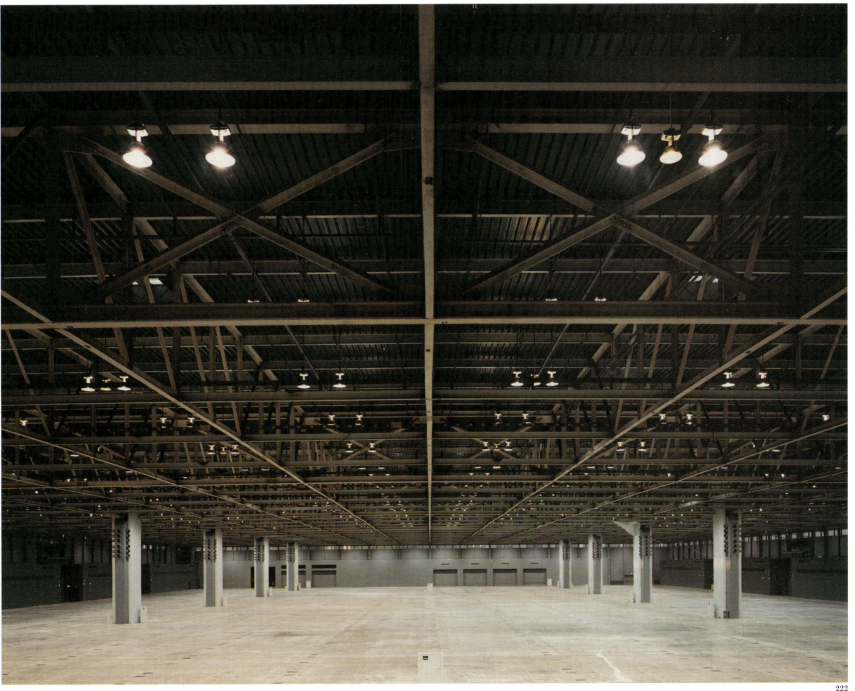

1988 Canary Wharf, Master Plan

City: London, England
Client: Olympia and York/Canary Wharf Development Corporation

Three major plans underway in London have convinced me even more that collaboration between architects is possible, and that ego in either architecture or planning does not serve our cities well. So with architect Henry Cobb and landscape architect Laurie Olin at Canary Wharf, we searched diligently for rules with which to play this collaboration game. Now others, such as Cesar Pelli, Kohn Pederson Fox, and SOM's Adrian Smith, have entered into the design of individual buildings and have become aware of the need to collaborate not only with one another, but also with Nash, Soane, Wren, and Hawksmoor. There are reasons, both physical and psychological, for the shape and form of existing buildings: social structures have changed, the psyche and mentality of modern man is different, and certainly the technology with which we make buildings has changed. But, these changes can and should be subtle and sensitive to the overall composition of a great city.

Canary Wharf is on the Isle of Dogs in the Borough of Tower Hamlets, two miles east of the City of London. Formerly part of the Port of London, the site is under the aegis of the London Docklands Development Corporation, an agency established by the government to promote the regeneration of a vacated eight square mile area. Linked to the city by road, rail, and river, the proposed Canary Wharf development revitalizes seventy-one acres of the former West India Docks by providing ten million square feet of office space and financial trading floors, necessary to accommodate the expansion of London's crowded financial center, as well as its public recreational and retail facilities.

Throughout the design phase the original existing features of the site—the linear quay, the access roads and bridges, and the riverside—have remained of primary importance. The quay, built between 1800 and 1806 and once defined by the warehouses and an intricate system of locks vital to the West India Company, will be transformed into a sequence of landscaped spaces. State of the art financial headquarters and commercial office buildings will be situated around the quay's outermost edges.

Placed beneath the quay will be a multi-level platform extending the full length of the wharf. The platform, acting as a service spine, will accommodate the utility distribution system, service roads, and car parks. Creation of this platform subtly elevates the public areas, and forms, in effect, a viewpoint from which to observe the River Thames.

The master plan includes three carefully located office towers. These landmark buildings, visible from the City, will enrich the London skyline and identify Canary Wharf from a distance. The remaining buildings will be of limited height, designed to frame and animate the sequence of landscaped areas that constitute the wharf's public realm. The full development of the site and the provision of open

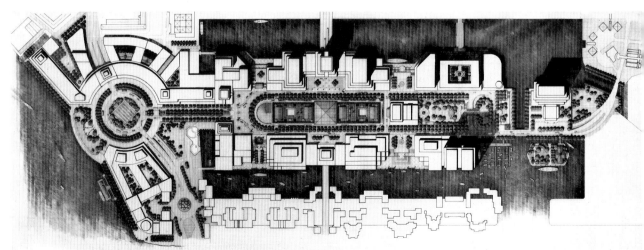

space calls for buildings to be constructed over the water at points to the north and south of the wharf. Thus, the impounded water will no longer form a long linear passage, but a series of water courts ringed by pedestrian areas and linked by pedestrian promenades.

After a thorough study of London squares, parks, streets, and buildings, architectural guidelines were developed to ensure that each individual parcel would contribute to the image of the project as a whole. These guidelines include consistent use of cornice lines, stone bases, setbacks, street furniture, and other site elements both within and without the individual parcels. These elements, along with easements and riverside walkways, are intended to provide a continuous and varied pedestrian network.

Bibliography: Architect's Journal, 12 June 1985; *Architectural Review*, January 1986; *Architecture*, September 1988; January 1989; *Architecture & Technology*, no. 9, 1988; *Art and Design*, December 1985; *Building*, 27 September 1985; 25 October 1985; 13 December 1985; 24 January 1986; 25 September 1987; *Building Design*, 13 September 1985; 4 October 1985; 22 November 1985; 29 November 1985; 4 July 1986; 25 September 1987; *Euromoney*, October 1985; *London Daily Telegraph*, 25 May 1988; *New York Times*, 7 January 1986; 18 July 1987; *Progressive Architecture*, January 1989; *The Sunday Times*, 10 April 1988; *Time*, 18 April 1988; *Wall Street Journal*, 13 July 1987; 26 July 1988.

223. Original master plan

224. Rendering, aerial view of original master plan seen across the River Thames from Greenwich

225. Section to show infrastructure

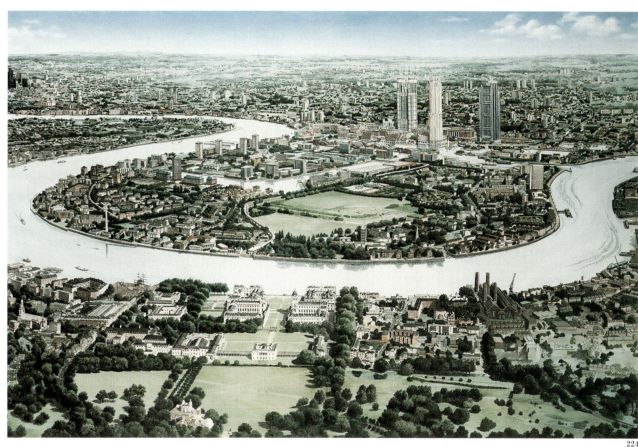

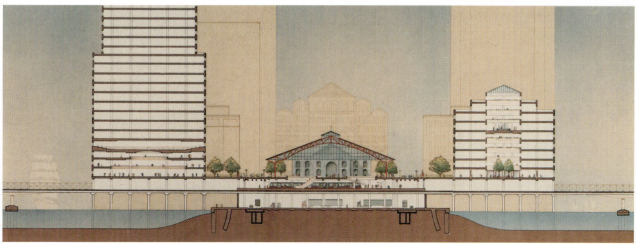

Canary Wharf, Master Plan

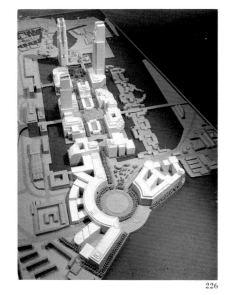

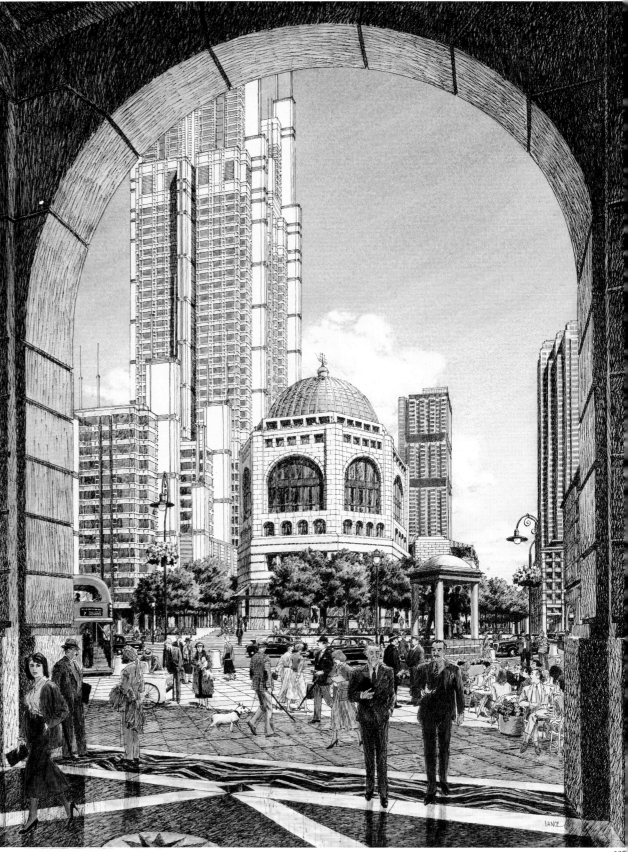

140

226. *Aerial view of model*
227, 229. *Renderings of Founder's Court*
228. *Rendering of Waterside Park*
230. *Canary Wharf Station*

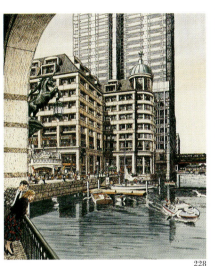
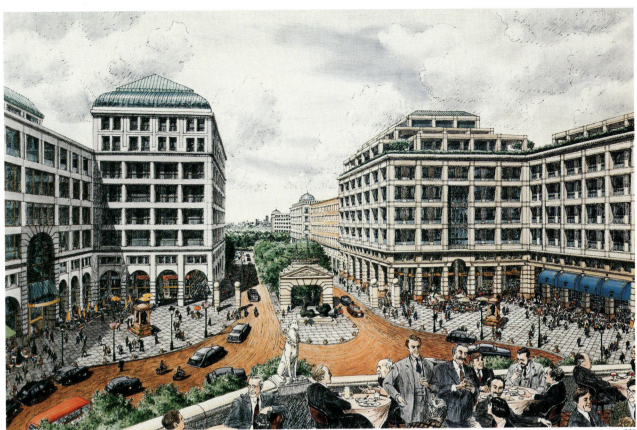
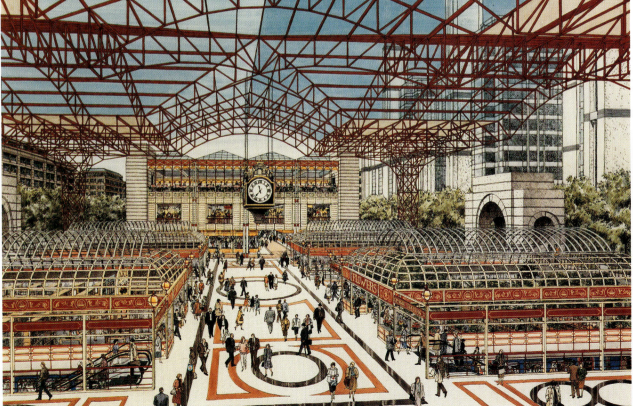

1988-1992

**Bishopsgate Project, Broadgate
Phases Five through Fourteen,
Multi-Use Complex**

City: London, England
Client: Rosehaugh Stanhope Developments PLC

So it was with Bishopsgate that the client, Rosehaugh Stanhope Developments, and authorities of London were not only responsive, but helpful in searching for the solutions to goals while also maintaining the rules of structure and of spatial definition. We were able, then, to manipulate those rules so as to continue the very useful definition of cities within cities that makes up the grand city of London. Where problem areas once existed, we created spatial relationships that established urban opportunities.

The Broadgate development is located in the northeastern portion of the city of London. Essentially an air-rights development, nearly all of its approximately twelve acres span the existing British Rail platforms and the railway tracks of Liverpool Street Station. The multi-use development expands the financial district of London by supplying new office space and trading floors and also enhances the surrounding transportation center and urban district with new retail space and parking facilities.

Phases six, seven, and eight form the three-building ensemble fronting the Bishopsgate thoroughfare. This complex establishes an identity both for the individual buildings and for the entire development. The three-building composition consists of an eight-story structure with three five-story towers linked by two two-story conservatories. The building entrances occur on axis with each of the three towers. The whole ensemble is tied together at the bottom by a two-story light colored stone clad base which encloses a pedestrian arcade. Above this, a highly articulated facade is

231

231-233. Conceptual drawings for Phases 6, 7, 8.

composed of polished granite and glass panels. A metal window wall system is employed to express and reinforce the structural integrity of a panelized wall system, recalling the texture and detail of traditional stone and cast-iron building. The entire facade is unified by elegantly detailed cornices at the second, fourth, eighth and twelfth floors. While the design of the Bishopsgate exterior is meant to recall the architectural order of grand compositions found throughout London, the interior speaks to its modern program through the use of elegant materials and functional design. Pedestrians using the main entrance from the east side of Bishopsgate are greeted by an arcade of select shops before entering the building lobbies. At the south end of the complex, commuters from Liverpool Street Station conveniently have access to the buildings through a pedestrian walkway running along the west side of the building complex. Levels one through three are trading floors while office space occupies floors four through twelve. Diffused light is admitted to the interior of the office space by skylit atria extending from floors four through nine. The design strategy for the Phase eleven building was to span the British Rail train tracks in the manner of a bridge. After studying a number of appropriate structural options, a parabolic arch was determined to be the most efficient solution. This singular structural concept was then expanded to create a functional and elegant architectural solution for the project, recalling the tradition of steel and glass structures built in Britain at the turn of the century.

The four parallel arches which support Phase eleven, along with the disposition of the various service elements, provide the architectonic strength of the project. The structure allows for large, column-free office and trading floor areas, with fire stairs, firemen's elevators, modular toilet room units, and plant rooms located in twin service towers which are clearly expressed as ancillary structures. The lobby and elevator shafts are hung from the building structure which allows for the movement differential between the lobby and the plaza. The lobby is enclosed with clear glass so as to appear nonstructural, and the elevator enclosures and cabs are also glazed to enhance the transparency of the lobby. The structural expression is carried inside to the office floors by the twin atria, which are set between the inner arches, flanking the elevators and mechanical core. The atria are staggered in section, in recognition of the vault of the arches. Vision glass is fire-rated, allowing the exterior steel structure to be exposed, further enhancing the purity and clarity of the tectonic expression.

Bibliography: Architects' Journal, February 1988; December 1988; *Architecture*, February 1989; *Architecture & Technology*, no. 9, 1988; *Building Design*, 4 March 1988; *Chicago Architectural Journal*, vol. 6, 1987; *London Daily Telegraph*, 25 May 1988; *Progressive Architecture*, January 1989; *Wall Street Journal*, 26 July 1988.

The Chicago Tapes, introduction by Stanley Tigerman, Rizzoli, New York 1987.

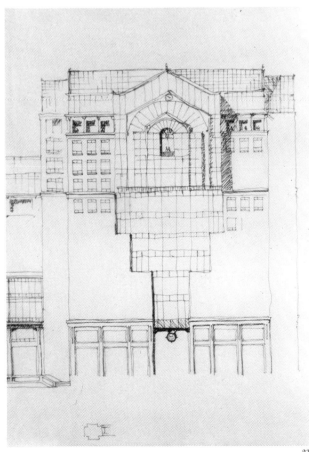

232

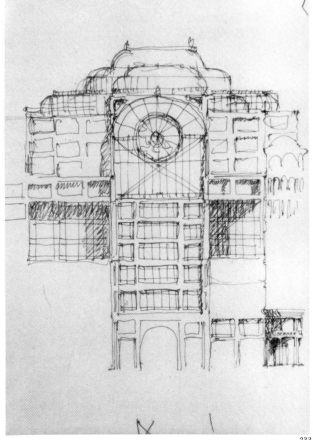

233

Bishopsgate Project, Broadgate *234. Master plan. Phases 1-4 are by Peter Fogo of Arup Associates* *235. Overall view of the model*

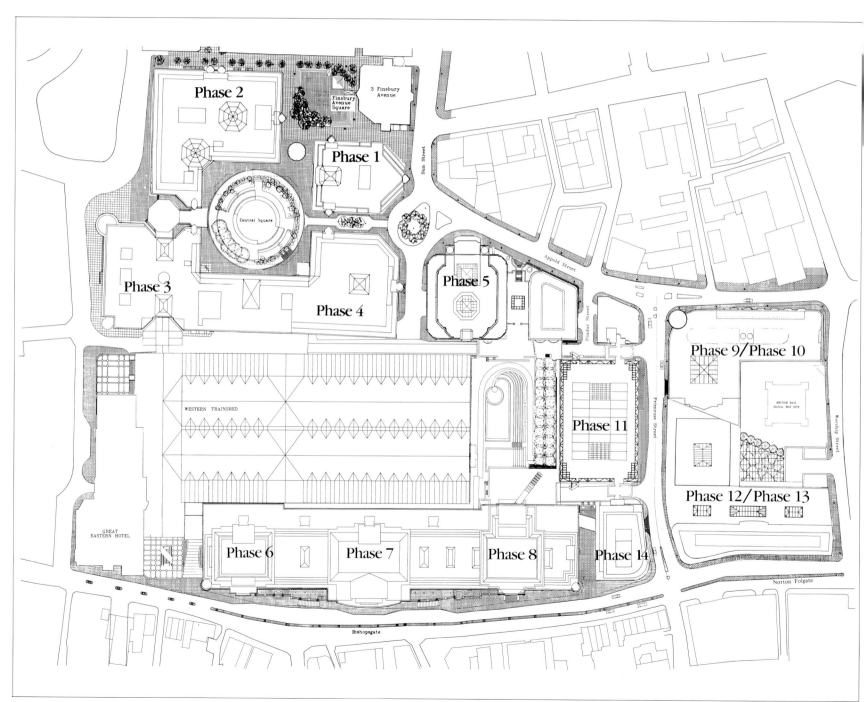

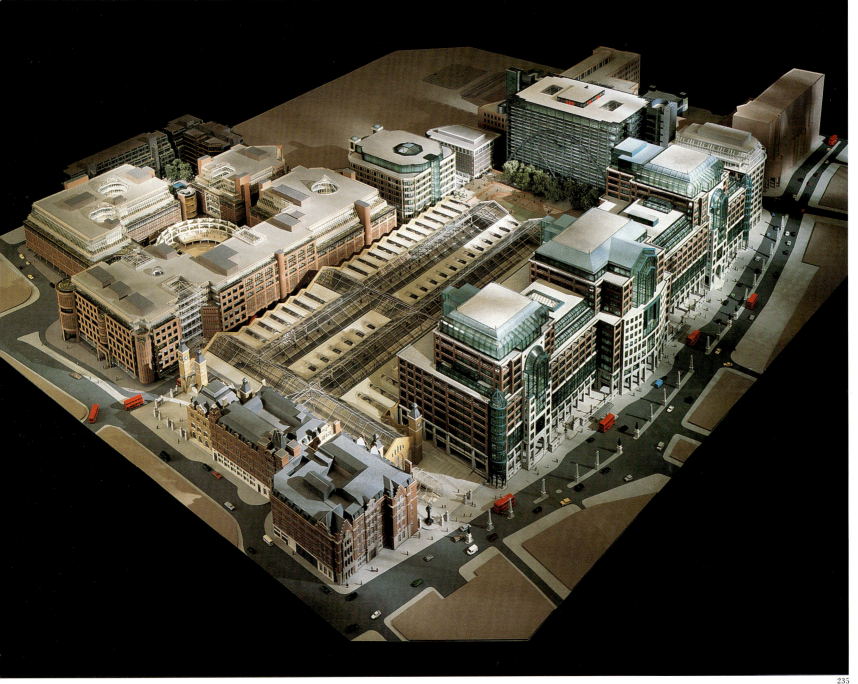

Bishopsgate Project, Broadgate *236. Rendering of east elevation, Phases 6, 7, 8* *237, 238. Model of east elevation*

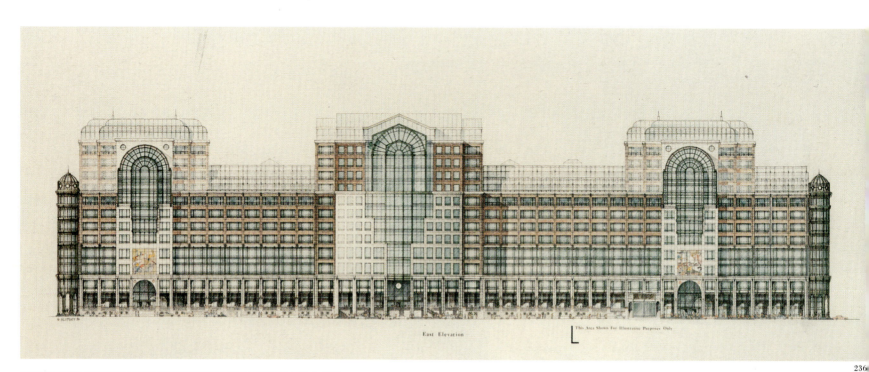

236

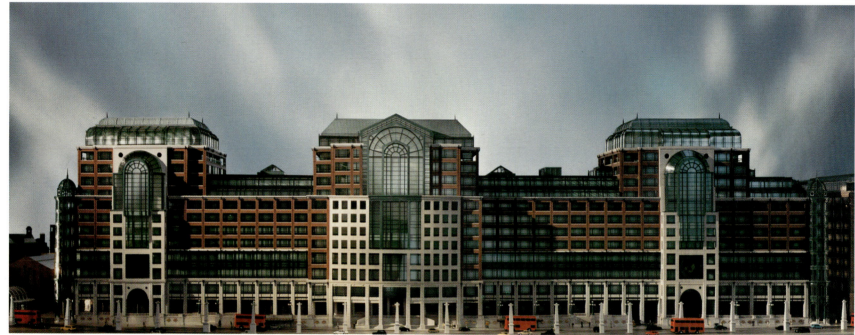

237

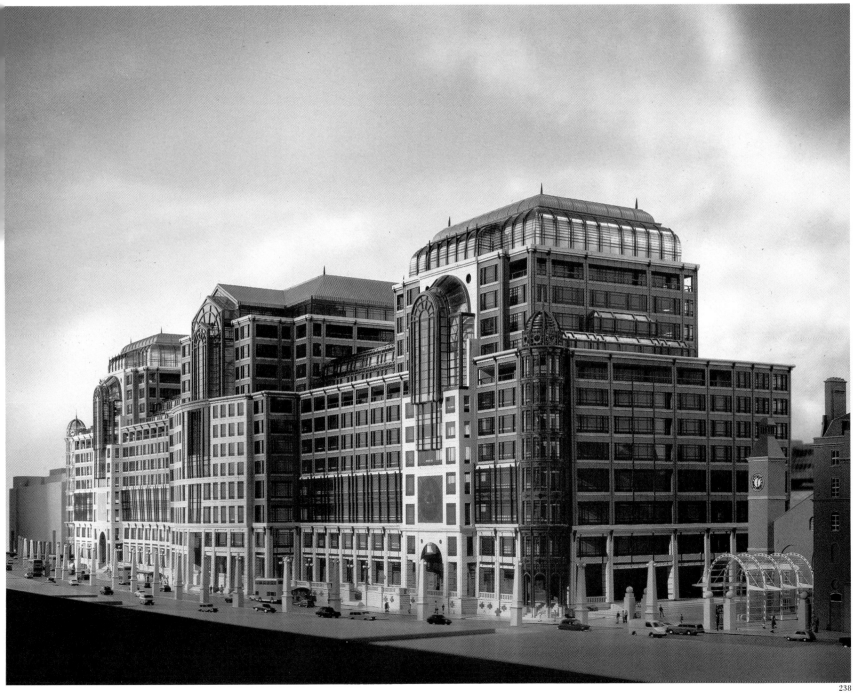

Bishopsgate Project, Broadgate

239. Exterior detail of Phases 9-10
240. Exterior detail of Phases 6-7
241. Exterior detail of Phases 9-10
242. Exterior detail of Phase 5
243. Exterior detail of Phase 6

239

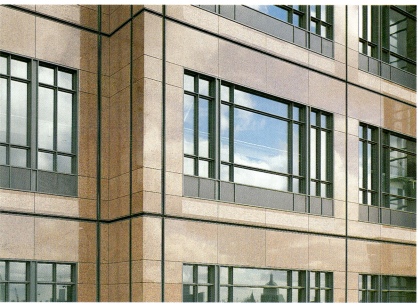
240

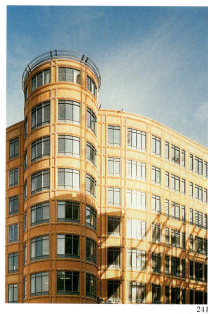
241

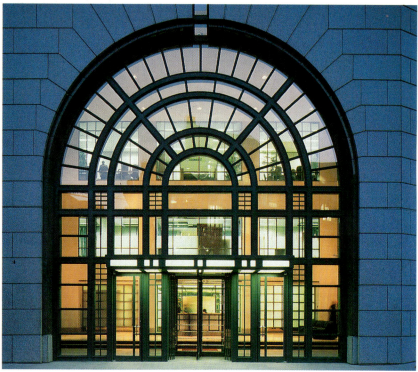
242

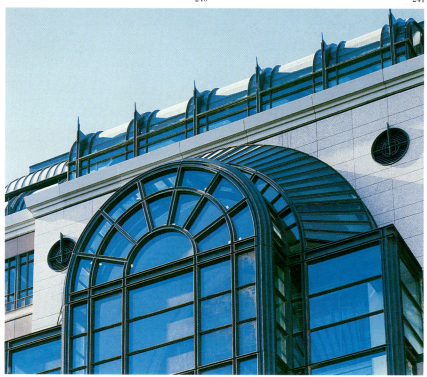
243

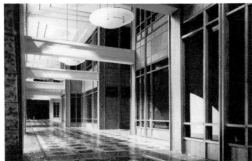

244

244, 245. *Interior pedestrian arcade linking Phases 6, 7, 8 from Liverpool Street Station to Exchange Square*

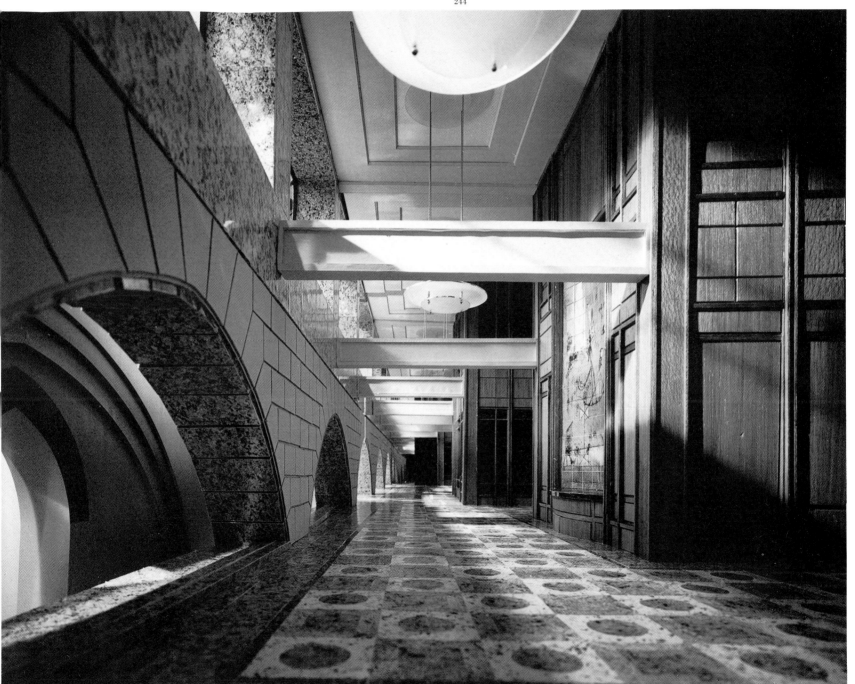

245

Bishopsgate Project, Broadgate

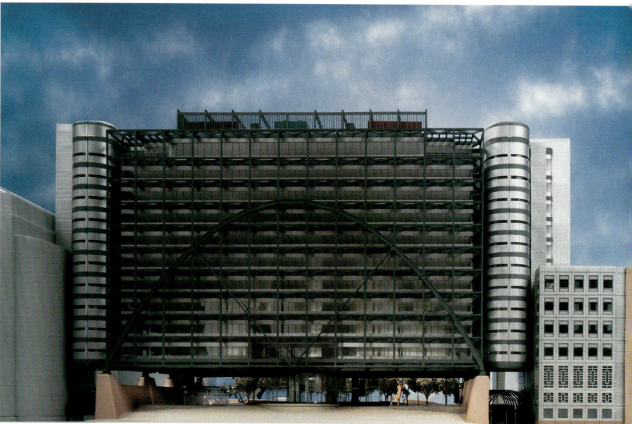

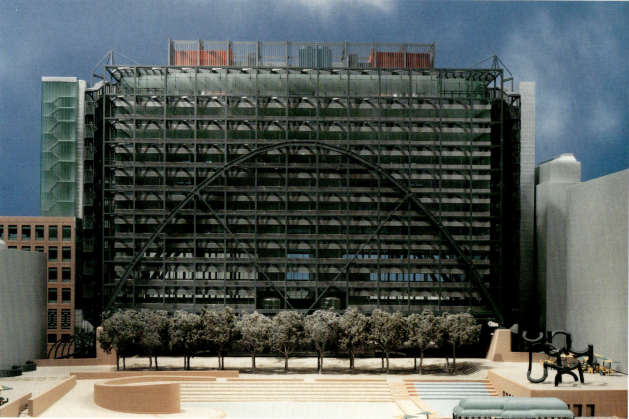

246. Computer-generated rendering of Phase 11
247. Model of Phase 11 from north
248. Model of Phase 11 from south
249. Phase 11 under construction

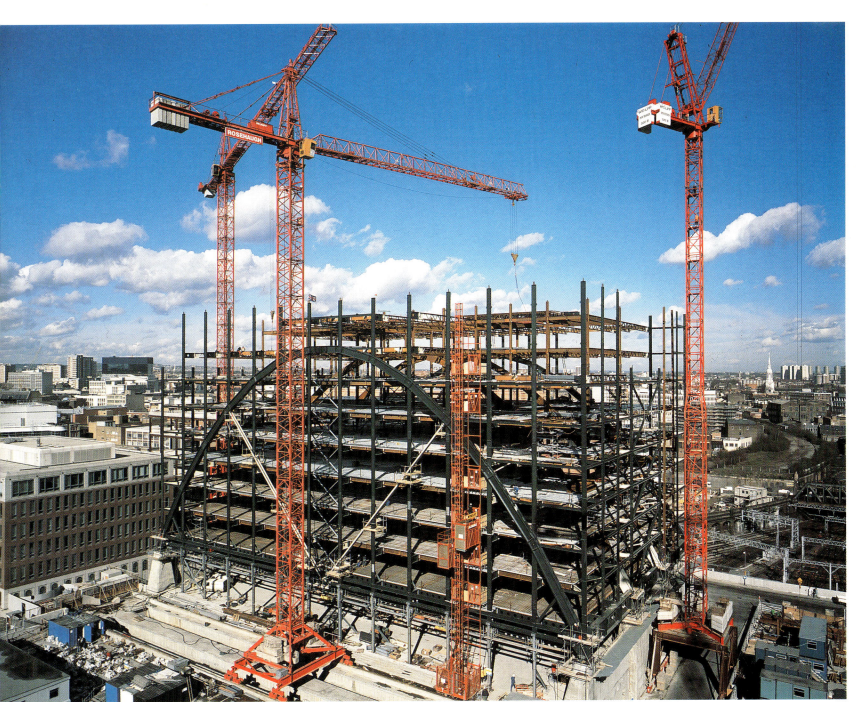

Bishopsgate Project, Broadgate

250

251

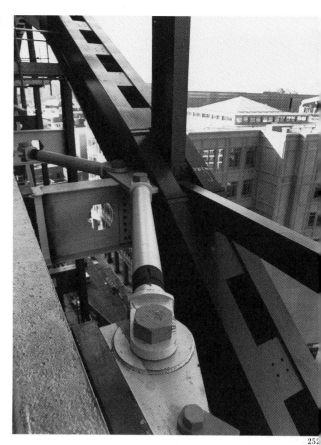

252

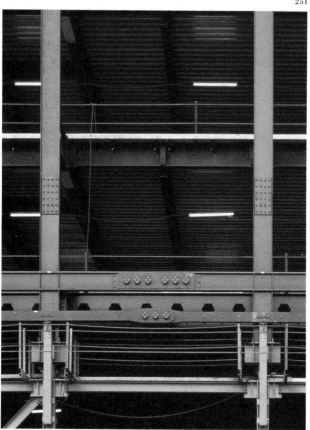

253

254

250. Detail of model, Phase 11
251-254. Details of Phase 11 under construction

255, 256. Computer-generated studies of stairway, Phase 11

257. Phase 11 under construction

255

256

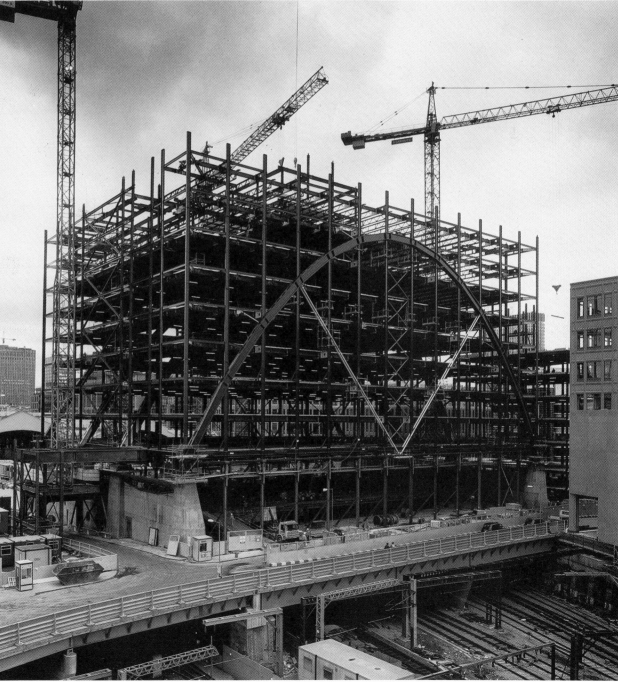

257

1987-1988 King's Cross, Master Plan

258. Site plan
259. Rendering of master plan showing St. Pancras Station on left and King's Cross Station on right

Associate Architects: Frank O. Gehry & Associates; Hanna-Olin, Inc.; Tigerman Fugman & McCurry; Chipperfield Associates
City: London, England
Client: London Regeneration Consortium PLC

It has become even more apparent at King's Cross through collaboration with Frank Gehry, Stanley Tigerman, Laurie Olin, David Chipperfield, and other consultants, that Camden is a town with a soul, with citizens who have pride and hope, and that a plan for this large missing piece can help fulfill the hopes and aspirations of that society. Fortunately, the clients feel the search is worthwhile and that an answer is possible. Here, we are not just searching for building forms and shapes, but for a definition of the kinds of space between buildings that give a sense of reality to the buildings. These spaces will not be the same as those of the last century. Elitist society does not play as commanding a role as it did then; it now has to learn to serve. We are no longer interested in simply designing objects, but in fulfilling the role of architecture in the design of cities.

The King's Cross Master Plan was a response to the request from the London Borough of Camden and British Rail for redevelopment of the rail properties north of the King's Cross and St. Pancras stations. The Plan was meant as a reconfiguration and improvement of the rail operations of the two landmark stations.

Covering approximately 120 acres, the King's Cross site is located in the northern fringe of Central London near the West End and the City. The layout of the Master Plan is generated by the orientation of the two landmark stations of King's Cross and St. Pancras and the respective alignment of their railway tracks. The street grid and orientation of buildings in the western section follow the alignment of St. Pancras, while those of the eastern section follow the alignment of King's Cross. The basic planning diagram consists of two major gateways into the development, one at the southern frontage between the two stations and the other on York Way to the north east of the extended Regent's Canal, which flows through the site. The Master Plan divides the site into five sectors. The southern sector or "King's Place" is intended to be a prestigious new office center with support retail close to the enhanced railway facilities. The central sector called "Battlebridge Island" is to be a mixed-use area that incorporates a hotel, heritage center, retail, leisure space, housing and offices. "York Way" is the eastern sector and features flexible industrial/workshop facilities, offices and retail. Housing, community facilities, and open space constitute the "Camden Fields" northern sector, and the "Camley Gardens" western sector incorporates the enlarged Nature Park, St. Pancras Gardens and a new entertainment and leisure park along the Canal.

Bibliography: London Daily Telegraph, 2 May 1988; *Progressive Architecture,* January 1989.

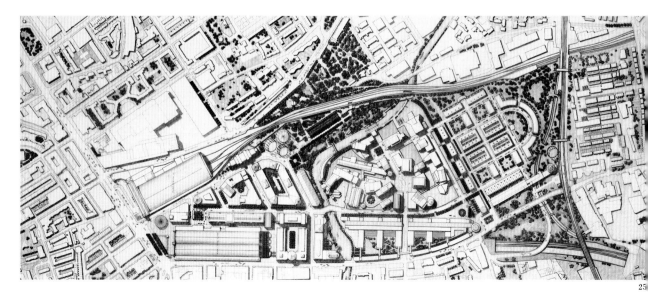

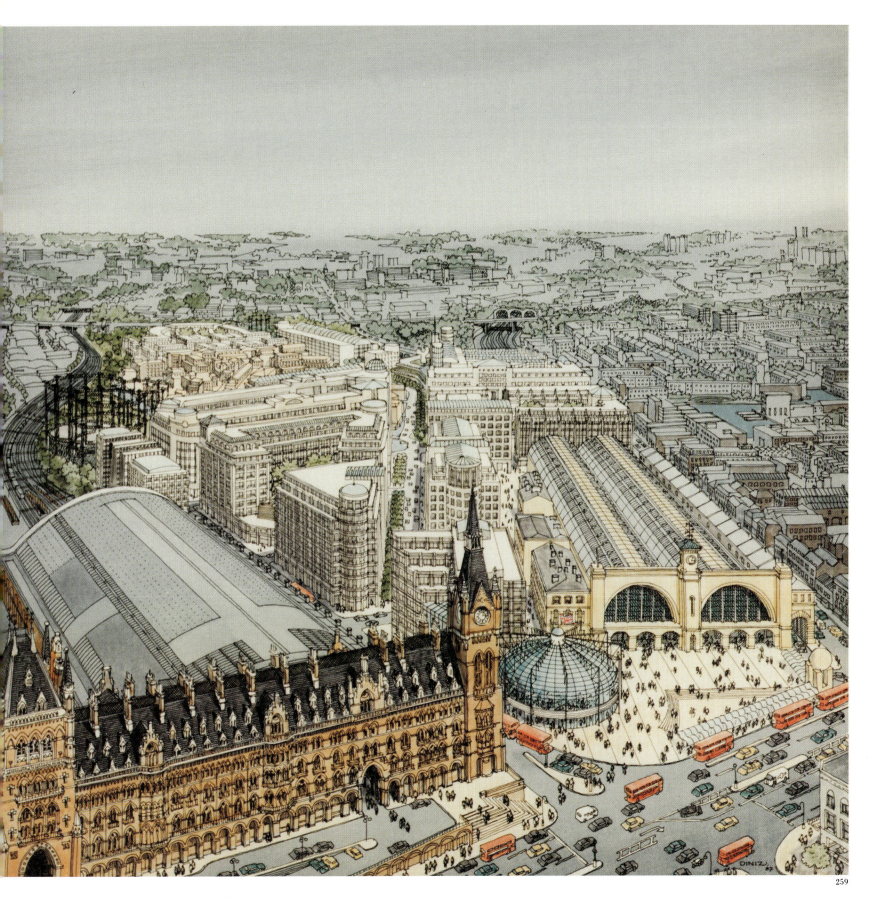

1990s

Port Imperial, Master Plan and Multi-Use Development

Associate Architects: Venturi, Rauch, Scott Brown, Frank O. Gehry and Associates, Inc., Studio di architettura Aldo Rossi (Morris Adjmi), Charles Moore Studio
City: West New York, New Jersey
Client: Arcorp Properties

The hope of collaborating with others in an attempt to search for the language of cities has not only been my personal objective since early youth, but is also an objective of SOM. The pleasure of working with other architects and sharing visions of what might be must, in fact, be rewarding to any architect. In New Jersey, across from Manhattan, the recent charette with Frank Gehry, Charlie Moore, Steve Izenour, and David Childs proved my point. The speed with which our thoughts and ideas became architectural realities was as I expected. No man can build an entire city alone, perhaps no group of architects can build a city alone, but such groups can certainly project visions generated by our interpretations of the human spirit—that is what it's all about. It is this enjoyment of collaboration that drives SOM.

Directly across the Hudson River from Manhattan, the Port Imperial Multi-Use Development covers 125 acres of abandoned railroad yards. The development will be situated along the river at the foot of the Palisades to provide some seven-thousand housing units in three primary neighborhoods and 1,7 million square feet of commercial space concentrated around a crescent-shaped town center. The layout and massing of the development takes advantage of expansive views and maximizes the waterfront amenities. An open space network with landscaping unites residential and commercial uses and brings the Palisades across the site in two major parks.
Development of the site will occur in stages throughout the 1990s.

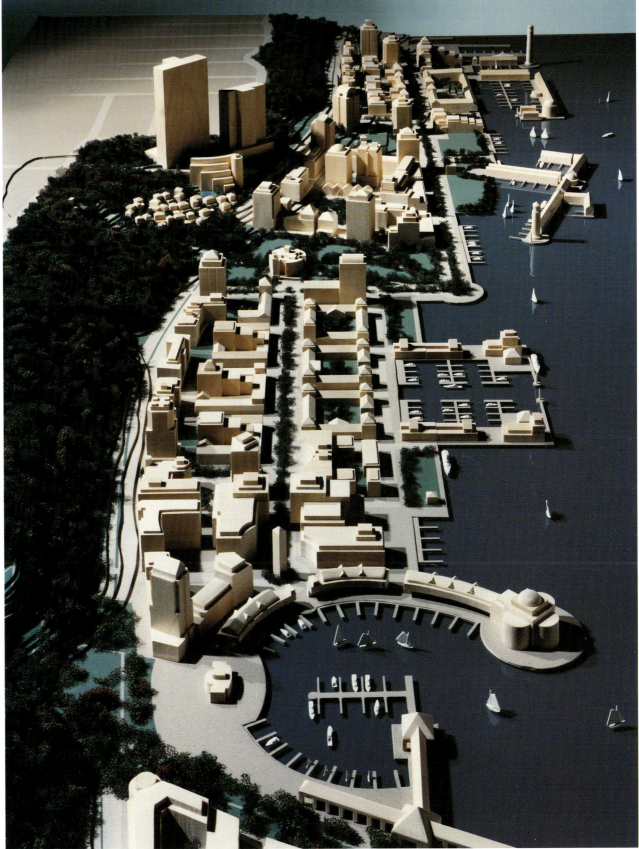

260. Aerial view of model

1990 **Stockley Park, Business Park Campus**

City: Uxbridge, England
Client: Stockley Park Consortium Ltd.
Three three-story office buildings; two of 119,000 square feet; one of 80,000 square feet; on-grade parking; landscaping
White painted aluminum, clear and fritted glass, pre-cast concrete, exposed steel roof frame

Office buildings in a park are the industrial buildings of our era. They become the ultimate flexible spaces; highly technological, but in the end a horror for workers who spend from eight to twelve hours in their confines. The new worker demands a more amenable environment. Material of concrete, steel and glass are assembled with a by-component of green nature so as to soften the tediousness of every day life. These buildings constitute the first one hundred percent computerized product at SOM in that all drawings (architectural, structural and mechanical), are the product of a total design program which incidentally produces the construction documents.

Stockley Park is a 343-acre site situated near Heathrow, the major airport for London, England. The master plan for the site, a former landfill area, was developed in 1984 by Arup Associates to include a golf course by Robert Trent Jones and an extensively landscaped office park with buildings by Arup, Norman Foster, SOM and others. The three buildings by SOM, slated for completion in 1990, are on an uneven triangular site bordered by a raised highway to the east and a canal on the south. A major concern of the client was the rooftop view of the buildings from the higher elevation of the golf course and highway. Thus the design solution for the three buildings incorporates a striking sculptural treatment of each roof. Another consideration in planning the site was the necessity of providing over 900

261

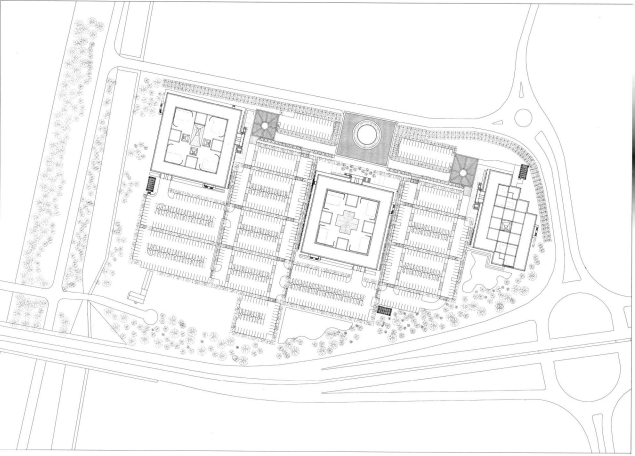
262

261. *Computer-generated study of exposed structural steel*
262. *Site plan*
263. *Computer-generated perspective study of exterior wall*

parking spaces. In response, a system of bays, partially concealed by berming and planting, was devised. A number of structural and mechanical options were explored through three-dimensional computer analyses to produce the most efficient and economical solution. The resulting 9-meter-square bay, used throughout, was logically expressed in the square plan for two of the buildings. The third building, while incorporating the same bay size, is irregular in plan in response to the site. The base of each building, is finished in pre-cast concrete. A white painted aluminum curtain wall, glazed with a combination of clear and fritted glass, is used for the two upper floors. The wall is stepped back at the top floor to expose the steel columns and give emphasis to the roof structure.

Stockley Park, Business Park Campus *Computer-generated studies: 264. Meeting point of steel frame and precast concrete* *265. Entrance stair and canopy* *266. Partial elevation of Building 9*

264

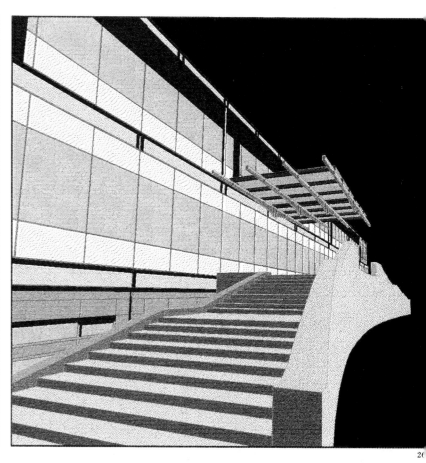

1990 Holy Angels Parish Church

City: Chicago, Illinois
Client: Archdiocese of Chicago
Single-story 10,000 square feet parish church with pitched roof sanctuary, baptistry and Daily Chapel with bell tower; 9,500 square feet multipurpose room below grade; walled garden; paved forecourt and entry plaza
White stucco over concrete and concrete block with clear glass set in black painted wood frames

Holy Angels is an ancient problem of man's search for God and one which architects fear. For faith was measured differently in the late 19th century than in the late 20th century. But, the meeting place for common prayer in a community church, amidst the hell of an American slum, is indeed a primary responsibility and opportunity. Simple materials which can be understood by the community, yet are formed in traditions with echoes of the past, will hopefully serve for the future.

In 1986 the late 19th century Holy Angels Parish Church burned to the ground. The church had been a lone symbol of hope in one of the most depressed and violent neighborhoods in the United States. Plans for the new church were begun in 1989 with an overriding concern in the design for simplicity, flexibility and energy efficiency. The basic basilica shape of the new church is anchored at the northeast by the chapel tower, marking the Daily Chapel, and at the west end by the glazed roof over the Baptistry. The main body of the church is marked by a simple rhythm of steel roof trusses, reaching a celebration of light above the altar, streaming down from dormer windows. The design also allows for services to be said in the more intimate space of the Daily Chapel, still using the main altar which rotates on a stone platform. The pitched roof will carry solar panels down the length of the south side, which will provide most of the heat for the church, backed up by a traditional heating and cooling sys-

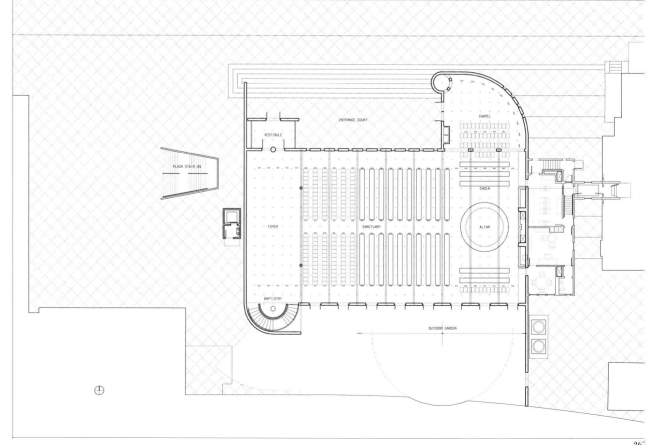

267. Ground floor plan
268. Model from northwest
269. Aerial view of model from west

tem. The south wall of the church will also respond to the sun with a series of doors, glazed with clear glass, which can be thrown open to a walled garden beyond. By contrast the north wall, which faces the street, will be open only on the west end for the main entrance to the church, and for fourteen small wall openings containing dioramas by local artists depicting the Stations of the Cross. A plaza on the north and west sides of the church will be terraced concrete with stone paving, connecting the church to the parochial school of Holy Angels which will use the plaza for their playground. As cost efficiency was of paramount importance, the building has been designed to use standard components wherever possible. At the lower level there will be a multipurpose room running the whole length of the church with kitchen and support functions which can be adapted to many uses for the parish, community and school. The church will be connected to the adjacent rectory by a private access bridge.

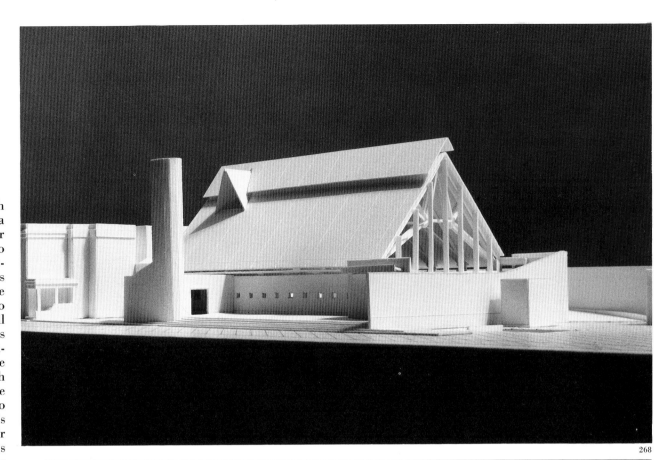

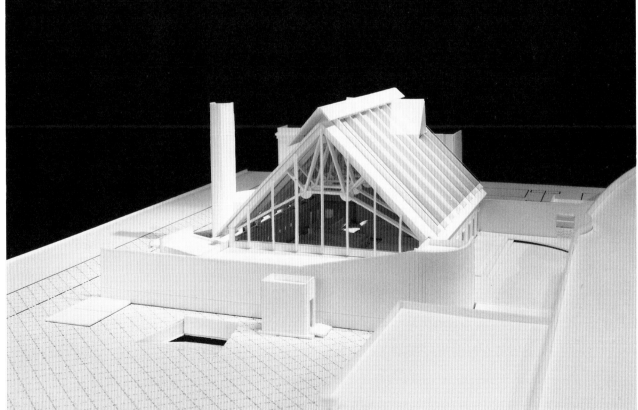

Biographical Note

Bruce Graham, design partner of SOM

Bruce Graham was born in La Cumbre, Bogota, Colombia in 1925, and completed his secondary education in South America. After two years in the U.S. Navy from 1943-1945, he graduated with a Bachelor of Architecture degree at the University of Pennsylvania in 1948. Since joining the firm in 1949, Mr. Graham has brought innovative aesthetic solutions to the varied requirements of major corporations, institutions and developers, not only in Chicago and across the United States, but also throughout the world in Hong Kong, England, Egypt, Spain and the Middle East. He was named a partner in charge of design in 1960. In the civic and professional realm, Mr. Graham's affiliations include the status of past president and current member of the Board of Directors for the Chicago Central Area Committee, a civic group of Chicago's most prominent business leaders, organized to direct the growth and development of Chicago's central area; a trustee of the Urban Land Institute and member of the Board of Directors of the Urban Land Research Foundation; member of the Commercial Club; Board member of the Chicago Council on Foreign Relations; honorary trustee of the Institute of Urbanism and Planning of Peru; Fellow of the American Institute of Architects, and a member of both the Royal Architectural Institute of Canada and the Royal Institute of British Architects. Mr. Graham is also active in the fields of education and the arts. In this capacity he serves as a trustee and chairman of the Board of Overseers for the School of Fine Arts at the University of Pennsylvania, a board member of the Temple Hoyne Buell Center for American Architecture at Columbia University, a trustee of the Chicago Museum of Contemporary Art and of the Art Institute of Chicago, and a trustee of WTTW Channel 11.

Mr. Graham is the recipient of numerous awards. From the Royal Institute of British Architects he has received awards for the W.D. & H.O. Wills Corporate Headquarters and Tobacco Processing Company in Bristol, England, and Boots Pure Drug Company Ltd. Corporate Headquarters in Nottingham, England. He has received Honor Awards from the American Institute of Architects for the Business Men's Assurance Company of America in Kansas City, Missouri, and for the Banco di Occidente in Guatemala City, Guatemala. He has been honored with many awards from the Chicago Chapter of the American Insitute of Architects, including an Honor Award for the Inland Steel Building which in addition was designated an official landmark by the Commission on Chicago Architectural Landmarks, and Distinguished Building Awards for Baxter Travenol Laboratories, Inc., the John Hancock Center, the Sears Tower and the Chicago Board of Options Exchange Bridge. The Chicago Central Area Plan which was coordinated by Mr. Graham was awarded the Urban Design and Planning Award by Progressive Architecture.

Bibliographical Note

Fazlur R. Khan and Bruce Graham with model of the John Hancock Center

Articles by Bruce Graham
B.J. Graham, "The Search for a Postmodern Architecture." *The Architectural Student Journal*, Fall 1978.
B.J. Graham, "Architecture, Fashion and Advertising." *Inland Architect*, July 1978.
B.J. Graham, "The Architecture of Skidmore, Owings & Merrill." *Royal Institute of British Architects, Transactions* 2, no. 2 (1983): 76-84.

Articles and photographic features that include the work of Bruce Graham and SOM
Abitare, August 1987.
Architect's Journal, 25 May 1983; 16 September 1987.
Architectural Record, October 1972; March 1981.
Architecture, February 1989.
Arquitecto Peruano, March - June 1977.
Bauen & Wohnen, April 1957.
Building, August 1982; Oct. 1986.
Building Design, September 1973.
Building Design & Construction, August 1981.
Chicago, May 1982.
Chicago Sun-Times, 24 September 1985; 30 September 1985; 11 November 1985; 2 November 1986.
Chicago Tribune, 14 December 1980; 16 April 1981; 6 September 1981; 17 October 1982; 26 June 1983; 3 January 1984; 1 April 1985; 14 June 1985.
Harvard Graduate School of Design News, January/February 1987.
Inland Architect, July 1968; March/April 1984; March/April 1987.
Interiors, February 1975.
Newsweek, 8 November 1982.
Progressive Architecture, May 1981.
Proq. Architectura Piseno Urbanismo Industrias, April 1984.
Real Estate Advertiser, June 1983.

Books containing information on Bruce Graham, Bruce Graham's works and SOM
Art Institute of Chicago, *Chicago Architects Design, A Century of Architectural Drawings from the Art Institute of of Chicago*, Rizzoli, Chicago 1982.
I.J. Bach, ed., *Chicago's Famous Buildings*, The University of Chicago Press, Chicago 1980.
L. Benevolo, *L'ultimo capitolo dell'architettura moderna*, Editori Laterza, 1985.
A. Bush-Brown, *Skidmore, Owings & Merrill Architecture and Urbanism 1973-1983*, Verlag Gerd Hatje, Stuttgart 1983.
F. Chermayeff, *Observations on American Architecture*, The Viking Press, New York 1972.
S.E. Cohen, *Chicago Architects*, Swallow Press Inc., Chicago 1976.
C.W. Condit, *Chicago 1930-70*, The University of Chicago Press, Chicago 1974.
F. Dal Co and M. Tafuri, *Modern Architecture*, Harry N. Abrams, Inc., New York 1979.
E. Danz, *Architektur von Skidmore, Owings & Merrill, 1950-1962*, Verlag Gerd Hatje, Stuttgart 1962.
E. Danz, *Architecture of Skidmore, Owings & Merrill, 1950-1962*, Frederick A. Praeger, Publishers, New York 1963.
E. Danz and A. Menges, *La Arquitectura de Skidmore, Owings & Merrill, 1950-1973*, Editoriale Gustavo Gili, Barcelona 1975.
B. Diamonstein, *American Architecture Now II*, Rizzoli, N.Y. 1985.
A. Drexler, *Transformations in Modern Architecture*, Museum of Modern Art, New York 1979.
M. Emanuel, ed., *Contemporary Architects*, St. Martin's Press, New York 1980.
P. Guedes, *Encyclopedia of Architectural Technology*, McGraw-Hill Book Company, New York 1979.
P. Heyer, *Architects on Architecture*, Walker and Company, New York 1966.
A.L. Huxtable, *Kicked a Building Lately?*, Quadrangle/New York Times Book Co., New York 1976.
A.L. Huxtable, *The Tall Building Artistically Reconsidered*, Pantheon Books, New York 1984.
C. Jencks, *Skyscrapers - Skycities*, Rizzoli, New York 1980.
Macmillan Encyclopedia of Architects, The Free Press, N.Y. 1982.
A. Menges, *Architecture of Skidmore, Owings & Merrill, 1963-1973*, Architectural Book Publishing Co., New York 1974.
A.L. Morgan and C. Naylor, eds., *Contemporary Architects*, St. James Press, 2nd ed., Chicago 1987.
N.A. Owings, *The Spaces in Between: An Architect's Journey*, Houghton Mifflin Company, Boston 1973.
V. Scully, *American Architecture and Urbanism*, Holt Rinehart and Winston, New York 1969.
D. Sharp, *A Visual History of Twentieth-Century Architecture*, New York Graphic Society, Ltd., Greenwich 1972.
G.E.K. Smith, *The Architecture of the United States*, Anchor Press/Doubleday, Garden City 1981.
M. Whiffen and F. Koeper, *American Architecture 1607-1976*, The MIT Press, Cambridge 1981.
Who's Who In America, 4 vols., Macmillan Directory Division, Wilmette 1974-1981.
Who's Who in America, 1 vol., Macmillan Directory Division, Wilmette 1986-1987.

Photographic Credits

The numbers refer to the pages

©Altman, Ben, Sadin Photo Group, Chicago: 132, 134 (right), 135 (bottom), 136, 137, 150, 152 (left), 163

Cabanban, Orlando, Chicago: 58 (bottom), 102, 103, 109, 140 (left), 149

Carlos Diniz Associates, Los Angeles (Renderings): 92, 93, 139 (top), 140 (right), 141, 155

Fine, Robert, Chicago: 60 (top)

Hedrich-Blessing, Chicago: 10 (right), 11, 29 (bottom), 30, 31, 36 (top), 40, 46, 49 (left), 57, 58 (top), 76, 82 (top), 95, 96 (left), 97 (left), 100 (left), 101 (left), 101 (top), 108, 110 (top right), 111, 125, 126, 127, 128, 129, 133, 134 (left), 135 (top), 138, 146, 147

Hoyt, Wolfgang, ©Esto, Mamaroneck, N.Y.: 96 (right), 97 (right)

Hursley, Timothy, Little Rock: 47, 59, 60 (bottom), 61 (bottom), 116, 118, 119, 120, 121, 122, 123

Kaplan, Howard N., HNK Architectural Photography, Inc., Highland Park: 12, 13, 17 (right), 77 (top), 78 (bottom), 79, 81 (bottom), 91

Karant & Associates, Chicago: 82 (left)

Merrick Nick, Hedrich-Blessing, Chicago: 145, 147

Murphey, Gregory, Chicago: 98, 99, 100 (right), 101 (bottom)

Schmid, Robert: 114 (bottom)

Stoller, Ezra, ©Esto, Mamaroneck, N.Y.: 14, 15, 16, 17 (left), 18, 19, 22, 23, 24, 25, 26, 27, 29 (top), 32, 33, 34, 35, 39, 41, 43, 44, 45, 48, 49 (right), 50, 51, 52, 54, 56, 63, 64, 65, 66, 67, 68, 69, 70, 71, 72, 73 (bottom), 74, 75, 78 (top), 80, 81 (top), 82 (bottom), 83

Steinkamp-Ballogg Photography Chicago, Chicago: 157

Turner, Philip, Chicago: 38

Williams, Alan, London: 151, 152 (top left-right), 152 (bottom left-right), 153

Wheeler, Nick/Wheeler Photographics, Weston (Mass.): 84, 86, 87, 88, 89

Printed by Electa
by Fantonigrafica, Venice